People

GREAT
LIVES

REMEMBERED

REMEMBERING

Here's an astonishing fact: In 1977, when Elvis Presley died suddenly, PEOPLE did not put him on the cover. In fact, we didn't even run a story: His death was mentioned, in one paragraph, on page 60.

We didn't mean any disrespect to the King—far from it. It's just that, at the time, PEOPLE was young, only three years old, and we were learning new lessons every week. We downplayed Elvis's passing because, we feared, any story about death—even that of a beloved celebrity—was too macabre a subject for the cover.

We were, of course, completely, obviously, demonstrably, 100-percent wrong. Over time we learned that, when someone famous dies, readers wanted the news, a recounting of the life they often had followed for years, and, not least, a memento. Farewell cover stories, beginning with John Lennon in 1980, have, over the decades, become some of the best-selling issues in PEOPLE's history. An earlier PEOPLE book, *Gone Too Soon*, about famous people who died young, also proved popular with readers.

People: Great Lives Remembered looks back at 55 celebrity tributes from the magazine's first 36 years. From Jackie Kennedy and Princess Diana to Audrey Hepburn, Frank Sinatra, Ronald Reagan, Johnny Carson, Paul Newman, Michael Jackson, John Belushi and more, they entertained, inspired or simply kept us watching.

To be reminded how and why—or to *learn* how and why—turn the page.

CONTENTS

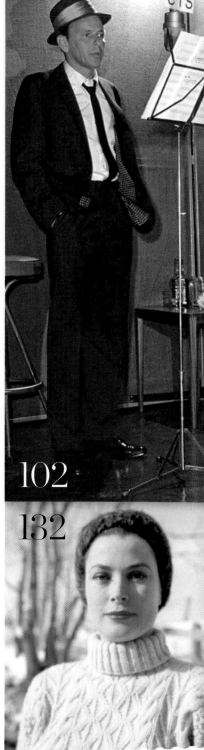

102

132

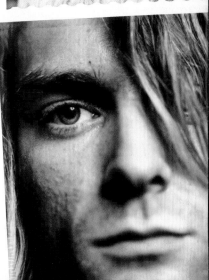

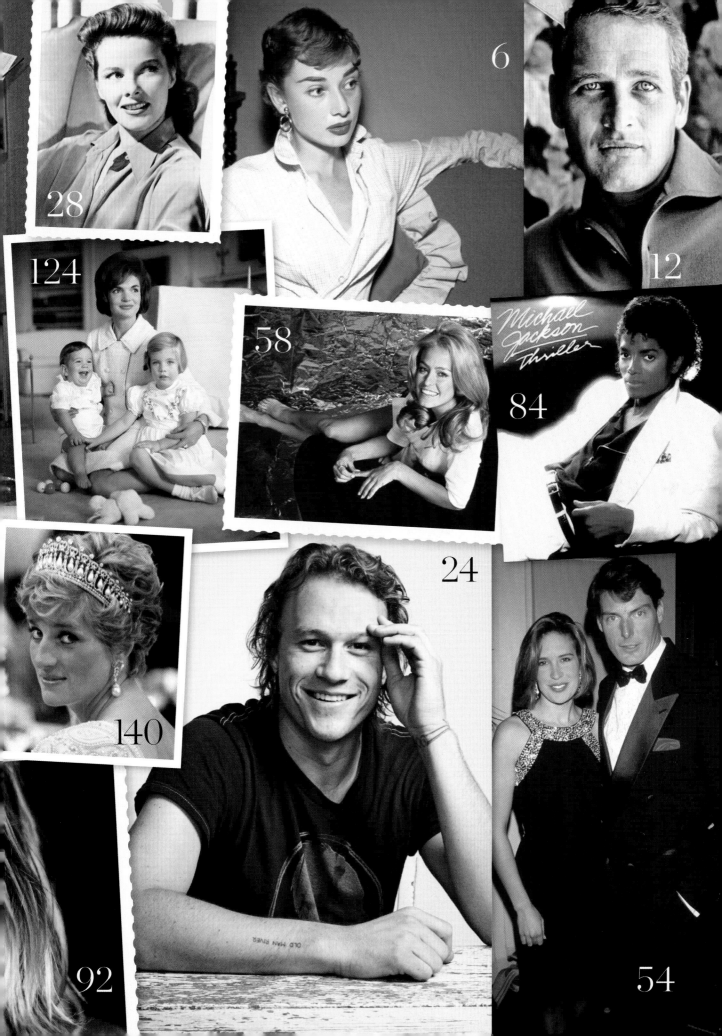

Michael Jackson
Thriller

MOVIES

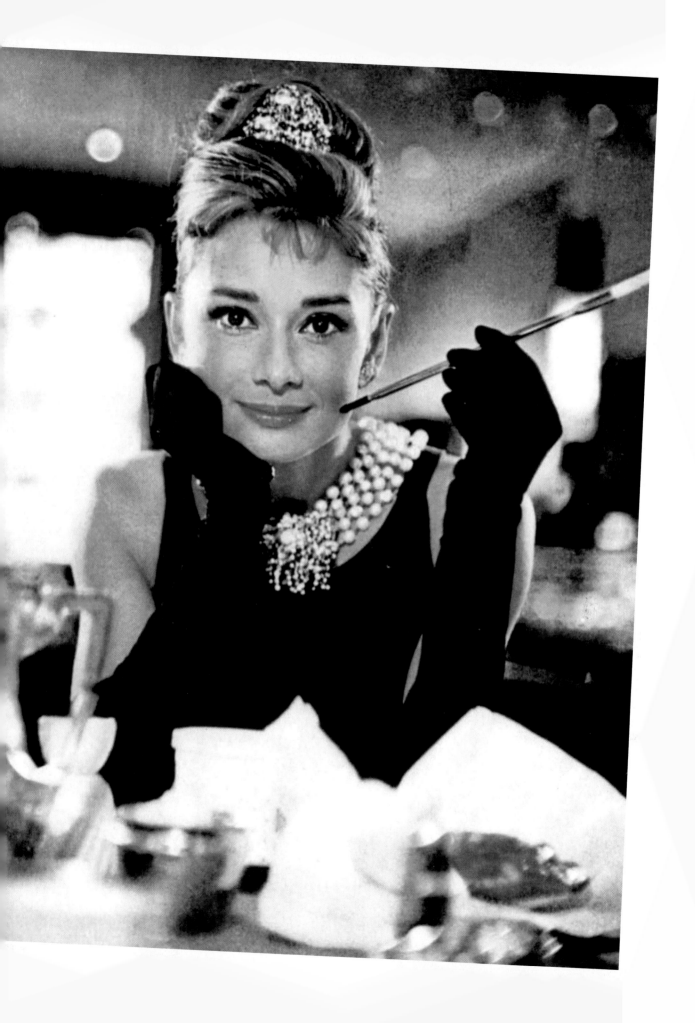

AUDREY HEPBURN

1929
1993

An icon of beauty, she overcame a daunting childhood
to lead a rich life with inspiring grace

You looked at her and all

you could think was that nothing bad should ever happen to
her," said one admirer. Shirley MacLaine called her "a cross
between the salt of the earth and a regal queen." In the long
list of attempts to capture Audrey Hepburn in a phrase,
perhaps William Wyler, who directed her in *Roman Holiday,*
put it best: "She *gets* to you."

Indeed. Women loved her movies, her clothes, her style;
men simply fell in love. Somehow she was beautiful and
soulful, innocent and sophisticated, all at once, the perfect
star for a long string of splashy Hollywood romances—*Funny
Face, Roman Holiday, Sabrina, Charade*—that still delight
after 50 years. "People associate me with a time when movies
were pleasant, when women wore pretty dresses in films and
you heard beautiful music," she said years later. "I always
love it when people write me and say, 'I was having a rotten
time, and I walked into a cinema and saw your movies, and it
made such a difference.'"

Her empathy was real, rooted in a traumatizing childhood.
The daughter of an Anglo-Irish banker and a Dutch baroness,
Hepburn—born Edda van Heemstra Hepburn-Ruston—was
raised by her mother in Holland after her parents divorced when

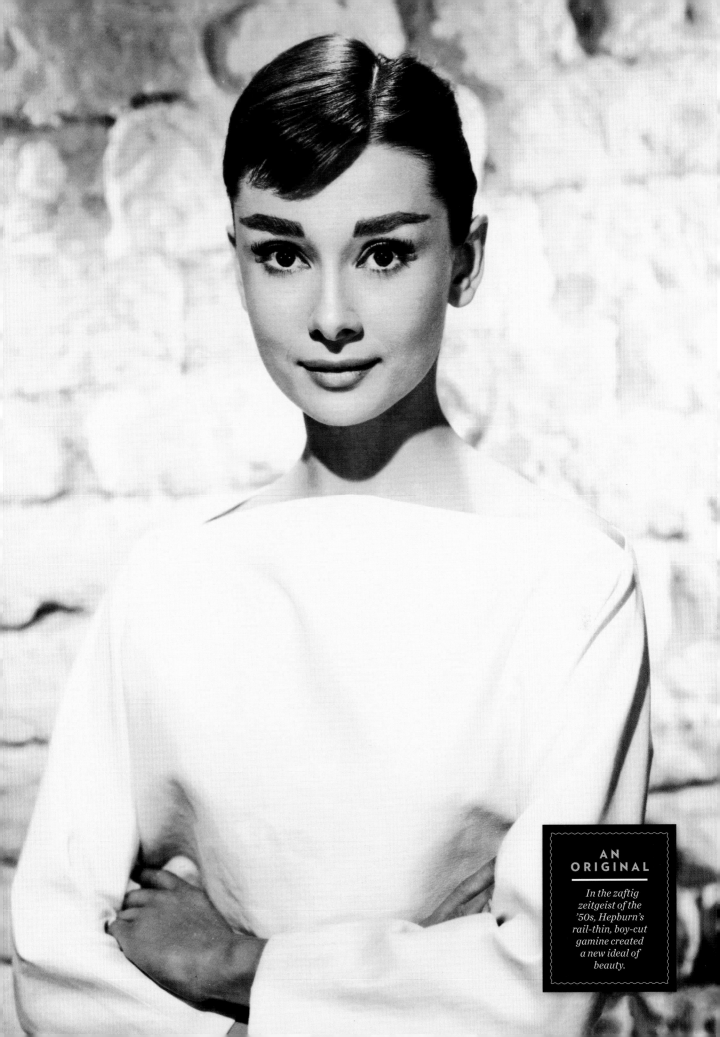

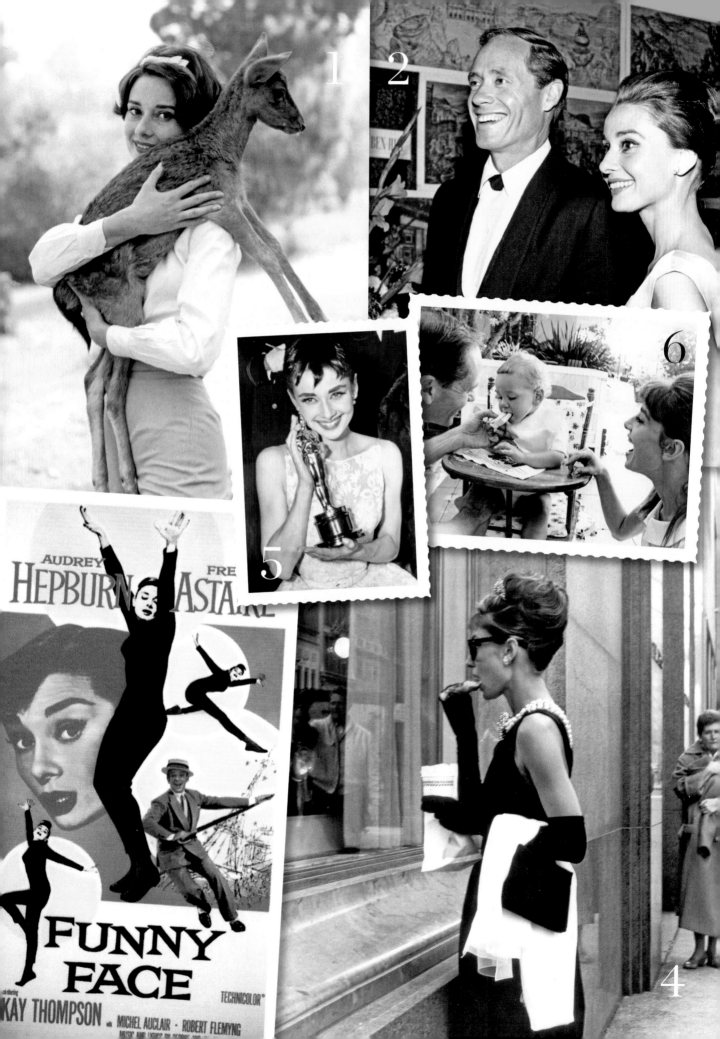

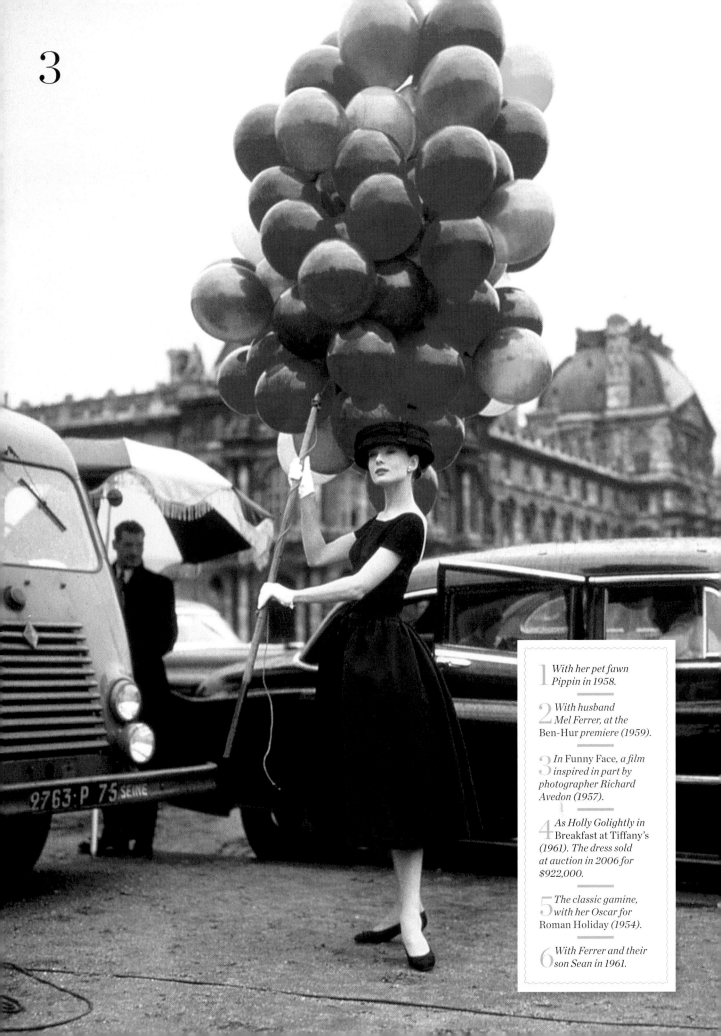

3

1 *With her pet fawn Pippin in 1958.*

2 *With husband Mel Ferrer, at the* Ben-Hur *premiere (1959).*

3 *In* Funny Face, *a film inspired in part by photographer Richard Avedon (1957).*

4 *As Holly Golightly in* Breakfast at Tiffany's *(1961). The dress sold at auction in 2006 for $922,000.*

5 *The classic gamine, with her Oscar for* Roman Holiday *(1954).*

6 *With Ferrer and their son Sean in 1961.*

> # WITH AUDREY, IT'S KIND OF UNPREDICTABLE. SHE'S LIKE A GOOD TENNIS PLAYER—SHE VARIES HER SHOTS"
>
> HUMPHREY BOGART,
> ON HEPBURN'S ACTING STYLE

she was 9. The Nazis invaded in 1940, and after a while "the rationing started," she recalled, "and, little by little, the reprisals began." Once chubby, Hepburn became gaunt and frail, subsisting for a time on flour made from tulip bulbs. Her mother helped the Resistance; Audrey carried messages stuffed into her shoes. Her uncle and cousin were shot; her older brother Alexander was conscripted to work in a Berlin factory. Those years marked her for life. "Your soul is nourished by all your experiences," she said. "It gives you baggage for the future—and ammunition."

Driven, she went to London after the war to study ballet and landed a chorus-girl part in the musical *High Button Shoes.* Three years later, in Monte Carlo for a movie bit, she was spotted by the novelist Colette, who instantly realized she had found the girl to play her Gigi on Broadway. The role made Hepburn, 22, a star; she kept a photo of Colette on her dressing table, inscribed, "To Audrey Hepburn, the treasure I found on the beach."

Hepburn married twice—to actor Mel Ferrer and psychiatrist Andrea Dotti—and, after five heartbreaking miscarriages, had two sons. She quit films for eight years to care for them. "The fact that I've made movies doesn't mean breakfast gets made," she said, "or that my child does better in his homework."

Toward the end of her life, inspired in part by groups that sought to alleviate suffering in Holland during the war, she worked tirelessly for UNICEF, drawing attention to the plight of children in Sudan, El Salvador, Guatemala, Honduras, Bangladesh, Somalia and Vietnam. Her two careers, she recognized, fed both sides of herself. "I was born with an enormous need for affection," she once said, "and a terrible need to give it."

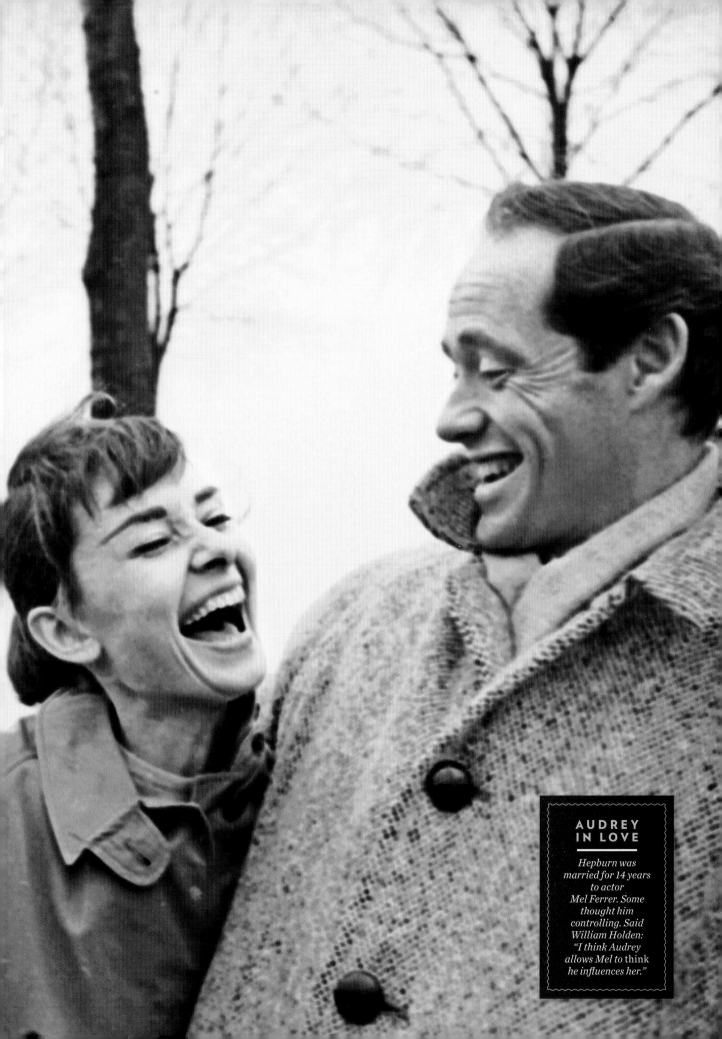

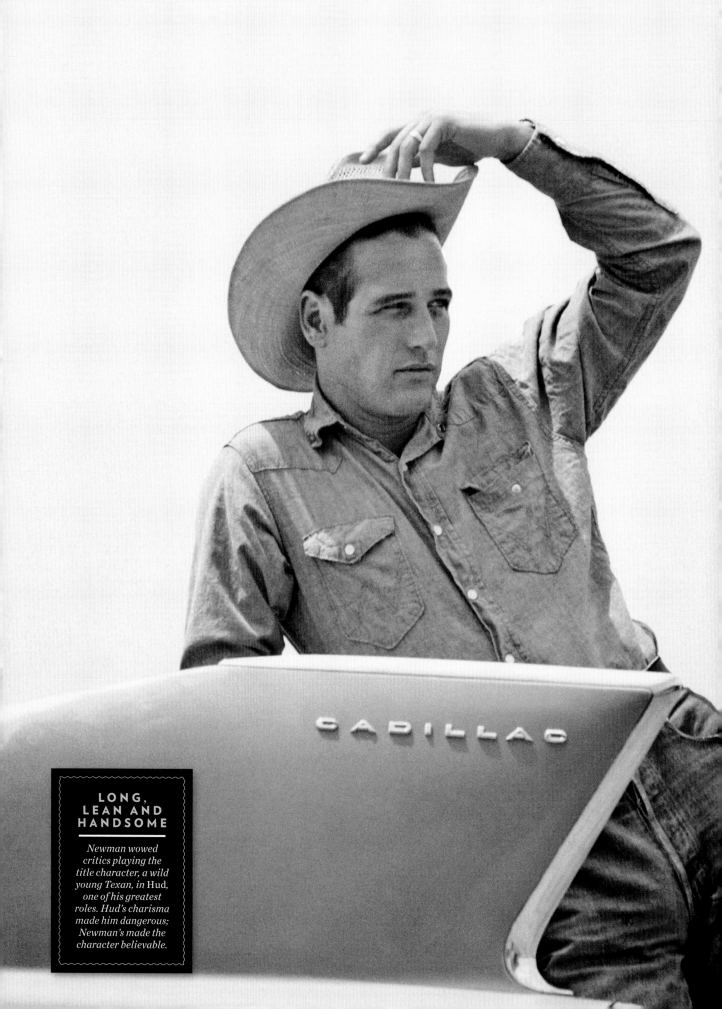

CADILLAC

PAUL NEWMAN

1925
2008

What is cool? Hard to say. But one thing is certain: Those who talk about it don't have it. And Paul Newman never talked about it

He was a public figure

who tried—often with humor, sometimes by any means necessary—to enjoy the simple pleasures of living a private life.

The public knew him first and foremost as an actor, one of the dominant stars of the last half of the 20th century. He came up in the '50s with Dean and Brando and made his name playing sexually charged antiheroes in *The Hustler, Hud* and *Cool Hand Luke.* Two of his biggest hits, *Butch Cassidy and the Sundance Kid* and *The Sting,* linked him forever in the public mind with friend and costar Robert Redford. In his 60s—traditionally long past the use-by date for men with matinee-idol looks—he forged a second career playing beat-up survivors in *The Verdict* and *Nobody's Fool.* He was thrilled by the change. "I was always a character actor," he insisted. "I just *looked* like Little Red Riding Hood."

Off-screen there were other Paul Newmans. Introduced to auto racing while filming 1969's *Winning,* he took lessons, turned pro and silenced doubters with speed— including, in 1979, a 2nd-place finish at Le Mans. He could be ambivalent about acting ("One day I wake up and I think I'm terrific, and the next day I wake up and I think it's all junk") but never about cars. "I don't care what

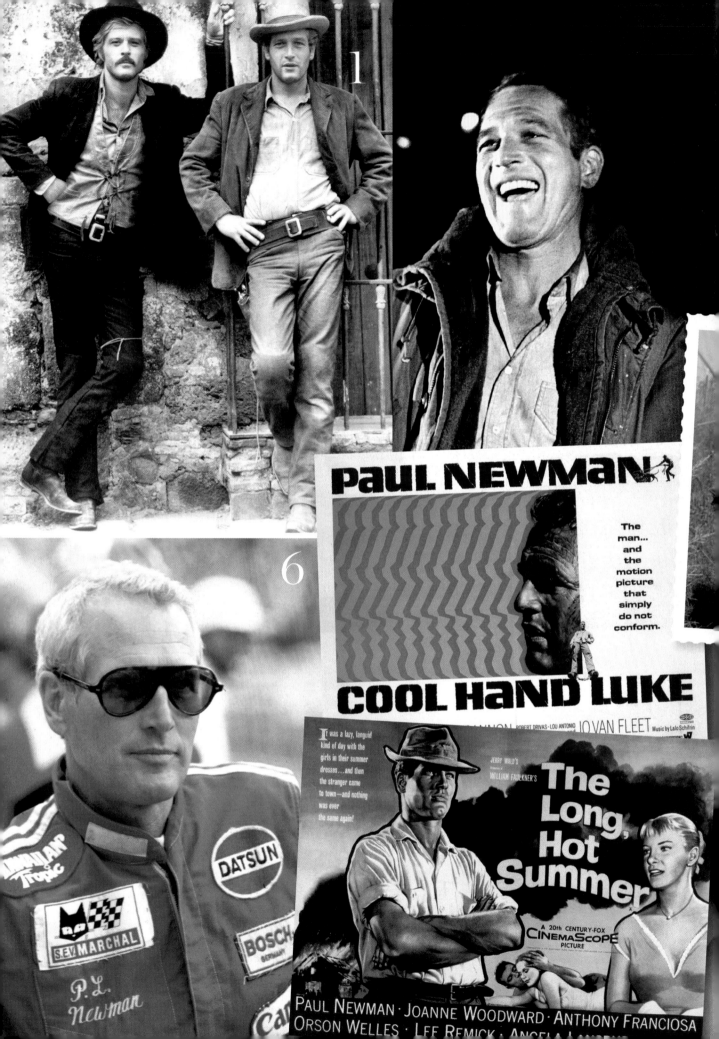

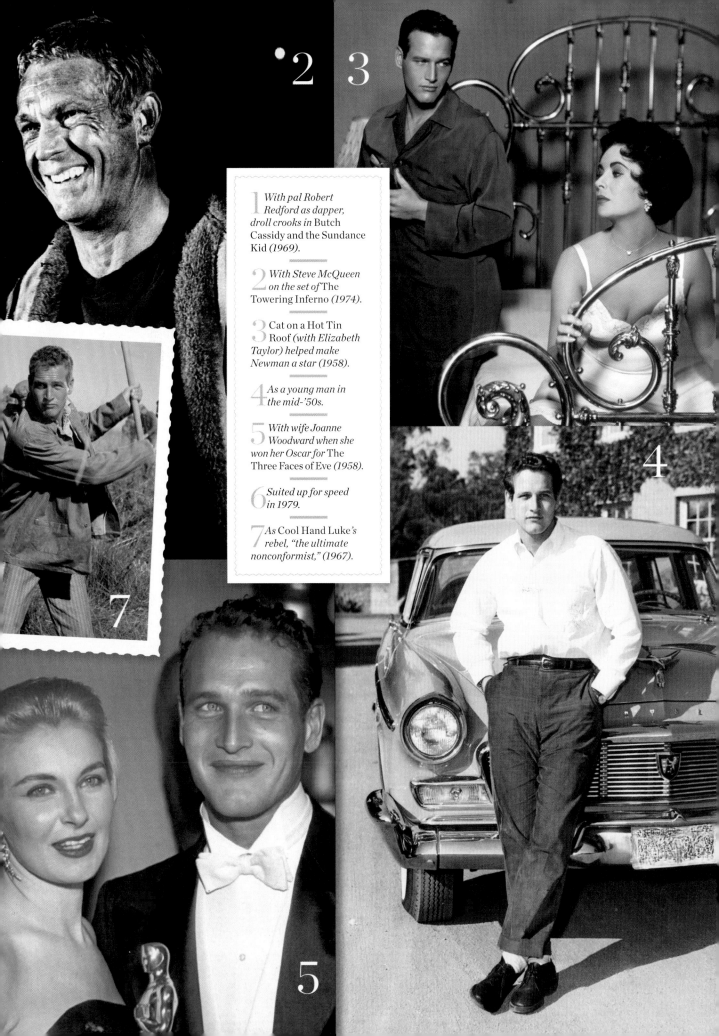

‘2 3

1 *With pal Robert Redford as dapper, droll crooks in* Butch Cassidy and the Sundance Kid *(1969).*

2 *With Steve McQueen on the set of* The Towering Inferno *(1974).*

3 Cat on a Hot Tin Roof *(with Elizabeth Taylor) helped make Newman a star (1958).*

4 *As a young man in the mid-'50s.*

5 *With wife Joanne Woodward when she won her Oscar for* The Three Faces of Eve *(1958).*

6 *Suited up for speed in 1979.*

7 *As* Cool Hand Luke*'s rebel, "the ultimate nonconformist," (1967).*

4

7

5

> ## "I DON'T THINK IN MY HEART I EVER THOUGHT WE WOULDN'T [BE TOGETHER]. SHE IS THE LAST OF THE GREAT BROADS"
>
> —PAUL NEWMAN

anyone says about my acting," he said. "I've been humiliated, lied about. But they mess around with my racing—that's something else."

In later years the public met another Newman: the whimsical entrepreneur who, with pal A.E. Hotchner, started Newman's Own, a food company that to date has donated more than $280 million to charity. "There are three rules for running a business," they said of their approach. "Fortunately, we don't know any of them." Some of the money went to another Newman project: the Hole in the Wall summer camps, which provide free recreation and escape to thousands of kids with cancer, HIV/AIDS and other serious illnesses. The simple goal, said Newman, was to let kids "raise a little hell and not feel different."

Lastly there was Paul Newman husband and, with actress Joanne Woodward, half of one of Hollywood's most famous and famously enduring couples.

Asked in an interview why, unlike other Hollywood stars, he was a one-woman man, Newman replied, "Why would you go out for hamburger when you have steak at home?" When Woodward was reportedly miffed at the kindly intended but perhaps awkward comparison to sirloin, Newman likened her instead to a 1959 Bordeaux, "a year that ages well in the bottle," he noted. "Will I get in trouble for that?" Said Woodward: "He makes me laugh and I make him laugh, and that's really the best thing of all."

In love with his wife he was. Publicly loquacious, about that or other personal matters? Only rarely, and if the moon was right. Once, at the Cannes Film Festival, a reporter asked a question that Newman had been chewing on all his life: "What does a star owe his public?" Newman, in just two words, gave an answer that spoke both of his gratitude and his lifelong battle to remain, as he called it, a "free agent": "Thank you."

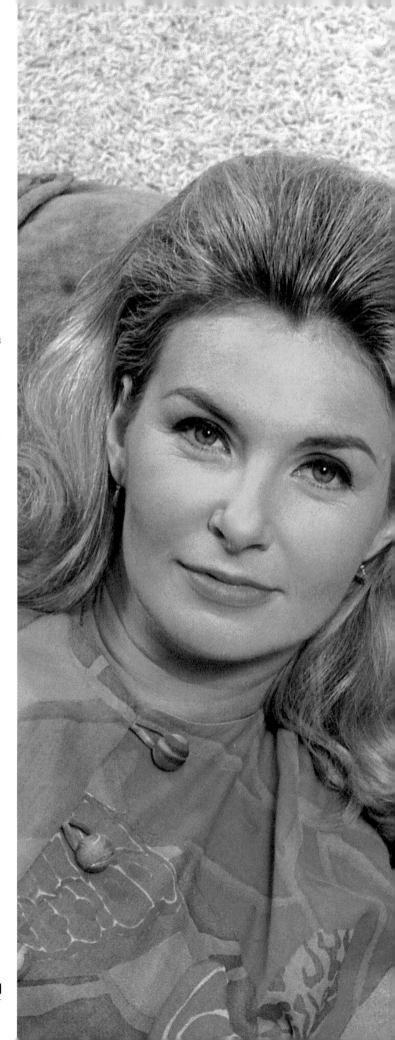

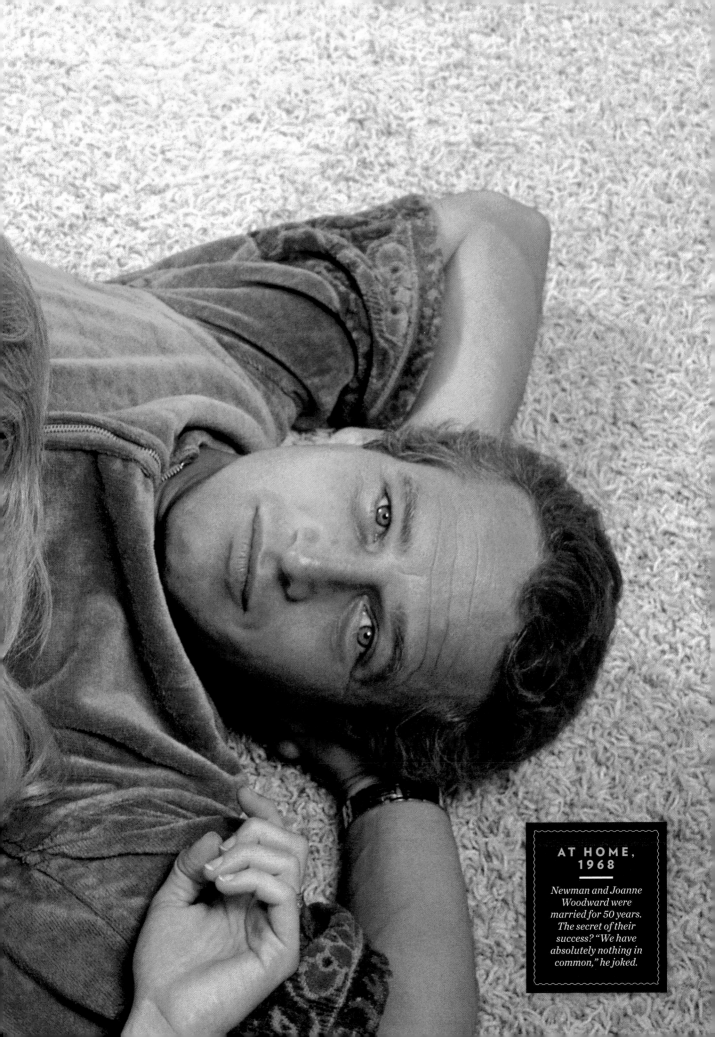

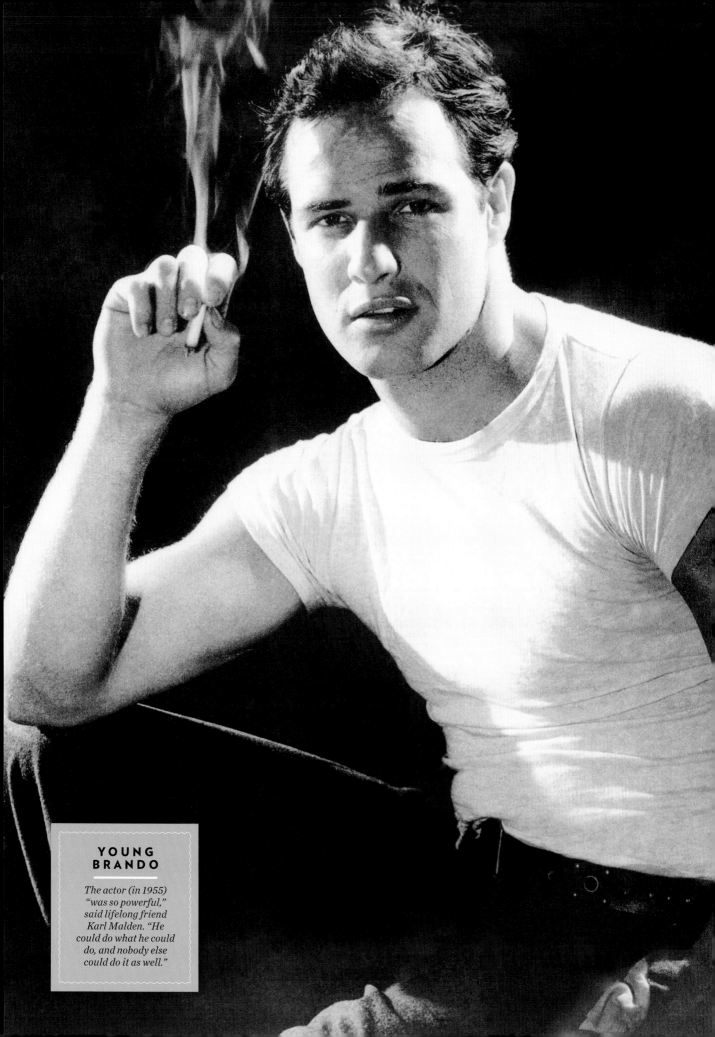

MARLON BRANDO

1924
2004

A towering talent was the movies' most influential actor—and greatest enigma

At 23, he stepped onstage as Stanley

Kowalski in *A Streetcar Named Desire* and revolutionized American theater. Hollywood came next. Just citing a line can evoke an entire performance: "I coulda been a contender"—the dockworker and failed boxer Terry Malloy in 1954's *On the Waterfront*, for which Brando won his first Oscar; Kowalski, sobbing and bellowing, "Stella! Hey—Stellaaaaaaaa!" in the classic 1951 film version of *Streetcar*; *The Godfather*'s Don Corleone, the 1972 comeback role that won him a second Oscar, running his mob with seignorial gravitas: "I'm gonna make him an offer he can't refuse."

"Marlon opened the door," said Robert Duvall, his *Godfather* costar. "He showed that you could be realistic as an actor, you could be natural, you could be alive. You didn't have to rely on convention. Marlon had a great, healthy sense of irreverence to knock away preconceptions." Without Brando, there would most likely be no Al Pacino, no Robert De Niro, no Jack Nicholson, no Sean Penn or Johnny Depp.

But Hollywood was only half the story; his life itself became a decades-long spectacle as outsize and dramatic as almost anything mere screenwriters could dream up. A man of unpredictable passions and enormous appetites, he seemed to give rein to them all. He gave his heart to causes, most notably the early civil rights movement. "Other celebrities would show up suddenly at other marches," recalled Rep. John Lewis, a Democrat from Georgia who, like Brando, marched with Dr. Martin Luther King Jr. in Washington, D.C., in 1963. "But Marlon was the first,

and they were following his lead." In a more controversial act, he deputized a 26-year-old part-Apache, part-Yaqui named Sacheen Littlefeather to attend the 1972 Oscars and, in protest of Hollywood's treatment of Native Americans, refuse the Best Actor Award he won for *The Godfather*.

His romantic appetite was large and global—and marked, it seemed, more by spontaneity than commitment. While filming *Mutiny on the Bounty* in Tahiti in 1960, he fell in love with his 19-year-old costar Tarita Teriipaia. They married two years later. Brando also bought a local island, Tetiaroa. In all he wed and divorced three times and fathered 11 children, including three with his former maid.

He was at best an inattentive father and in later years all but collapsed with guilt when nightmarish tragedy swamped his sprawling family. In 1990 his son Christian shot and killed his half-sister Cheyenne's boyfriend Dag Drollet during an argument at Brando's L.A. home. (Christian, who spent five years in jail, claimed the shooting was an accident.) Five years later Cheyenne hanged herself. "Marlon never got over her death," said a friend.

In the end he was obese—more than 300 lbs.—in terrible health and, it seemed, lonely. Said an acquaintance whom Brando phoned in his last days while trying to find a current phone number for Christian: "He sounded like he was destitute of friends. Just a lost soul."

But in at least one way he was still Marlon Brando, the performer whose sheer life-force had electrified acting 50 years before. A director who spoke frequently with Brando about a possible project in the weeks before his death recalled that the aging titan often donned an oxygen mask to help his breathing. When one day the director suggested that perhaps the role they were discussing would be too physically taxing for him, Brando slipped off the mask. "I am ready," he said. "You just say, 'Action.'"

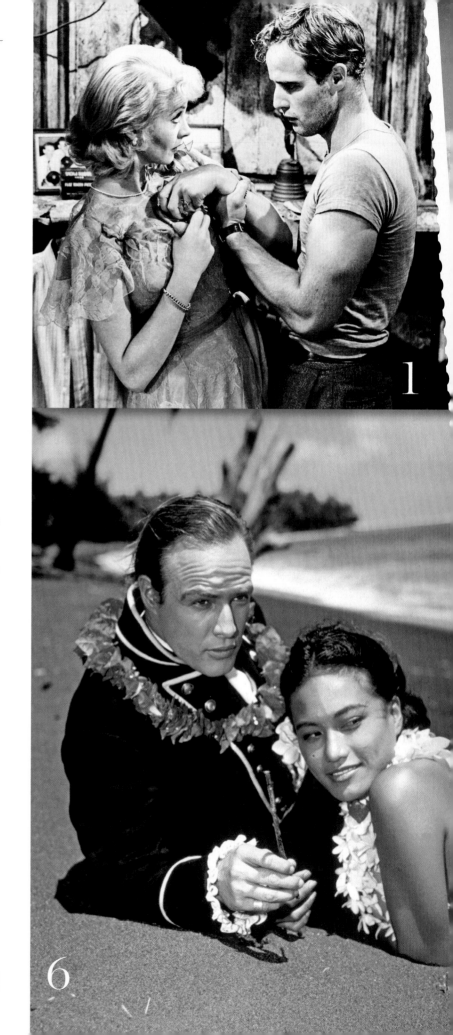

1

6

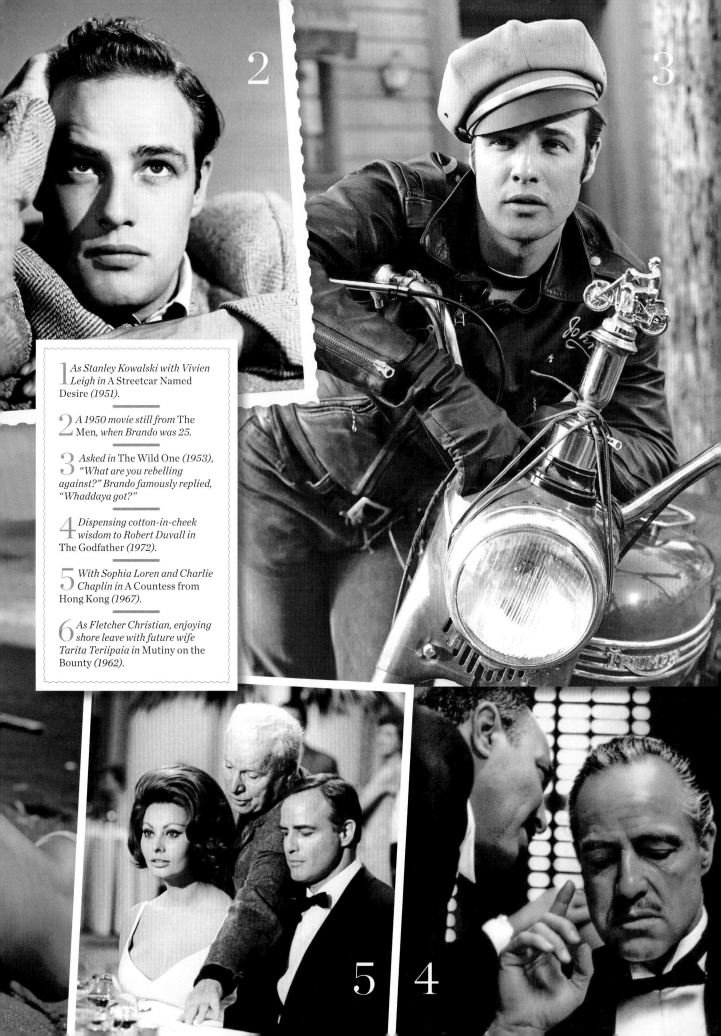

1 *As Stanley Kowalski with Vivien Leigh in* A Streetcar Named Desire *(1951).*

2 *A 1950 movie still from* The Men, *when Brando was 25.*

3 *Asked in* The Wild One *(1953), "What are you rebelling against?" Brando famously replied, "Whaddaya got?"*

4 *Dispensing cotton-in-cheek wisdom to Robert Duvall in* The Godfather *(1972).*

5 *With Sophia Loren and Charlie Chaplin in* A Countess from Hong Kong *(1967).*

6 *As Fletcher Christian, enjoying shore leave with future wife Tarita Teriipaia in* Mutiny on the Bounty *(1962).*

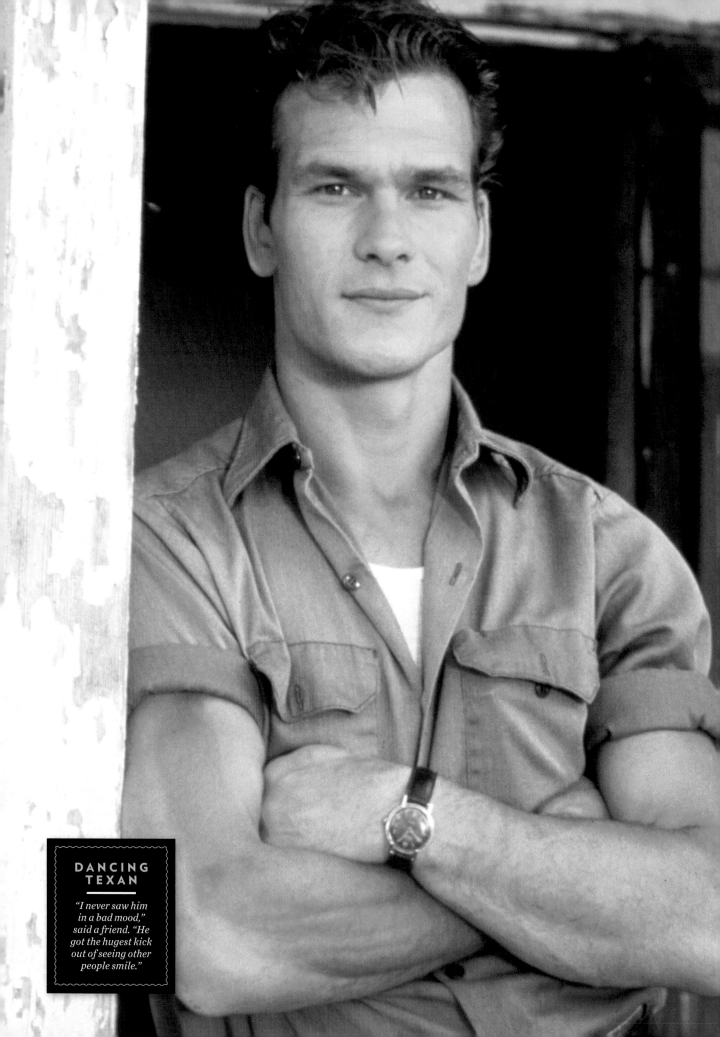

PATRICK SWAYZE

1952
2009

Of cancer, he wrote, "I've had more lifetimes than any 10 people put together, and it's been an amazing ride. So this is okay"

No matter what

he was going through, Patrick Swayze never missed a chance to pay tribute to his wife of 34 years. So when Lisa Niemi turned 53 in May, the actor hosted a barbecue for friends and family at his ranch in the San Gabriel Mountains near L.A. Although he was battling pancreatic cancer, he remained as determined as ever. "His energy was, 'I'm going to beat this,'" recalled a friend, Bill Rotko. Yet, at the barbecue, "it was the first time you saw Patrick as you think of cancer patients," said Rotko. "He had switched from one chemo to another; it was a type of chemo he lost his hair with, and the fight was more obvious. If you judged a book by its cover . . . but you couldn't do that with Patrick Swayze because his energy was the opposite. He was a strong guy."

On Sept. 14, 2009, after a 20-month battle, Swayze, 57, died at home with Lisa by his side. A classically trained ballet dancer who became a movie leading man, "Patrick was a rare and beautiful combination of raw masculinity and amazing grace," said his *Dirty Dancing* costar Jennifer Grey. A high school football player who could pull off gravity-defying grands jetés, a big-screen heartthrob who drove his own cattle, Swayze brought his almost paradoxical talents to huge hits like 1987's *Dancing* and 1990's *Ghost*. "He lived 100 lifetimes in one," said Rob Lowe, who costarred with him in 1983's *The Outsiders*. Adds choreographer Kenny Ortega: "He had such an enthusiasm for everything he did. If he could climb it, he climbed it. If he could write it, he wrote it. If he could dance it . . . well, we all knew he did. He lived."

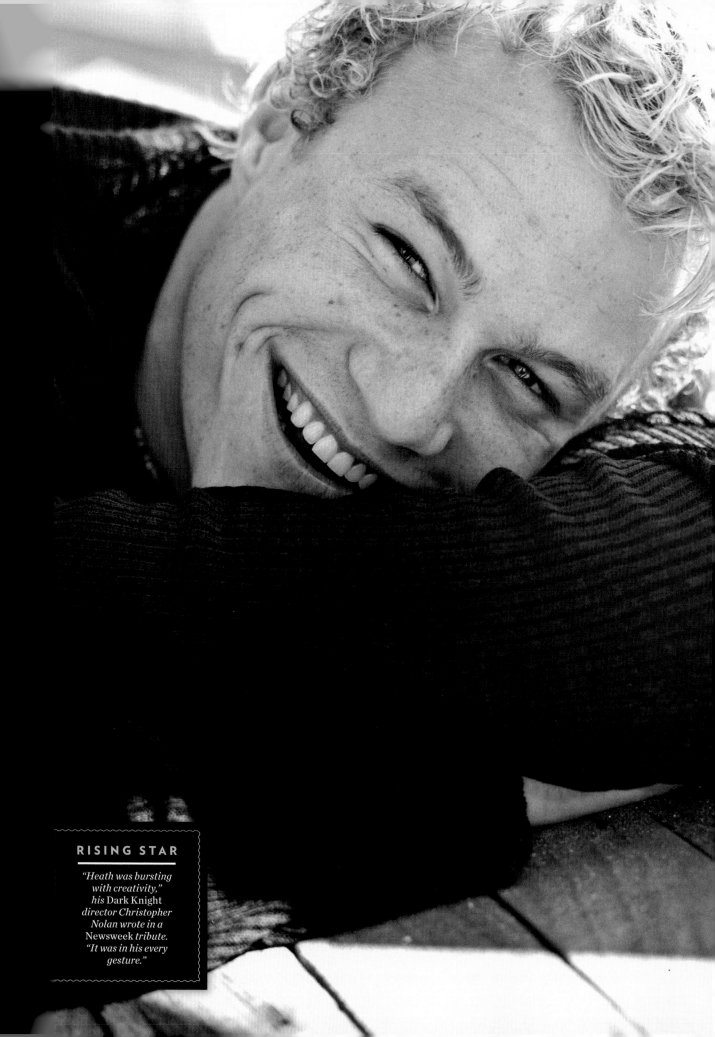

RISING STAR

"Heath was bursting with creativity," his Dark Knight director Christopher Nolan *wrote in a* Newsweek *tribute. "It was in his every gesture."*

HEATH LEDGER

A gifted young actor and loving father fought demons the public never saw

He always said that

he never wanted to be an actor," recalled a friend, "but that he didn't know what else to do."

Perhaps the problem for Heath Ledger was that he was very good at something that didn't really make him happy. Certainly the trappings of stardom—paparazzi, awards season mayhem, PR handlers—seemed anathema to a kid from Perth who cherished his workaday Australian roots. When he became a star and earned an Oscar nomination for 2005's *Brokeback Mountain*, he told Catherine Hardwicke, who had directed him in 2005's *Lords of Dogtown*, "I just want to move away to Holland and ride bicycles for a year—and get away from all this craziness." Ledger and girlfriend Michelle Williams, who fell in love on the *Brokeback* set, didn't move to the Netherlands but, with baby daughter Matilda, did ditch Hollywood for Brooklyn in hopes of leading a more normal life. Ledger proclaimed himself perfectly wired for domesticity. "I'm Mr. Mom!" he told *Rolling Stone* in 2005. "I get [Michelle] granola and cook her an egg. I clean the dishes. And then I'm cooking lunch . . . and I love it!"

That may well have been true; or it may well have been true for that moment, at least. Despite Ledger's claims of contentment, friends knew what the public did not: that he had a wild side he seemed unwilling or unable to control. "He

was trying to lead a healthy life," said a close friend. "But it's harder for some people than others. Heath was a great guy. He did his best, but sometimes he went to excess."

Friends say those excesses played a role in his 2007 breakup with Williams. Still suffering from the split, and missing Matilda, he spent months in England filming the bleak Batman film *The Dark Knight,* playing the Joker, whom he described as "a psychopathic, mass-murdering, schizophrenic clown with zero empathy." Ledger complained of insomnia and said that even sleep drugs didn't help. "Last week I probably slept an average of two hours a night," he told *The New York Times.* "I couldn't stop thinking. My body was exhausted, and my mind was still going." In New York he stayed out late—including a night he spent drinking at the bar of the trendy Beatrice Inn while wearing a ski mask and a hood. Said one club-goer: "At nights when I was going home, he was just starting. . . . Everyone knows he did a lot of drugs."

But no one was prepared for what happened next: On Jan. 22, 2008, a massage therapist who had an appointment entered Ledger's SoHo apartment, found him unconscious and phoned 911. Paramedics tried CPR, but it was too late. An autopsy later concluded that Ledger, 28, had died of an accidental overdose of prescription drugs.

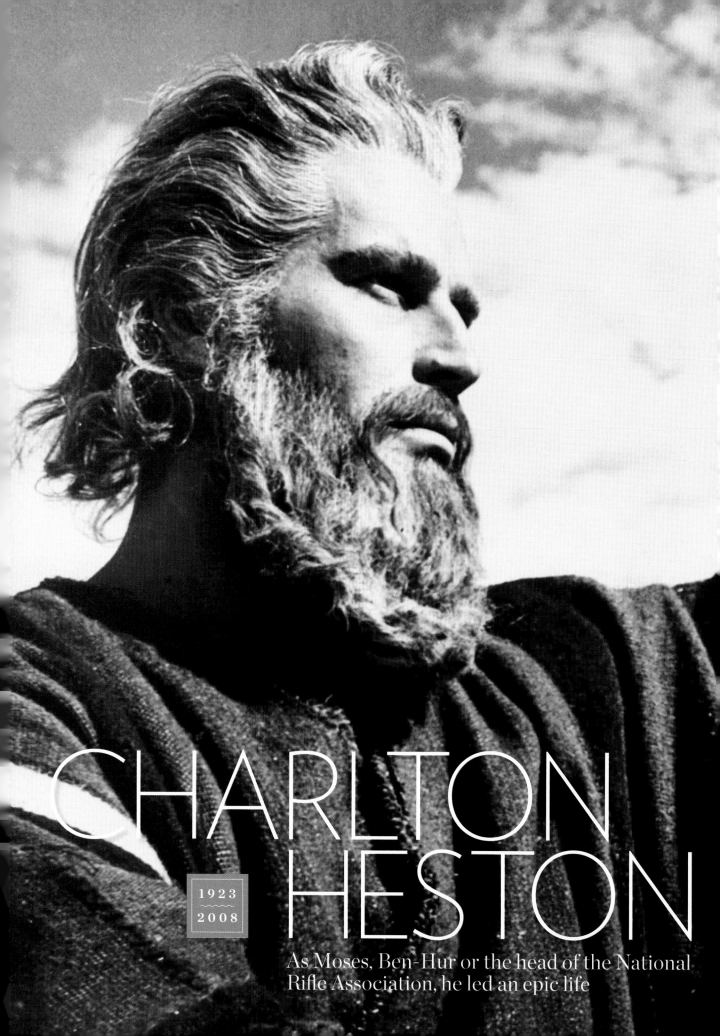

CHARLTON HESTON

1923
2008

As Moses, Ben-Hur or the head of the National
Rifle Association, he led an epic life

He was made for big

roles—on- and off-screen. In a five-decade film career Charlton Heston portrayed the likes of Ben-Hur, Moses and Taylor, the angry hero of *Planet of the Apes.* But he became almost as well known for his outspoken politics, chiefly as president of the National Rifle Association from 1998 to 2003, when he proudly proclaimed that if gun control advocates wanted to take away his firearms, they'd have to pry them "from my cold, dead hands."

Which is why it surprised many people who didn't know him that Heston was, in private, unfailingly gracious. "The sweetest man in the world, kind and thoughtful to all the cast and crew," said actor Robert Vaughn, who'd been an extra in *The Ten Commandments.* Said John James, who costarred with Heston on TV's *The Colbys:* "He'd have everyone over for barbecues. He went out of his way to put people at ease."

Raised in Michigan and Illinois, Heston, as a teen, won an acting scholarship to Northwestern University. After service in the Aleutian Islands during WWII, he landed on Broadway in *Antony and Cleopatra,* then headed for Hollywood. At the Paramount lot, he gave Cecil B. DeMille—who would later direct *The Ten Commandments*—a jaunty wave. "I like the way he waved," DeMille told an aide. "We'd better have him in."

Heston was married to his college sweetheart, Lydia, for 64 years. The secret, he told PEOPLE, was to remember "three little words: 'I was wrong.'"

Heston died of complications from Alzheimer's in 2008. First diagnosed in 2002, he had accepted the news with exceptional grace. "He looked at me and said, 'Why so glum, pal—you feel bad for me?'" recalled his close friend Tony Makris. "I said, 'Yes,' and he said, 'Don't. I got to be Charlton Heston for 80 years. That's more than fair.'"

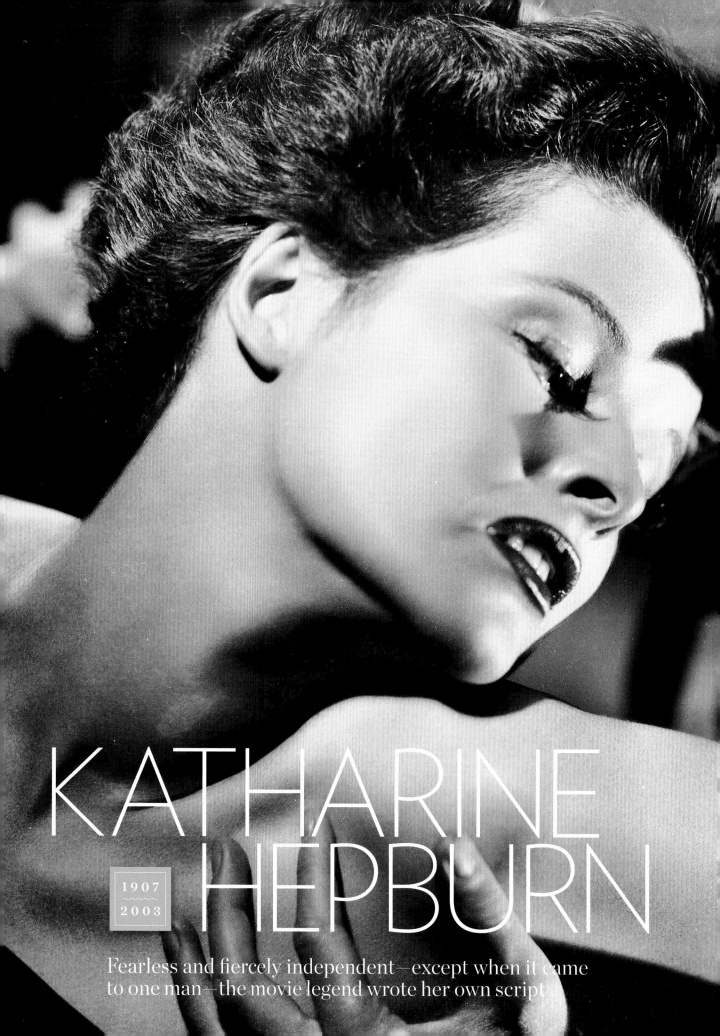

KATHARINE HEPBURN

1907 2003

Fearless and fiercely independent—except when it came
to one man—the movie legend wrote her own script

If you obey all the

rules," Katharine Hepburn once said, "you'll miss all the fun."

She didn't miss much. Wickedly smart and unapologetically opinionated, Hepburn trailblazed her way through Hollywood and life for 96 years. In an era when studios told stars how to dress and whom to date, she wore pants, maintained a 27-year romance with married actor Spencer Tracy, developed her own projects and rewrote scripts to her liking. "The boat may be only a canoe," she once said of the independence that helped make her a feminist role model, "but I'm paddling it."

Her attitude, she admitted, was largely inherited. Her father, a doctor, led a lifelong crusade to inform the public about venereal disease; her mother, a New England blue blood, was an early campaigner for women's rights and helped found Planned Parenthood. Their example, said Kate, helped give her a "freedom from fear."

And the toughness to take rejection: With her Old Yankee voice and angular body, she was an unlikely movie queen. "Not much meat on her, but what there is cherce," Tracy famously put it in their 1952 movie *Pat and Mike*. Producer David O. Selznick told her he would never give her the role of Scarlett O'Hara in *Gone with the Wind* "because I can't imagine Rhett Butler chasing you for 12 years." When she was dropped from a

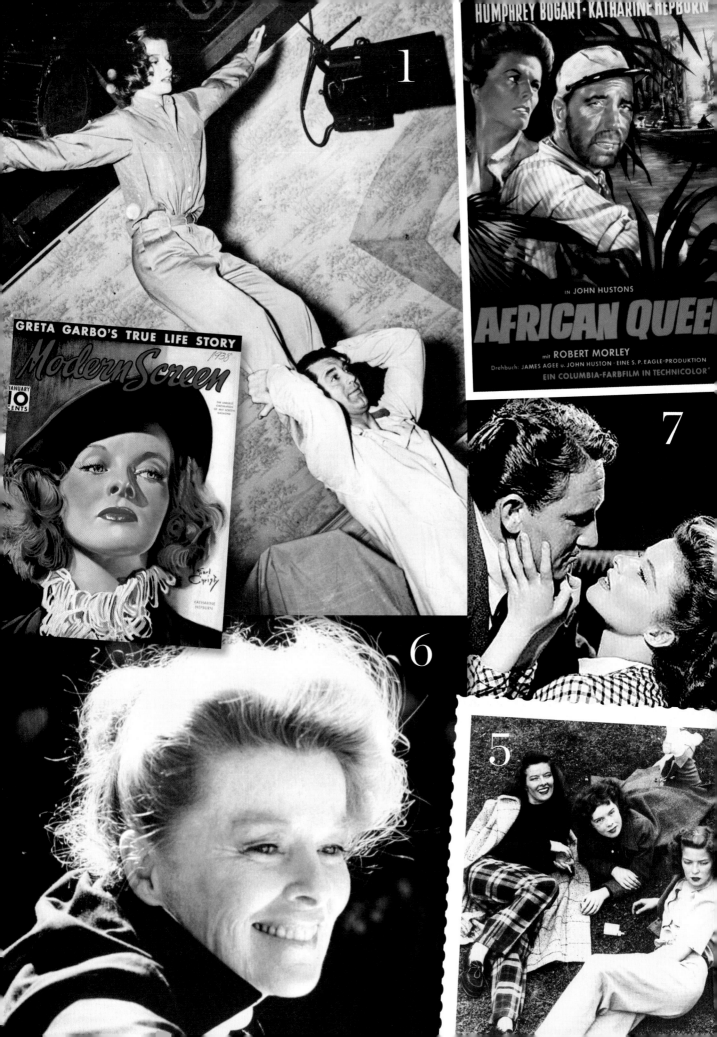

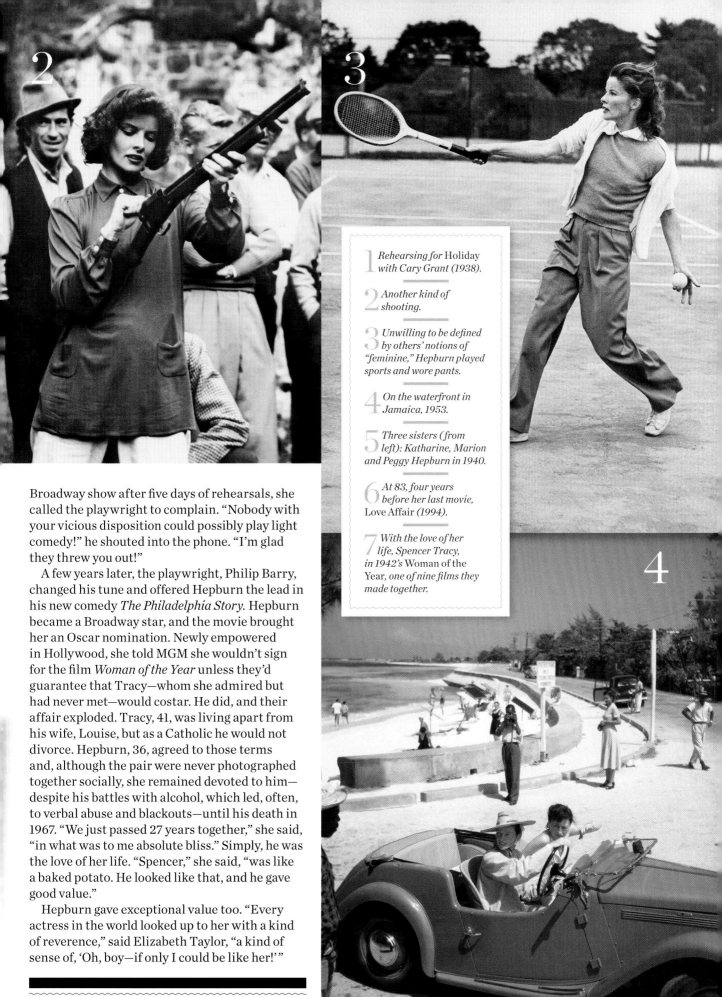

Broadway show after five days of rehearsals, she called the playwright to complain. "Nobody with your vicious disposition could possibly play light comedy!" he shouted into the phone. "I'm glad they threw you out!"

A few years later, the playwright, Philip Barry, changed his tune and offered Hepburn the lead in his new comedy *The Philadelphia Story.* Hepburn became a Broadway star, and the movie brought her an Oscar nomination. Newly empowered in Hollywood, she told MGM she wouldn't sign for the film *Woman of the Year* unless they'd guarantee that Tracy—whom she admired but had never met—would costar. He did, and their affair exploded. Tracy, 41, was living apart from his wife, Louise, but as a Catholic he would not divorce. Hepburn, 36, agreed to those terms and, although the pair were never photographed together socially, she remained devoted to him— despite his battles with alcohol, which led, often, to verbal abuse and blackouts—until his death in 1967. "We just passed 27 years together," she said, "in what was to me absolute bliss." Simply, he was the love of her life. "Spencer," she said, "was like a baked potato. He looked like that, and he gave good value."

Hepburn gave exceptional value too. "Every actress in the world looked up to her with a kind of reverence," said Elizabeth Taylor, "a kind of sense of, 'Oh, boy—if only I could be like her!'"

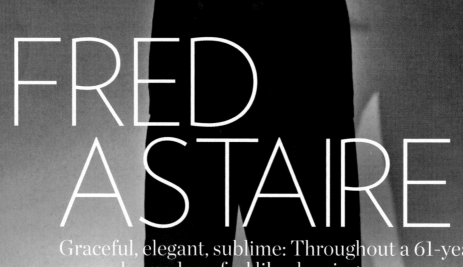

FRED ASTAIRE

Graceful, elegant, sublime: Throughout a 61-year
career, he made us feel like dancing

1899
1987

When Fred Astaire

passed away in 1987, words of awe and affection filled the press. Mikhail Baryshnikov: "He will be a never-ending legend." Gene Kelly: "One of the greatest dancers who ever lived." Irving Berlin: "The purest talent I have ever worked with."

The praise was surely merited, but Astaire was far too subtle a figure to be caught in a net of loose superlatives. The star of more than 30 Hollywood musicals was an odd little elf with pipe-cleaner limbs, yet a thing of ineffable beauty when he moved. He had barely enough voice to gargle with, yet he introduced more all-time hit songs (among them "Night and Day," "The Way You Look Tonight" and "One for My Baby") than any singer of his day. Born in Omaha, the son of an Austrian immigrant beer salesman, he came to epitomize elegance and taste.

Astaire's ambitious mother, Ann, hied Fred and his older sister Adele off to New York City for dancing lessons when they were tykes. "Adele has real talent," said their dad, "and maybe Fred will come around to it someday too." Pretty soon the kids dipped their toes in vaudeville—and never looked back. Years of hard work took them to Broadway, where a string of hits including *Lady Be Good*, *Funny Face* and *The Band Wagon* made them stars. London called, and the Astaires answered; the Duchess of York, a fan, insisted they come over and meet "the baby" (now better known as Queen Elizabeth II). Another fan, Lord Charles Cavendish, a son of the Duke of Devonshire, proposed to Adele; she accepted and quit the stage forever.

Fred, suddenly alone, headed to Hollywood to reinvent himself. (An earlier screen test had resulted in the famous assessment by a Paramount exec, "Can't act. Can't Sing. Balding. Can dance a little.") This time Astaire was teamed, by chance, with a young Texan, Ginger Rogers. Their charisma was electric; as Katharine Hepburn put it, "Astaire gave her class; Rogers gave him sex." Half a century later, their 10 movies still contain some of the most exciting duets danced in front of a camera.

A maniacal perfectionist, Astaire sometimes rehearsed 18 hours a day—and demanded the same of his partners. "You must *never* have to think about what comes next," he said. But when critics, impressed by his body of work, began to hunt for meaning and subtext, the pragmatic kid from Omaha would have none of it. "I am not sending messages with my feet," he said. "All I ever wanted was to not come up empty. I did it for the dough and the old applause."

HAPPY FEET

As a child, Astaire (with his own son, Fred Jr., circa 1940) initially resisted lessons. "Dancing was something girls did," he wrote later. "I let it go at that and the hell with it."

GENE KELLY

1912
1996

Proud of his working-class background, he was a man from the street with magic feet

Fred Astaire epitomized

top-hatted elegance; Gene Kelly, in khakis and white sox, came across as an ordinary guy who through athletic, exuberant footwork made joy visible: as a sailor on leave in *Anchors Aweigh*; turning trash-can lids into tap shoes in *It's Always Fair Weather*; blissfully in love in *Singin' in the Rain*. "His appeal was simplicity," said Leslie Caron, his costar in *An American in Paris*. "He wasn't the elite, he didn't play a gentleman. Gene was the everyday man."

His blue-collar roots were real. When the Depression hit, Kelly dropped out of college, moved back to his parents' Pittsburgh home and pumped gas and dug ditches to help his family get by. When things got better, Kelly, whose mother had steered him to dance lessons as a kid, returned to school but taught the terpsichorean art in his family basement to help pay tuition. Soon he opened a dance school—and did well. "A lot of this was due to Shirley Temple," he said. "Every mother thought her kid could be better."

Kelly was certain *he* could do better too and headed to Broadway. "I wasn't worried about getting a job," he recalled. "The other dancers weren't that good." Two years later he was starring in *Pal Joey,* followed by a dizzying Hollywood career that brought him numerous awards (including an honorary Oscar for a 17-minute ballet in *An American in Paris*) and a lifetime of renown.

But his greatest legacy may be his joyous, unfussy style—a democratic movement, if you will. He was proud of that. "As a Depression-era kid who went to school in some very bad times," he said, "I didn't want to move like a rich man. "

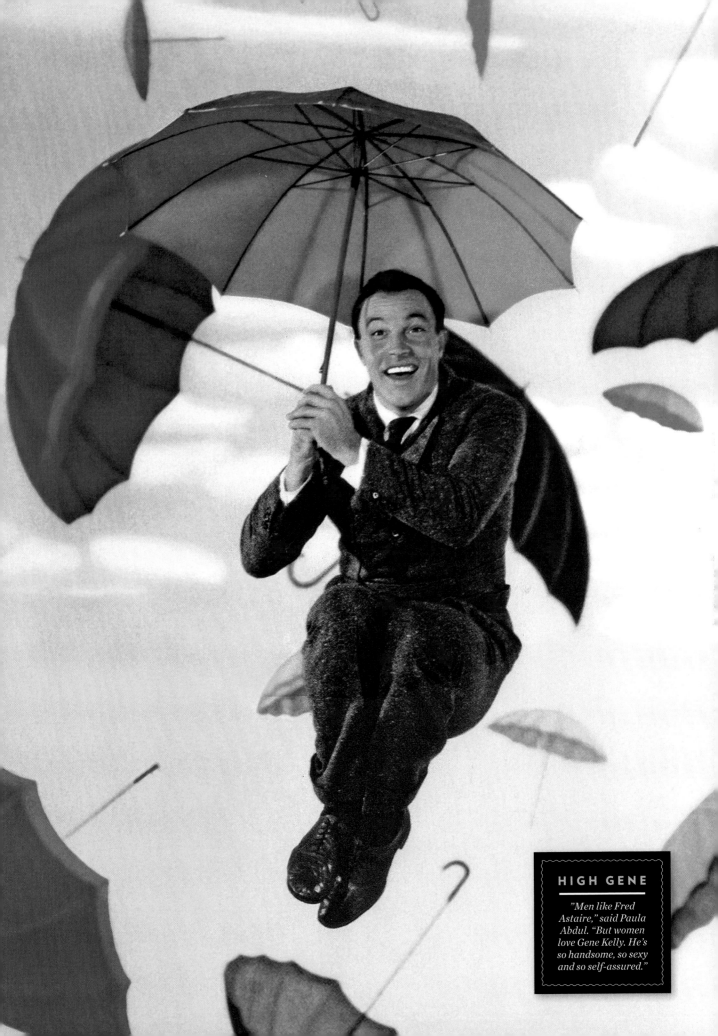

HIGH GENE

"Men like Fred Astaire," said Paula Abdul. "But women love Gene Kelly. He's so handsome, so sexy and so self-assured."

GRETA

1905
1990

GARBO

Fifty years of solitude: the
curious life of a furtive star

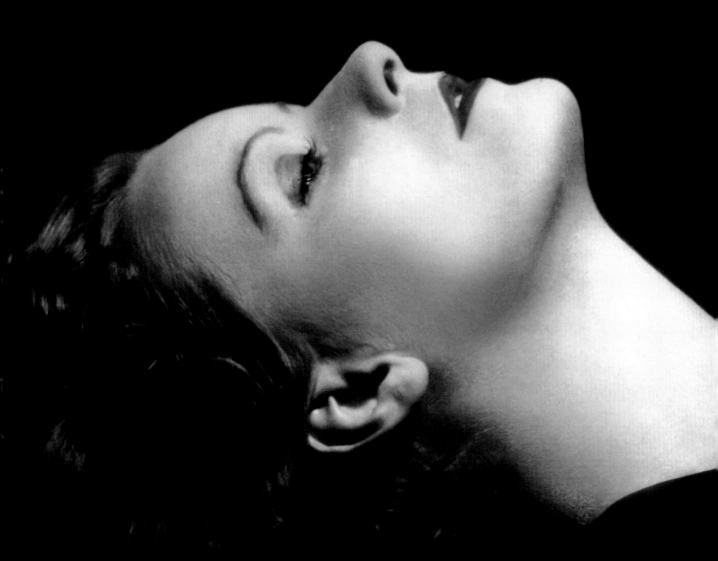

S

She was born in Stockholm to a family so impoverished that a benefactor made a salutary offer to adopt her. Yet Greta Lovisa Gustafsson, third child of a privy cleaner who died of tuberculosis when Greta was 14, somehow managed to make her way in the world. Discovered by Swedish director Mauritz Stiller, she sailed with him at 19 to New York City and then went to Hollywood, where her luminous beauty lit 24 films. Then, at 36, she abruptly abandoned her career, beginning one of filmdom's longest and most puzzling public silences. Fans, movie buffs and the media hungered for any scrap of news about the actress whose onscreen image was a haunting blend of glamour and vulnerability. What was she doing? Where was she last sighted? What did she *look* like? Garbo wasn't saying; the enigma, and the legend, only grew.

So what *did* she do for the next five decades? Mostly she lived in her seven-room, river-view New York City apartment—four rooms were closed off, but her living room was an opulent mix of 18th-century antiques, Aubusson rugs and damask curtains—read the papers and watched TV. "I watched the dreck," she said. "Schmutz."

"She'd always watch *Hollywood Squares*," said a psychic she had consulted over the years. "She adored Paul Lynde. I think she even wrote him a fan letter."

And: She walked. A lot. "Often I just go where the man in front of me is going," she said. "I couldn't survive here if I didn't walk. I couldn't be 24 hours in this apartment." Raymond Daum, a film scholar who met her at a New Year's party in 1963 and sometimes accompanied her on her "trots," kept detailed notes and, after her death, published a book, *Walking with Garbo.* She would always initiate the amble—she never gave him her phone number—calling Daum on an unpredictable schedule and saying, "Let's go." There was no destination—she was content to simply take in impressions of New York street life. "This sophisticated, worldly woman," said Daum, "could sound as if she were experiencing it all for the first time." In truth she wasn't so much a hermit as a hermit-about-town.

As for why she dropped out in the first place, she never discussed it, but perhaps it wasn't so much of a mystery. Her last film, 1941's *Two-Faced Woman,* flopped. She stepped away but probably never meant her retirement to be permanent: She considered several films in the '60s, though none got made. So . . . she kept walking.

It seemed odd to others but normal to her. "I was born," she said. "I had a mother and father. I lived in a house. I grew up like everybody else. What does it matter?"

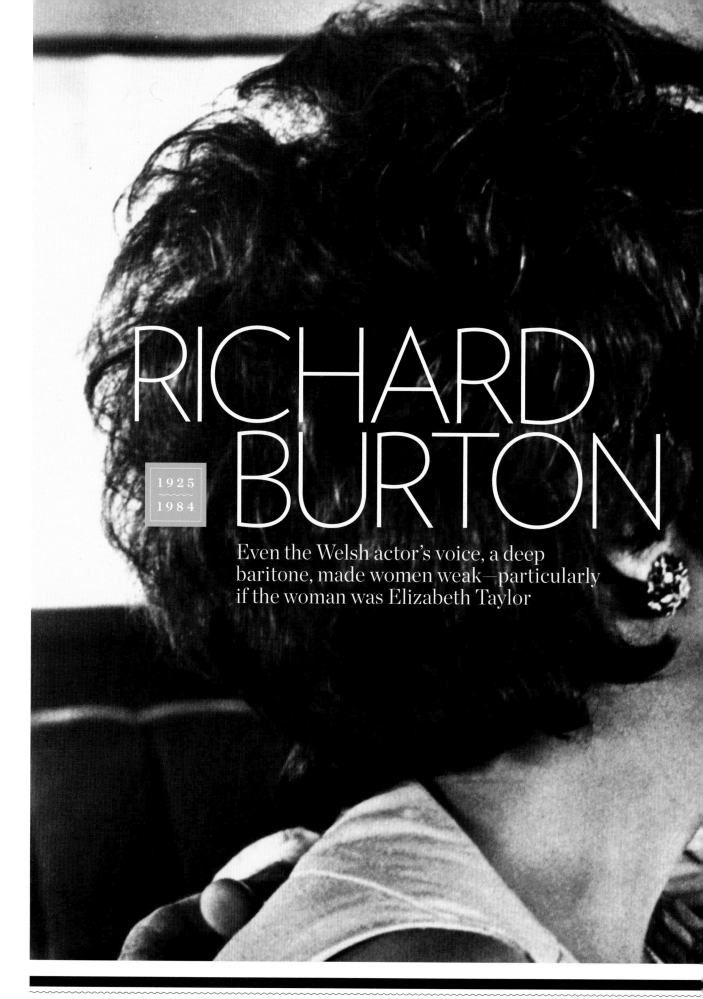

RICHARD BURTON

Even the Welsh actor's voice, a deep baritone, made women weak—particularly if the woman was Elizabeth Taylor

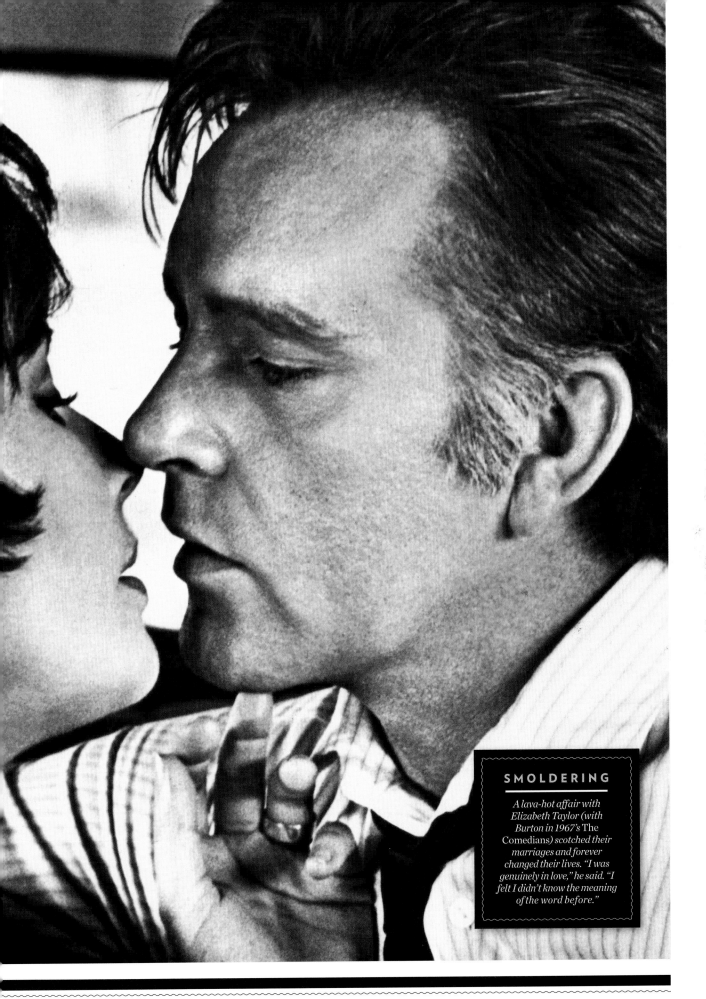

He was a coal

miner's son, a gifted actor and an astonishingly handsome dichotomy. Part of Richard Burton wanted to live up to the soaring talent that his peers—including Laurence Olivier and John Gielgud—sometimes chastened him for squandering. Then there was the other Burton, a legendary hell-raiser whose tempestuous affair with, and eventual marriages to, Elizabeth Taylor made headlines around the world. "He never said the critics were wrong, because in his heart he knew they were not," British columnist Roderick Mann said of Burton's often-perplexing career choices. "Fifty percent of him had wanted to marry Taylor, knowing that fame and fortune would accrue. The other half bitterly resented what he had done. So, he drank."

More precisely: He did what he had always done, only more so. His father, a Welsh miner, died in a bar at 83. At Oxford, which Burton attended briefly on scholarship, he distinguished himself as an actor—and by guzzling two pints of beer in 30 seconds. After WWII service in the RAF, he became a respected Shakespearean actor and began a film career that maddeningly mixed equal parts glory (*The Robe, Becket, Who's Afraid of Virginia Woolf?*, all of which contributed to his seven Oscar nominations, without a win) and schlock (*The Klansman*; *Exorcist II: The Heretic*). But it was a Broadway turn, as King Arthur in *Camelot* in 1960, that made Burton a full-blown star. "Richard would amaze me," recalled costar Julie Andrews. "There was a big speech and, depending on his mood, he would play it for laughs or play it straight for tears. The audience reaction was phenomenal."

Then came *Cleopatra*. Initially, Burton dismissed costar Taylor as a "fat little tart." Taylor vowed she would "be the one leading lady that Richard Burton would never get." Vows, schmows: Their fiery affair, and prolonged public shedding of spouses, made global headlines (and, at one point, drew an official rebuke from the Vatican). The couple married in 1964 and drank, fought and shopped to spectacular excess (famously, he bought her a $1.2 million, 69.42-carat diamond). Exhausted, they divorced in 1974, remarried a year later and split, for good, in 1976.

But their love lasted to the end, long after they were able to live together. When Burton died of a stroke at 58 at his home in a small Swiss village, his fourth wife, Sally Hay, called his surviving family, and then Elizabeth Taylor.

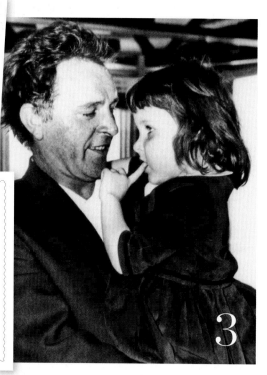

1 Many women found Burton, a hard-drinking Welshman, hypnotic. (1971)

2 As the young King in Henry V (1951). One director said he suspected Burton, who loved stage acting, "despised making movies."

3 Circa 1962 with daughter Kate, now an actress.

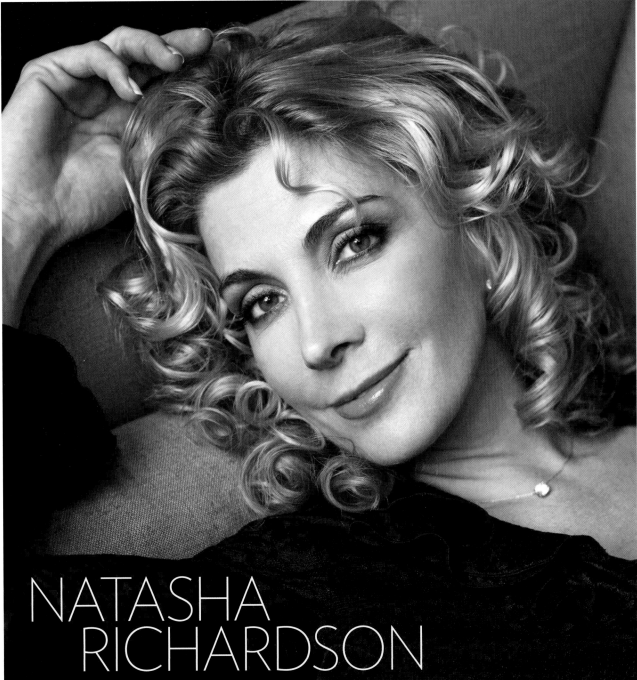

NATASHA RICHARDSON

A sudden accident claims a beloved actress, wife and mother

1963 ~ 2009

At first it seemed like nothing. On vacation in Canada, actress Natasha Richardson, 45, took a ski lesson and tumbled on a beginners' run. "Two ski-patrol officers came down and checked her out," said a resort spokesperson. "She was lucid, talking, even making jokes." They advised her to see a doctor; she declined.

Brought to her hotel room an hour later, "she was walking," said the spokesperson. "She didn't have any signs of impact. Then just all of a sudden, she started to suffer headaches, and the instructor said, 'Okay, you better go to the hospital,' and she agreed."

Her condition worsened with alarming speed. Medically nothing seemed to help. She died two days later; an autopsy showed she had suffered a fatal epidural hematoma, bleeding between her brain and skull. Her husband, actor Liam Neeson, then 56, and children Micheal, 13, and Daniel, 12, were devastated. "The loss of Tasha . . . leaves a gaping hole in many of our lives," said Mia Farrow, a close friend. "There is nothing she would not do for her friends 24-7. That's rare."

RICHARD PRYOR

1940
2005

He mined his life for laughs and transformed American comedy

He was raised by his

grandmother, who owned a brothel. His mother worked in the brothel. His father was an occasional pimp and a bartender. It is perhaps no surprise that in the world of Richard Pryor's comedy there were few taboos. Onstage he joked about everything from the N-word to his severe drug and alcohol abuse—famously, in 1980, he set himself on fire while freebasing cocaine and went running through the streets of Los Angeles—to his seven marriages to five women. It was a wild, dangerous, sometimes thrilling, often painful life.

By the mid-'70s Pryor had turned himself into a major box office draw. His movie pairings with Gene Wilder, starting with 1976's *Silver Streak*, proved to be Hollywood gold, and he was paid $4 million for his role in 1983's *Superman III*—a then-record for a black actor and an astonishing $1 million more than Superman himself, Christopher Reeve, was paid. His talent and his taste for risk helped shape a generation of comedians. "We're all walking in his footsteps," said Damon Wayans at a 2005 tribute to Pryor. "Richard Pryor was the first and last thing I wanted to be."

When he died in 2005 from a heart attack, the man who'd changed the face of comedy hadn't performed onstage in over a decade. Multiple sclerosis, with which he was diagnosed in 1986, had robbed him of his ability to walk and to talk in full sentences. Still, he never felt sorry for himself. "As a comedian," he once said, "I couldn't have asked for better material."

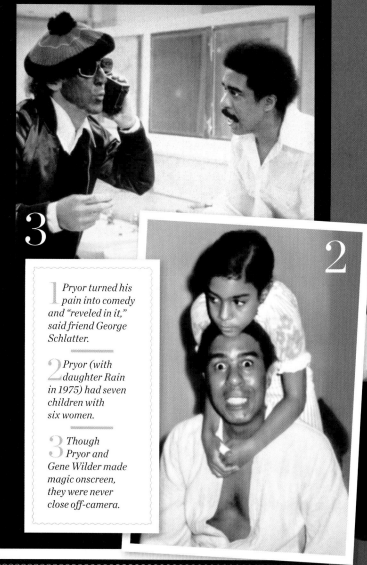

3

2

1 Pryor turned his pain into comedy and "reveled in it," said friend George Schlatter.

2 Pryor (with daughter Rain in 1975) had seven children with six women.

3 Though Pryor and Gene Wilder made magic onscreen, they were never close off-camera.

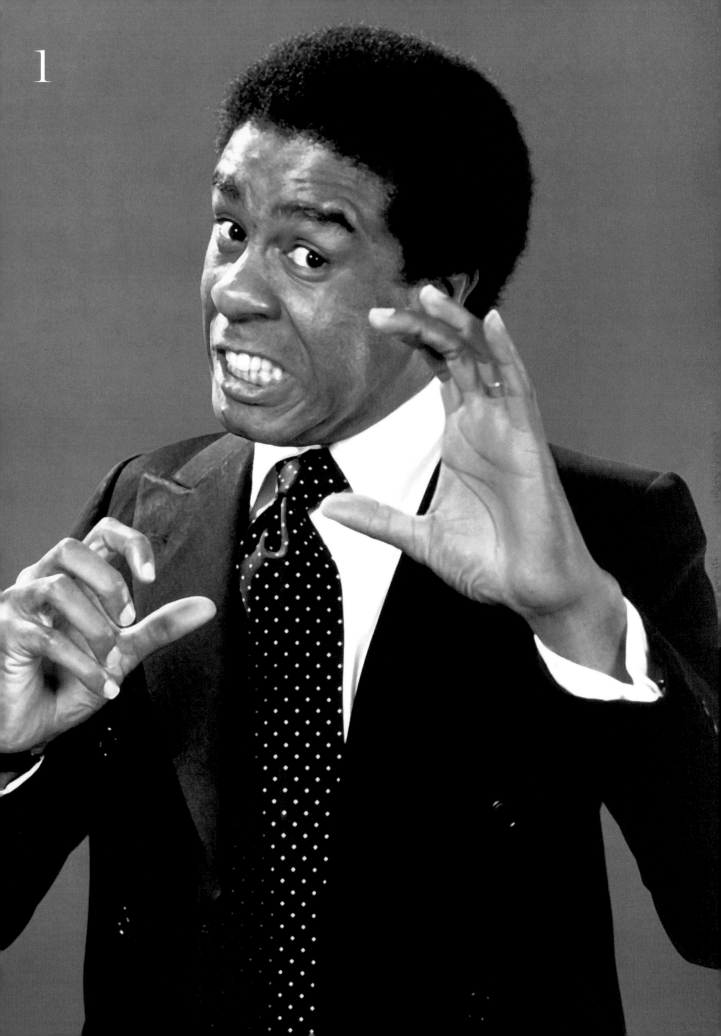

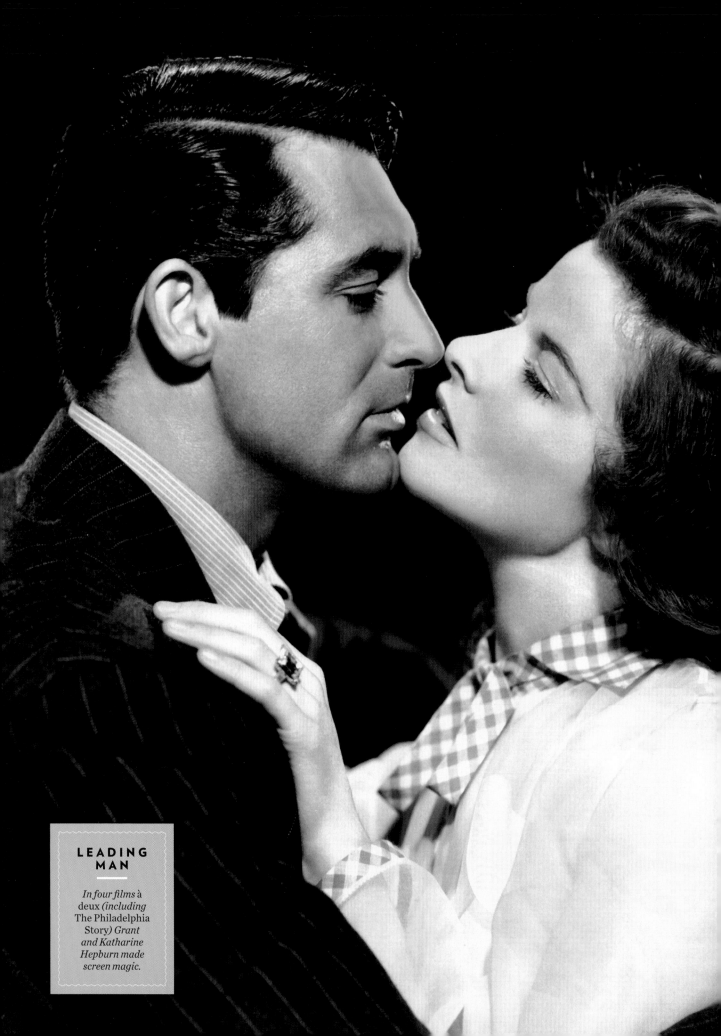

CARY GRANT

Offscreen, Hollywood's King of Hearts could be a troubled soul

1904 1986

Throughout his

life, Cary Grant could seem like two separate men—even to Cary Grant. He was born Archibald Alexander Leach in Bristol, England, and his life turned dreary at age 9, when his father, a factory worker, announced that Archie's mother had gone to the seashore for a rest. In fact, as Archie did not discover for another 20 years, she'd been committed to an asylum. Abandoned (so he thought) by his mother and neglected by his father, Archie lived as a latchkey kid until, at 14, he left home to join a troupe of acrobats. Two years later the troupe visited America. Archie stayed.

By 1930 he was starring on Broadway, and in 1932 Paramount signed him to a five-year contract and changed his name to Cary Grant. Cary was a hit: In movies like *The Awful Truth* and *The Philadelphia Story,* he polished the facets of his dazzling screen personality: the whip-taut body, the deft movements, the caressing twang, the what's-it accent. Was he serious? Was he kidding? Was the joke on him? On you? You could never be sure. Startlingly Grant was the same man in person. "I pretended to be a certain man onscreen," he once said. "And I became that man in life." What happened to poor, pale, desperate, unloved, lower-class Archie? He was replaced by rich, bronzed, adored, debonair Cary.

Or was he? From the late '30s through the early '60s, Grant made a string of superhits (from *Bringing Up Baby* to *Charade*). He had hot-and-heavy affairs with Sophia Loren and Ginger Rogers and wed three actresses (Virginia Cherrill, Betsy Drake and Dyan Cannon), plus one of the richest women in the world, Woolworth heiress Barbara Hutton. Yet he often seemed irritable, vain, socially insecure, stingy, fearful of women. In short, Archie/Cary had a smoldering identity crisis. He went into treatment with a therapist who prescribed LSD (Grant ingested the drug more than 100 times under controlled conditions). "It helped me a lot," he later said, though at the time his fourth wife, Dyan Cannon, did not agree. Their 1968 divorce (during which she claimed that when he couldn't get his way he spanked her) and custody battle for daughter Jennifer made headlines.

Eventually, they made peace with their differences, and Grant, who never made another movie, devoted himself to being a father. He and his fifth wife, a PR executive 47 years his junior, spent most days resting, reading, swimming and watching TV. Were Archie and Cary finally in synch? Grant never told. "If you write your memoirs," he said, "you've got to expose other people, and I hope to get out of this world as peacefully as possible, without embarrassing them—or me."

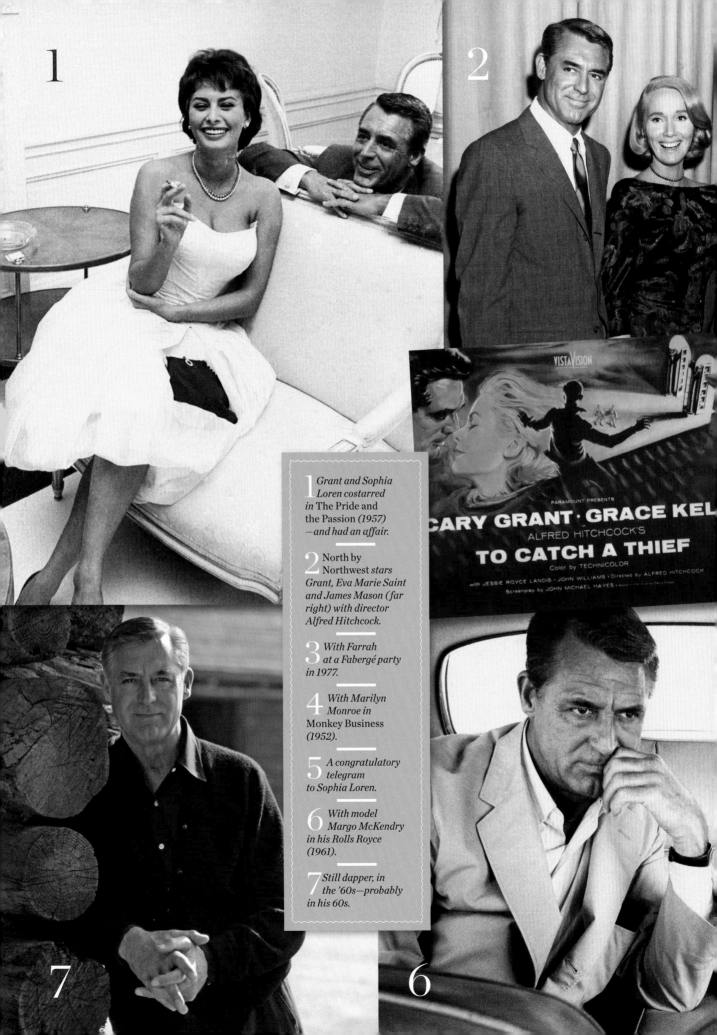

1 *Grant and Sophia Loren costarred in* The Pride and the Passion *(1957) —and had an affair.*

2 North by Northwest *stars Grant, Eva Marie Saint and James Mason (far right) with director Alfred Hitchcock.*

3 *With Farrah at a Fabergé party in 1977.*

4 *With Marilyn Monroe in* Monkey Business *(1952).*

5 *A congratulatory telegram to Sophia Loren.*

6 *With model Margo McKendry in his Rolls Royce (1961).*

7 *Still dapper, in the '60s—probably in his 60s.*

VISTAVISION

PARAMOUNT PRESENTS

CARY GRANT · GRACE KEL

ALFRED HITCHCOCK'S

TO CATCH A THIEF

Color by TECHNICOLOR

with JESSIE ROYCE LANDIS · JOHN WILLIAMS · Directed by ALFRED HITCHCOCK

Screenplay by JOHN MICHAEL HAYES ·

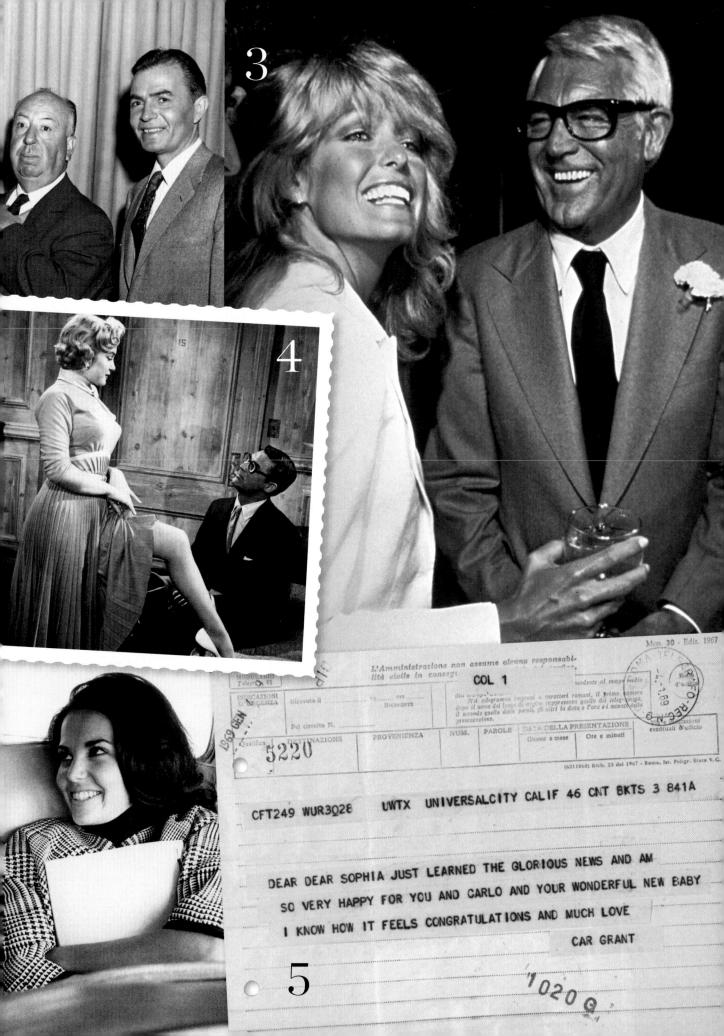

3

4

5

Mod. 30 - Ediz. 1967

L'Amministrazione non assume alcuna responsabilità civile in conseg...

COL 1

INDICAZIONI D'URGENZA Ricevuto il 19........ ore Ricevente

Pel circuito N.

DESTINAZIONE PROVENIENZA NUM. PAROLE DATA DELLA PRESENTAZIONE
 Giorno e mese Ore e minuti

5220

(6211060) Rich. 23 del 1967 - Roma, Ist. Poligr. Stato V. G.

CFT249 WUR3028 UWTX UNIVERSALCITY CALIF 46 CNT BKTS 3 841A

DEAR DEAR SOPHIA JUST LEARNED THE GLORIOUS NEWS AND AM

SO VERY HAPPY FOR YOU AND CARLO AND YOUR WONDERFUL NEW BABY

I KNOW HOW IT FEELS CONGRATULATIONS AND MUCH LOVE

CAR GRANT

1020 Q

BETTE

DAVIS

1908
1989

Runty, fidgety, with

eyes like poached pears and a voice like a gasping lawn mower, Bette Davis defied notions of what it took to be a star. Except two: drive and talent. In films like *All About Eve, Dark Victory* and *Now, Voyager,* she came across as an unstoppable, if eccentric, life force. "She entered a room," one critic wrote, "as though she were slicing it in half with a knife." "I guess I'm larger than life," she once mused. "That's my problem."

The drama of her roles was no match for her real life. Her father, a lawyer, didn't want her and tried to force his wife to give the baby away. He eventually left the family, but when Bette became a Hollywood success, her mother and sister treated her like a human ATM. She was spectacularly unsuccessful at love: An empty first marriage ended after her husband bugged their bedroom, caught her canoodling with Howard Hughes—from whom he then extorted $70,000—and divorced Davis, taking

half her fortune. One of her four husbands died when a cuckolded former friend hit him with a lamp. She described her third marriage, to a muscular ex-Marine, as a reign of terror; he described it as a failed attempt at castration. And so on. In 1985 daughter B.D. Hyman published *My Mother's Keeper*, a 347-page diatribe describing her mother as a human wrecking ball. Heartbroken, Davis chided her daughter for "lack of loyalty and thanks for the very privileged life you have been given."

Still, "she never gave up, never gave in," said an actress friend. In 1989, dying of cancer and barely able to stand, she flew to Spain because a film festival wanted to give her an award, and she, quite simply, never said no to applause. Days later she died in a Paris hospital.

The essence of Bette? Years before, her housemaid—whom Davis loved to quote—said it best: "It's nice and peaceful when Miss Davis isn't around. But I kind of miss her disturbances."

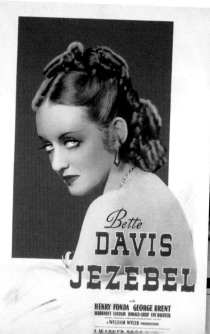

Bette
DAVIS
JEZEBEL

HENRY FONDA · GEORGE BRENT
MARGARET LINDSAY DONALD CRISP FAY BAINTER
A WILLIAM WYLER PRODUCTION
A WARNER BROS.

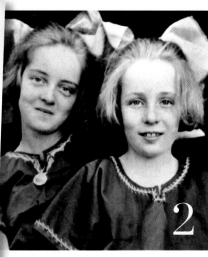

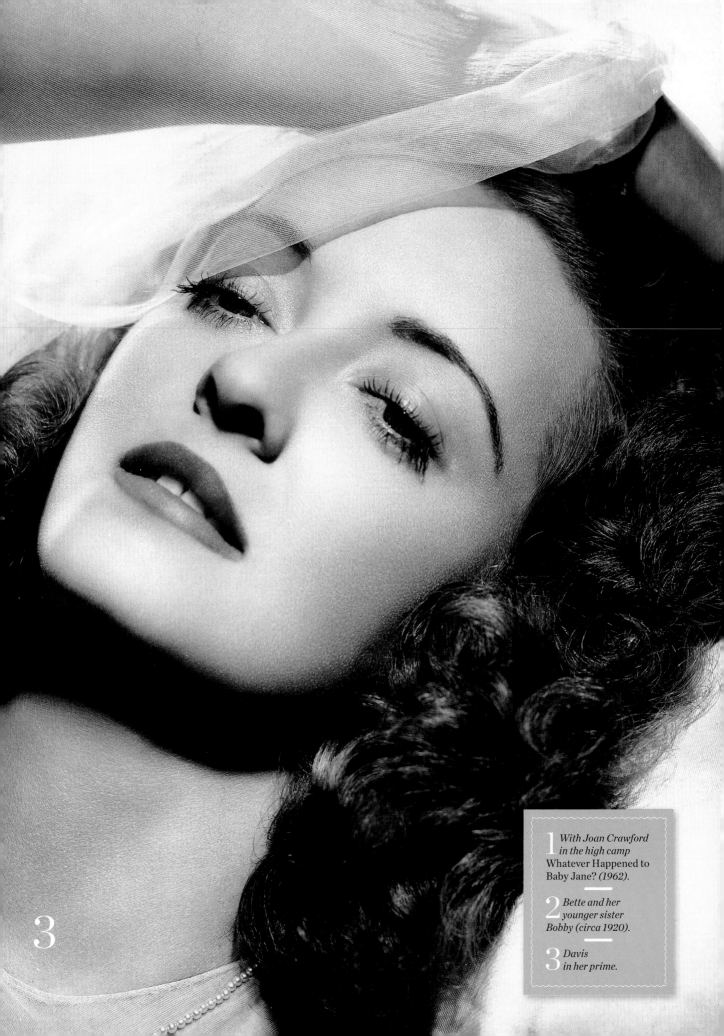

3

JOHN WAYNE

1907
~~~
1979

## In the American psyche, Hollywood's hero became nearly as big as the wild land his cowboy characters helped tame

# When I started,"

John Wayne once confessed, "I knew I was no actor, and I went to work on this Wayne thing. It was as deliberate a projection as you'll ever see. I figured I needed a gimmick, so I dreamed up the drawl, the squint and a way of moving to suggest that I wasn't looking for trouble but would just as soon throw a bottle at your head as not. I practiced in front of a mirror."

The mirror should have hired a William Morris agent. The man born Marion Morrison, the son of an Iowa druggist, went on to appear in 177 films, saying little, protecting the womenfolk, righting wrongs and, somehow, always walking like a man whose feet hurt. He became as much a part of the American West in people's minds as the buttes and purple sage of Monument Valley, where many of his classic films, like *Stagecoach* and *The Searchers,* were made. The characters he played had different names, wore different clothes and lived decades apart, but almost all shared the John Wayne code, concisely expressed in his final film, *The Shootist*: "I won't be wronged, I won't be insulted, I won't be laid a hand on," says his character J.B. Books, an aging gunfighter. "I don't do these things to other people, and I require the same from them."

Real life wasn't much different. "I stay away from nuances," said Wayne, a vocal and passionate patriot ("I am proudest every day in my life I wake up in the United States of America," he said) who also wasn't shy about sharing his archconservative political views.

In a controversial 1971 *Playboy* interview, Wayne startled many by saying, among other things, "I believe in white supremacy until blacks are educated to a point of responsibility" and argued that, regarding the conquest of the American West, "our so-called stealing of this country from them was just a matter of survival. There were great numbers of people who needed new land, and the Indians were selfishly trying to keep it for themselves." His jingoism, said his third wife, Pilar, grew out of a somewhat surprising fact: The red-blooded star of *Sands of Iwo Jima* and *The Alamo* did not serve in the military during WWII (initially his age and four children gave him a low draft status; later Wayne's studio got him deferred based on "support of national health, safety, or interest"). "He would become a 'superpatriot'—for the rest of his life," Pilar wrote in *John Wayne*, "trying to atone for staying home."

Wayne died in 1979 after an extended, and brave battle with cancer. A 2009 Harris Poll ranked him as No. 7 among America's favorite movie stars; he was the only deceased actor on the list.

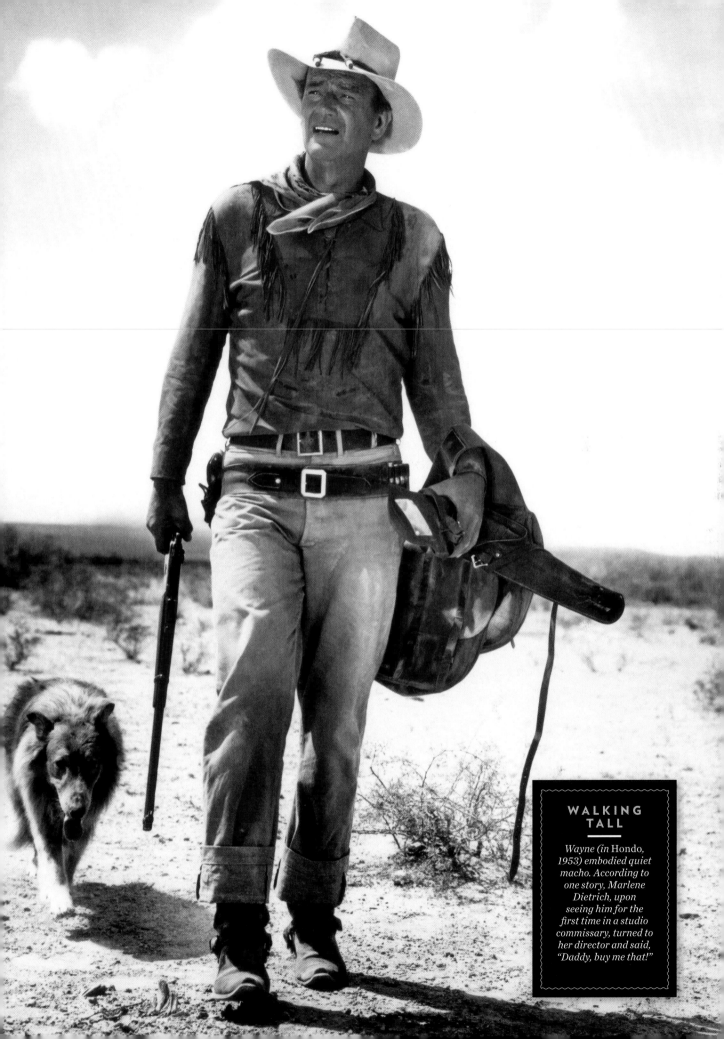

## WALKING TALL

*Wayne (in* Hondo, *1953) embodied quiet macho. According to one story, Marlene Dietrich, upon seeing him for the first time in a studio commissary, turned to her director and said, "Daddy, buy me that!"*

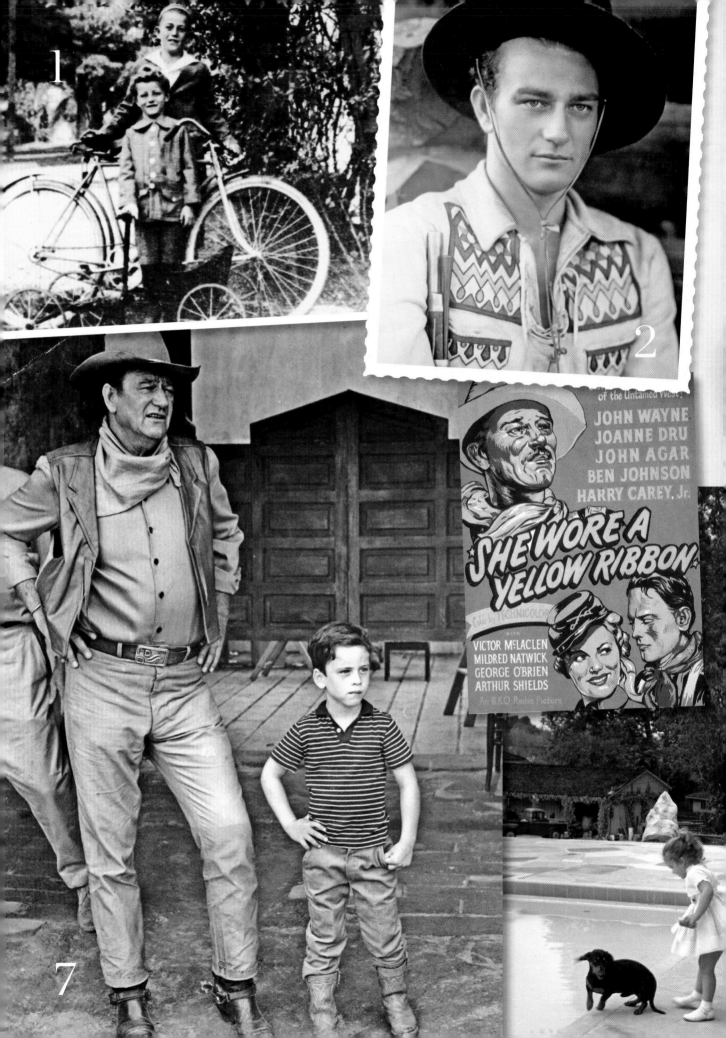

**1**

**2**

of the Untamed West!

JOHN WAYNE
JOANNE DRU
JOHN AGAR
BEN JOHNSON
HARRY CAREY, Jr.

★SHE WORE A
YELLOW RIBBON★

Color by TECHNICOLOR

WITH
VICTOR McLAGLEN
MILDRED NATWICK
GEORGE O'BRIEN
ARTHUR SHIELDS
An RKO Radio Picture

**7**

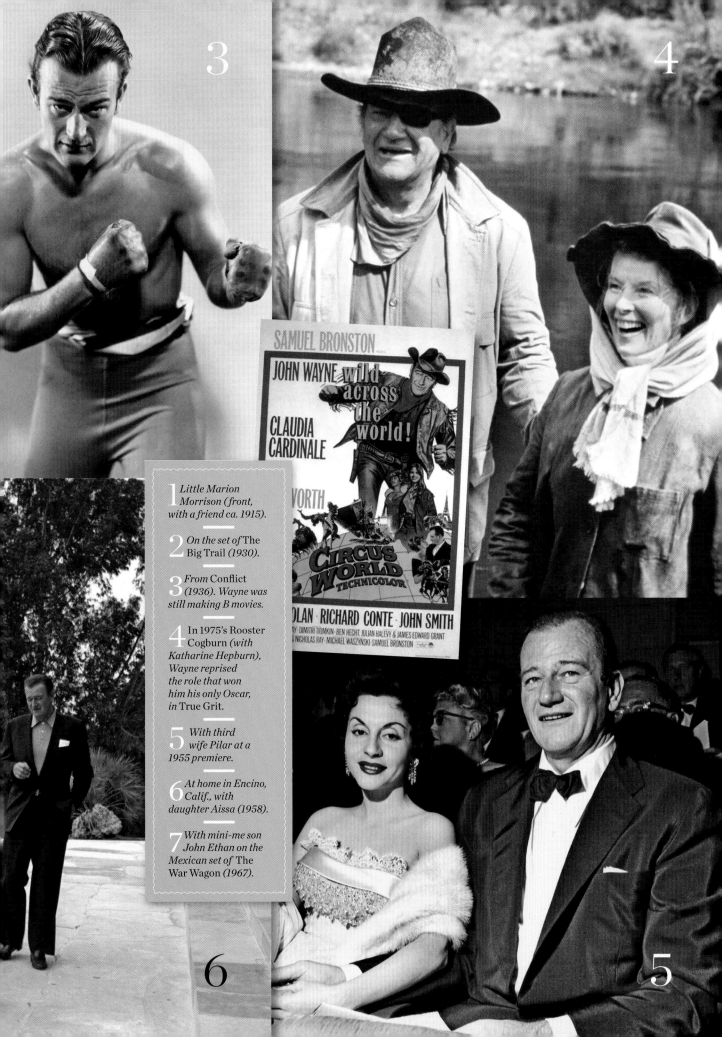

**3**

**4**

SAMUEL BRONSTON works
JOHN WAYNE wild
across
the
world!
CLAUDIA
CARDINALE

...VORTH

...OLAN · RICHARD CONTE · JOHN SMITH
...RY · DIMITRI TIOMKIN · BEN HECHT, JULIAN HALEVY & JAMES EDWARD GRANT
... NICHOLAS RAY · MICHAEL WASZYNSKI · SAMUEL BRONSTON

**CIRCUS WORLD** TECHNICOLOR

**1** *Little Marion Morrison (front, with a friend ca. 1915).*

**2** *On the set of* The Big Trail *(1930).*

**3** *From* Conflict *(1936). Wayne was still making B movies.*

**4** In 1975's Rooster Cogburn *(with Katharine Hepburn),* Wayne reprised the role that won him his only Oscar, in True Grit.

**5** *With third wife Pilar at a 1955 premiere.*

**6** *At home in Encino, Calif., with daughter Aissa (1958).*

**7** *With mini-me son John Ethan on the Mexican set of* The War Wagon *(1967).*

**6**

**5**

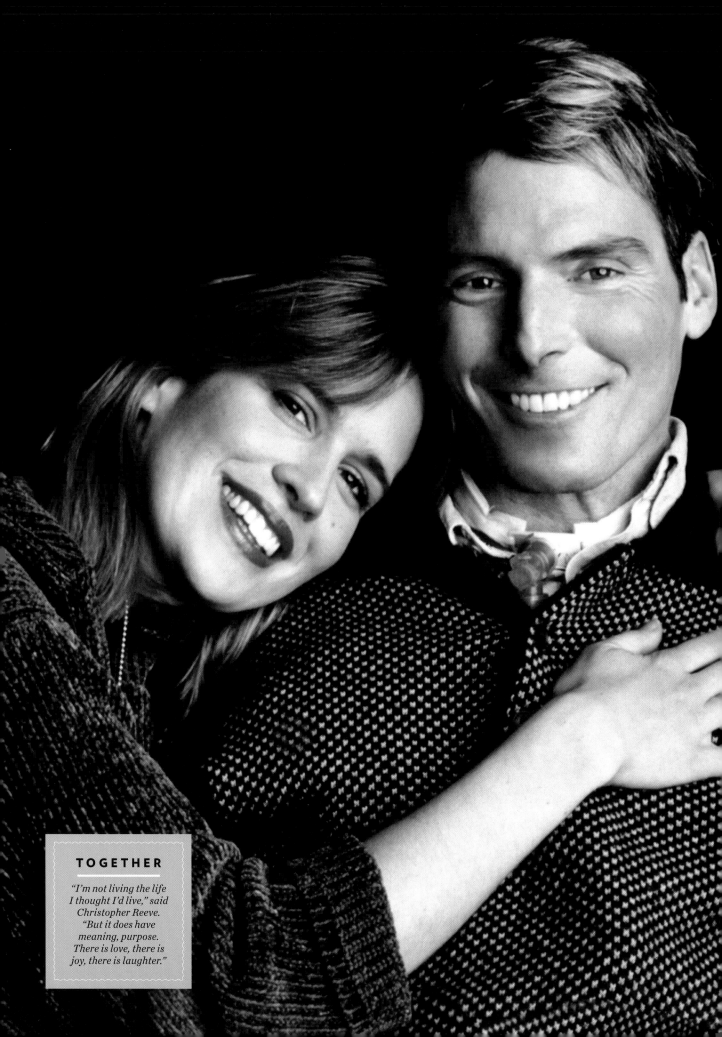

## TOGETHER

*"I'm not living the life I thought I'd live," said Christopher Reeve. "But it does have meaning, purpose. There is love, there is joy, there is laughter."*

**1952**
**2004**

# CHRIS REEVE
# &
# DANA REEVE

**1961**
**2006**

"You're still you," she said after his accident. "And I love you"

## He had been a strapping,

6'4" leading man, the star of four *Superman* movies, before a riding accident left him paralyzed below the neck. He later said that he thought of letting go of life altogether, until his wife, Dana, uttered the words that saved him: "You're still you, and I love you." Together they built a brave new life and raised millions for spinal cord research. Chris faced his challenges "with courage, intelligence and dignity I can only aspire to," said his friend Michael J. Fox, who has Parkinson's disease. "If he could ever have walked, he would have walked over to help someone else get up." What *did* bother Reeve? "I get pretty impatient," he once said, "with people who are able-bodied but are paralyzed for other reasons."

Tragically, shortly after Christopher's death, more heartbreak followed: Dana was diagnosed with lung cancer. She died at 44. "Her compassion, her fortitude, are a source of inspiration," said a friend. "Her impact is immeasurable."

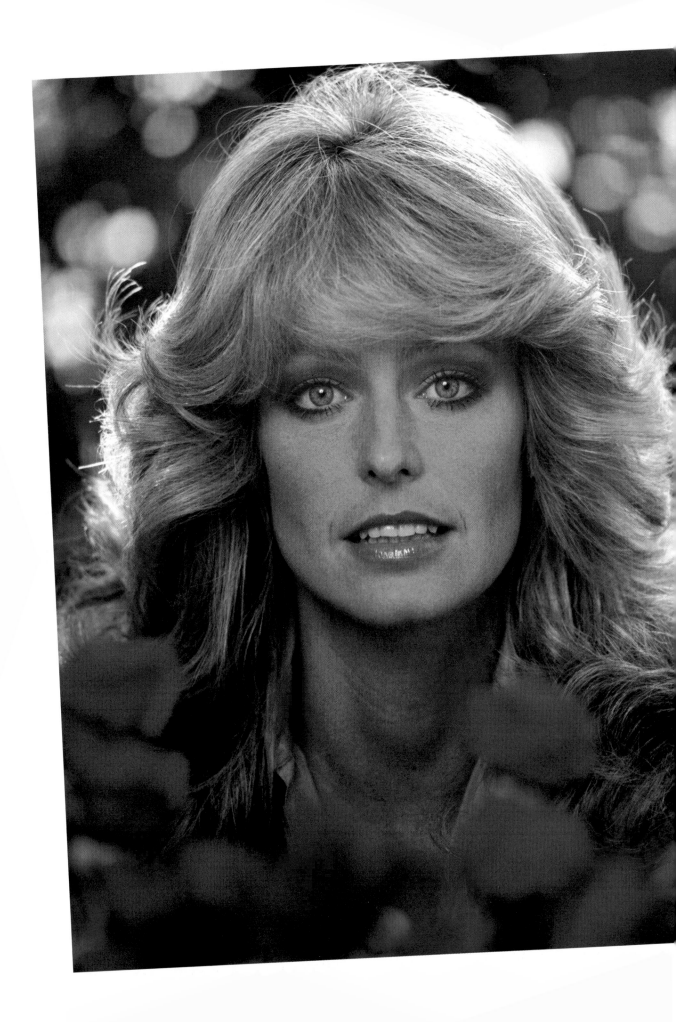

# TELEVISION

FARRAH FAWCETT

# FARRAH FAWCETT

Caught in the spin cycle of sudden stardom, she
spent a lifetime coping with the whiplash

## On Sept. 22, 1976,

*Charlie's Angels* premiered on ABC, and Farrah
Fawcett, 29, became an overnight sensation. A
poster with her image sold 12 million copies—
still a record. Her magnificent hair sparked a
nationwide trend; fans bought Farrah shampoo,
dolls and lunch pails in droves. At the height
of Farrah mania, her manager Jay Bernstein
claimed to have turned down a seven-figure offer
to market water "from Farrah's own faucet."

What was going on? Big brains tried to explain.
A TIME writer attributed *Charlie's Angels'* success
to "an aesthetically ridiculous, commercially
brilliant brainstorm surfing blithely atop the
zeitgeist's seventh wave." Her manager offered a
simpler explanation: "Nipples." A more modest
answer came from designer Nolan Miller: "Men
watch the girls, women watch the clothes."

Arguably, Fawcett spent the rest of her life
dealing with the fallout from that night. A shy girl
from Texas, she had married TV star Lee Majors
and, to help support their traditional marriage,
added a clause to her TV contract that guaranteed
she could leave work in time to get home and
cook Lee's dinner. But as she was exposed to a
wider world—and adulation—she sought more
independence, and the couple separated. "I still
like to cook his meals," she said, "but I'm not
dependent anymore, and that's hard for him."

To everyone's surprise, she took up with
Hollywood wild man Ryan O'Neal. "I was
overwhelmed by this physical and mental
attraction," she said. The two had a son,
Redmond, but never married.

Professionally, she struggled to be taken
seriously. "I was a TV sex symbol who wanted
to be an actress," she said. There were some
early howlers—*Saturn 3* comes to mind—but
she eventually won critical acclaim Off-
Broadway in *Extremities* and in the TV movie
*The Burning Bed*.

In 2006 Fawcett was diagnosed with anal
cancer and for years fought a public, and
painful, battle to beat it. "She was the bravest
and funniest in the face of that awful fight," said
her *Angels* costar and friend Kate Jackson. "At
the end there was no hair and makeup. And yet
she was beautiful. She will be remembered as the
smiling courageous girl who wasn't afraid to show
her humanity."

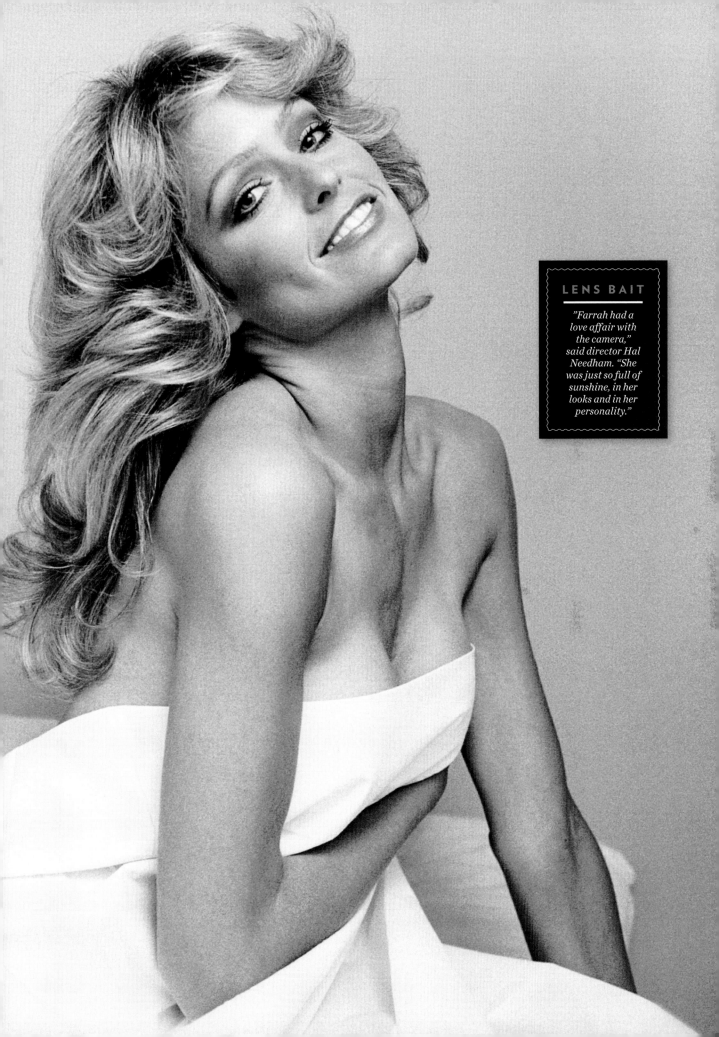

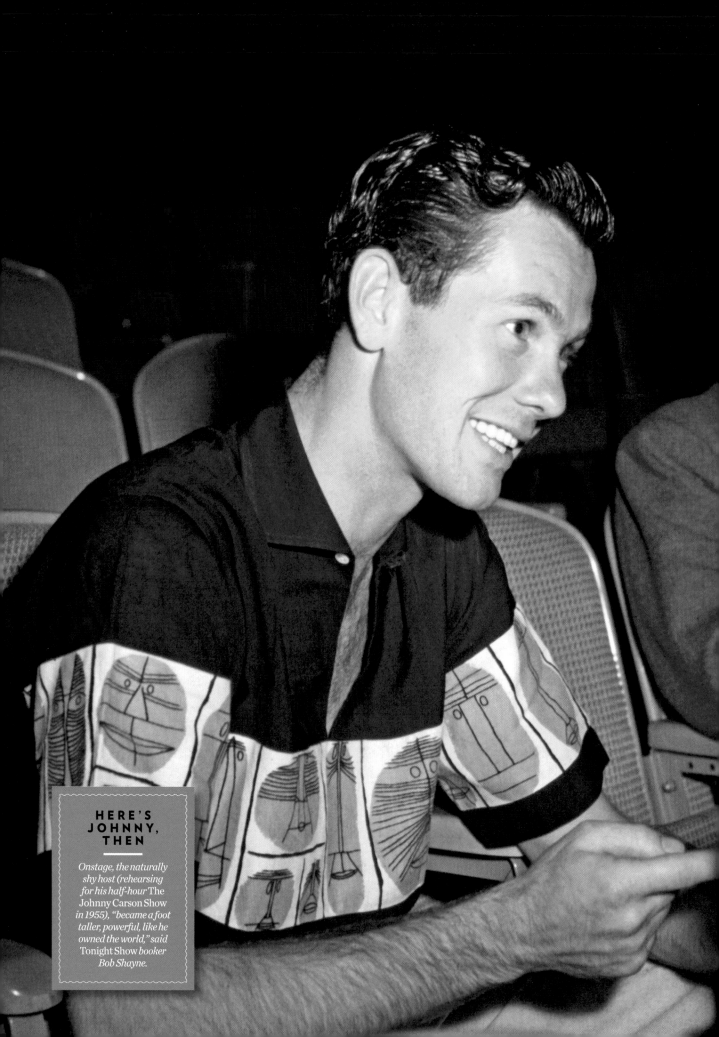

1925
2005

# JOHNNY CARSON

For 30 years the wry magician from Nebraska told jokes, touched lives and tucked America in

## Of all the stars

spawned by the tube, declared an uncharacteristically un-glib David Letterman, none "meant as much to the daily lives of the people of this country for as long as Johnny Carson." As the *Tonight Show* host's sidekick, Ed McMahon, put it, "You got up, you had breakfast, you went to your job and came home, you had a couple of drinks and dinner and you watched Carson and you went to bed. That was the routine. If you were lucky, you had wild sex."

Carson, though, was a tonic, not an aphrodisiac. From 1962 until 1992 the talk king reigned with charm, grace and, of course, humor. "Johnny's monologue was like *The New York Times*," Letterman said. "It was the nightly television comedy of record. And if a joke bombed, with a sly look of withering disdain, Johnny made that the funniest moment of the night."

Carson turned his host's desk—a flimsy prop table—into the holy grail for several generations of comedians, from Woody Allen to Jerry Seinfeld. A greenroom full of future talk show hosts, including Letterman, Jay Leno and Conan O'Brien, studied him like a treasure map. "Anyone who does this for a living," said O'Brien, "is trying in vain to be Johnny Carson."

He never returned to TV after retiring at 66 and spent most of the ensuing years in self-imposed exile in Malibu or sailing his beloved yacht *Serengeti* with his fourth wife, Alexis. He stayed close to comedian pals and poker buddies like Steve Martin and Carl Reiner and continued to supply jokes to Letterman. He would even entertain friends with informal monologues based on the latest headlines. "He would do full routine," said one friend. "He was hysterical. It was as if he had to perform." A lifelong smoker, Carson died of complications from emphysema. Years before, he had suggested the words he wanted for an epitaph: "I'll be right back."

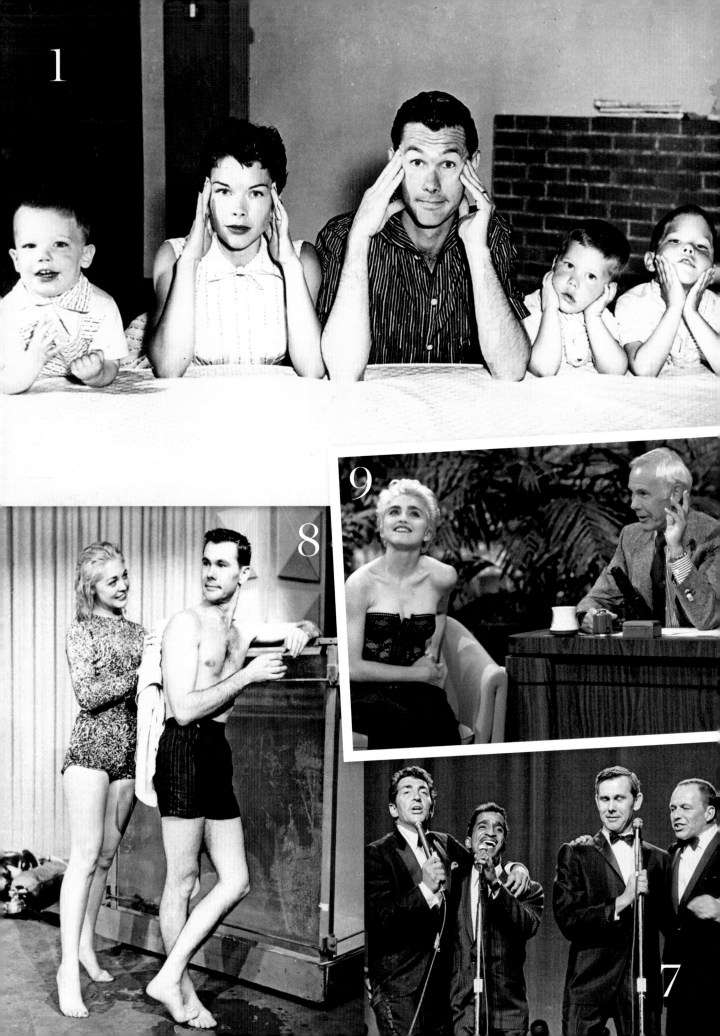

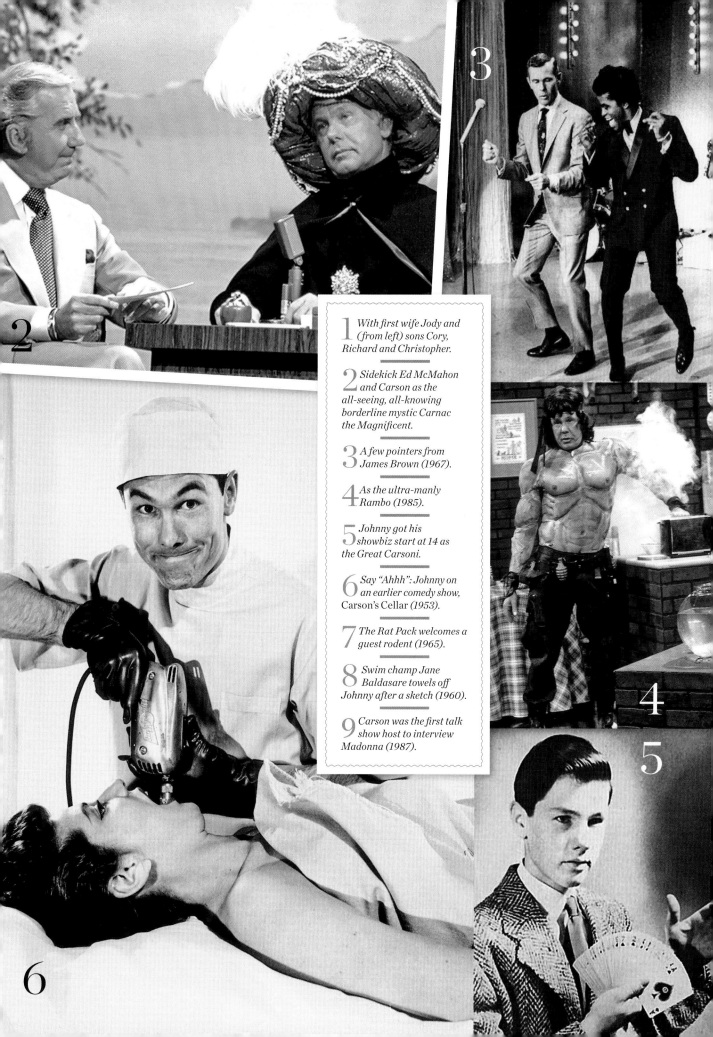

1 With first wife Jody and *(from left)* sons Cory, Richard and Christopher.

2 Sidekick Ed McMahon and Carson as the all-seeing, all-knowing borderline mystic Carnac the Magnificent.

3 A few pointers from James Brown (1967).

4 As the ultra-manly Rambo (1985).

5 Johnny got his showbiz start at 14 as the Great Carsoni.

6 Say "Ahhh": Johnny on an earlier comedy show, Carson's Cellar (1953).

7 The Rat Pack welcomes a guest rodent (1965).

8 Swim champ Jane Baldasare towels off Johnny after a sketch (1960).

9 Carson was the first talk show host to interview Madonna (1987).

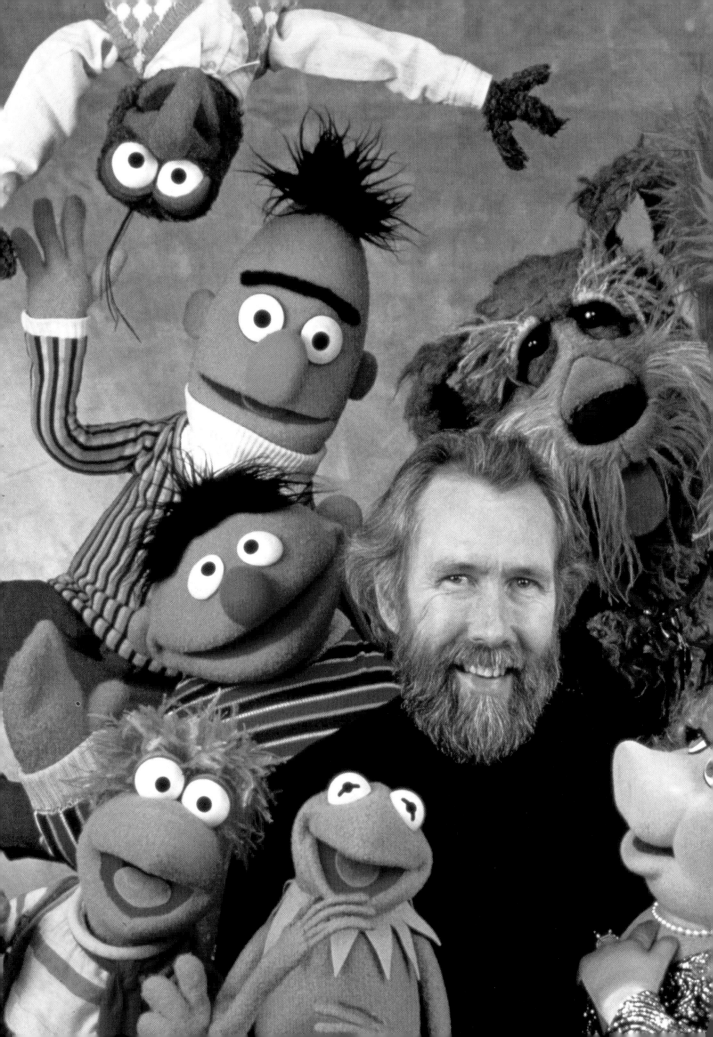

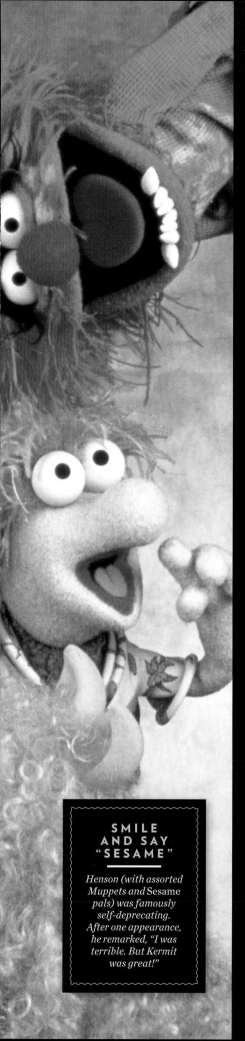

# JIM HENSON

1936
1990

### Children's television's gentle genius walked softly and let a frog do the talking

*t*

## There may be no greater

tribute to Jim Henson than this: Miss Piggy once danced *Swine Lake* with Rudolf Nureyev and, on another occasion, joined Beverly Sills to sing *Pigaletto*. Seldom, if ever, had so many stars—over the years there were scores—been upstaged, voluntarily, by a pig.

That desire to join in the fun was testimony to the talent and the sheer joy that radiated from Henson's most famous creations, *Sesame Street* and the Muppets. "Jim was an authentic American genius," said Children's Television Workshop's Joan Ganz Cooney. "He was our era's Charlie Chaplin, Mae West, W.C. Fields and Marx Brothers." At the heart of it all was a quirky humor that amused but never stung, teased but never ridiculed. "He would never do any humor that would make another character feel bad," said his daughter Cheryl. Indeed, he would never do anything to make *anyone* feel bad. "If he didn't like something, he'd just say, 'Hmmmm,'" said Carroll Spinney, who played the character Big Bird. "'Lovely' was the word you just died to hear."

Sadly, his own gentleness—his desire never to intrude or cause anyone inconvenience—had tragic consequences. Ill with a severe but treatable form of pneumonia, but not wanting to trouble his family or doctors, he put off seeking help until it was too late. He died at 53, hours after finally checking into a hospital.

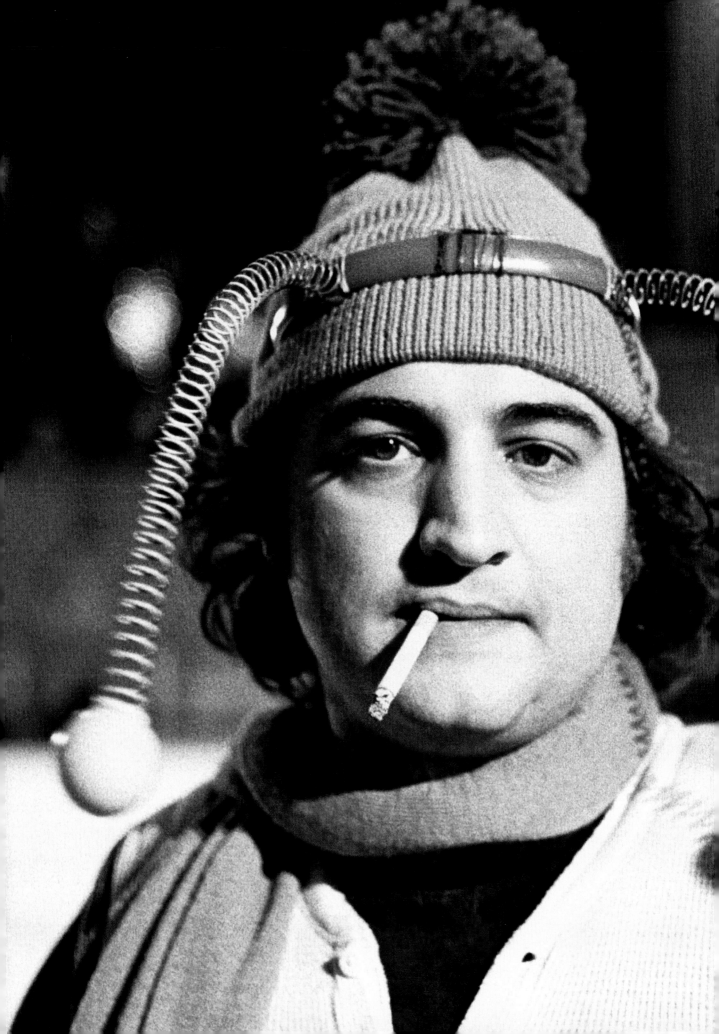

# JOHN
# BELUSHI

1949
1982

For *SNL*'s comedy rhino, the party never
stopped until the night it stopped forever

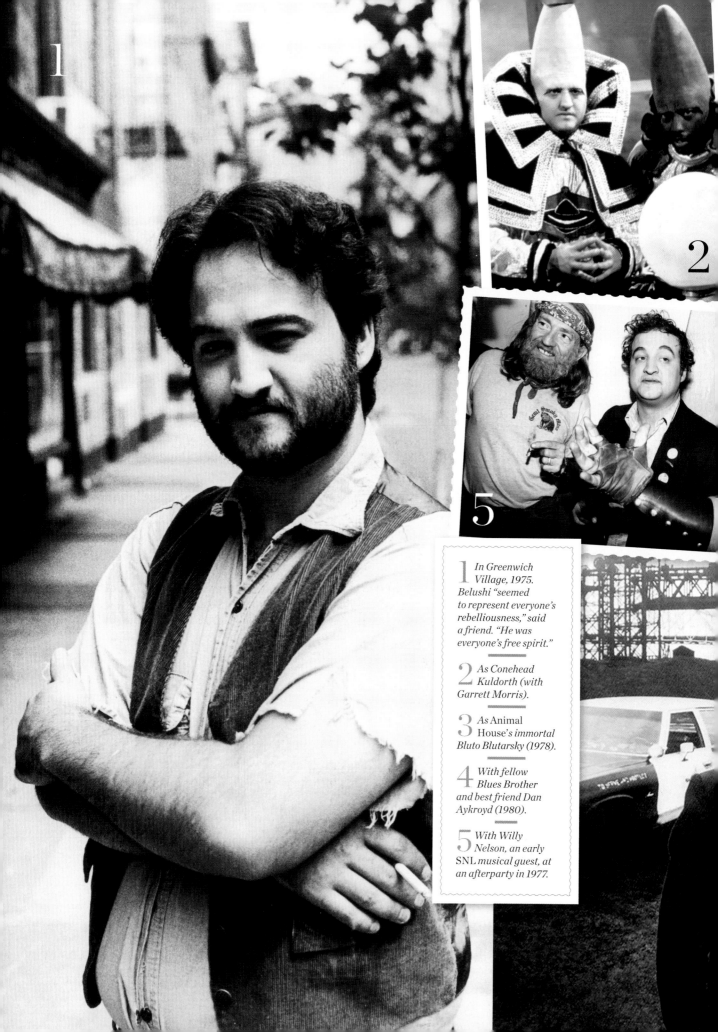

1 *In Greenwich Village, 1975. Belushi "seemed to represent everyone's rebelliousness," said a friend. "He was everyone's free spirit."*

2 *As Conehead Kuldorth (with Garrett Morris).*

3 *As* Animal House's *immortal Bluto Blutarsky (1978).*

4 *With fellow Blues Brother and best friend Dan Aykroyd (1980).*

5 *With Willy Nelson, an early* SNL *musical guest, at an afterparty in 1977.*

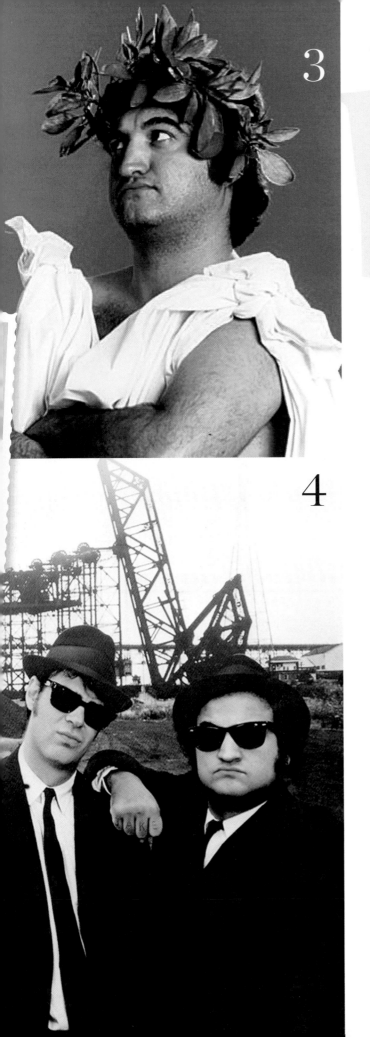

3

4

# What rock and roll was

supposed be about was getting loose, enjoying it, going a little crazy and not caring how you act or dress," John Belushi once said. "Now rock and roll is at a standstill I think—and comedy is taking its place as something exciting."

Belushi did his anarchic best to help it along. A breakout star on *Saturday Night Live,* he turned a Greek diner owner ("No Coke! Pepsi!"), a Samurai tailor, killer bees and a wicked Joe Cocker imitation into must-see TV. "[Chevy] Chase was the first star of the show," said NBC exec Dick Ebersol, "but Belushi was the first to become the audience's friend. There was a huge bond." It only grew stronger when Belushi, as proto-frat-boy Bluto Blutarsky, a rampaging id in a toga, made the movie *Animal House* a huge hit.

Offstage Belushi could be just as wild, to the point of self-destruction. His appetite for drink and drugs was legendary. "The same violent urge that makes John great will ultimately destroy him," said *SNL* head writer Michael O'Donoghue with chilling prescience. "He's one of those hysterical personalities that will never be complete. I look for him to end up floating dead after the party." O'Donoghue was famous for his dark humor, but Belushi would not have been offended by that brutal assessment. Once, clowning around with *National Lampoon* cofounder Doug Kenney, Belushi did an impromptu impression of Elvis Presley in his death throes. Kenney told him it wasn't funny. "But," Belushi replied, "that's the way we're all going to die, Dougie."

For Belushi, the evening of March 4, 1982, was a night like any other: drug-fueled and manic. He stopped at On the Rox, an L.A. club, and hung out with Robert De Niro and Harry Dean Stanton. Then he headed back to his bungalow at the Chateau Marmont, where Robin Williams dropped by. After Williams left, Cathy Smith, a drug dealer, injected Belushi with a "speedball," a combination of heroin and cocaine. The next day, Belushi, 33, was found dead from an overdose.

He was buried on Martha's Vineyard, where his best friend, *SNL* costar Dan Aykroyd, led the funeral cortege on a Harley Davidson. Belushi's headstone reads, "I may be gone, but rock and roll lives on."

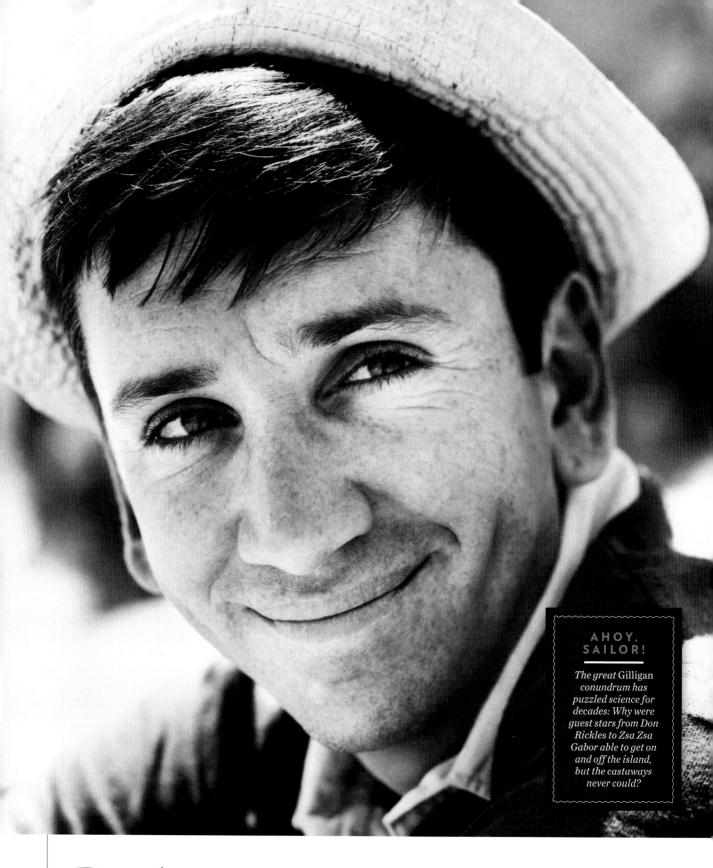

# BABY BOOM

# BOB DENVER

## FAREWELL, LITTLE BUDDY: YOUR THREE-HOUR TOUR LASTED A LIFETIME

**1935 2005**

As the lovable but inept castaway on the 1960s sitcom *Gilligan's Island,* he would set his pants on fire, thwonk the Skipper with a boomerang and tangle himself up in a hammock. In real life Bob Denver "was the opposite of the goofy guy he played," said friend and castmate Russell Johnson (the Professor). But "he wasn't the opposite in terms of sweetness, generosity and kindness." Denver was also beloved for his portrayal of Maynard G. Krebs, the beatnik sidekick on TV's *The Many Loves of Dobie Gillis*. "As an actor he saw the world through the eyes of a child," said *Island* costar Dawn Wells (Mary Ann). "As a person he had intellect and wisdom in his soul." Added *Gilligan*'s creator Sherwood Schwartz: "You think of him as inept, but he was very ept!"

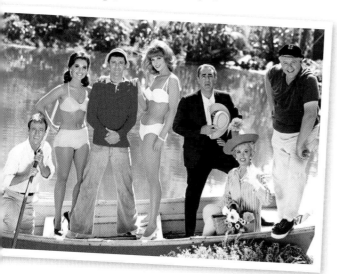

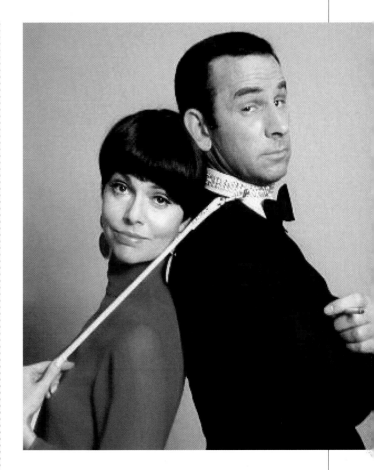

## DON ADAMS

### HIS AGENT 86 WAS A BUMBLING ANTI-BOND, AND WE LOVED HIM FOR IT

**1923 2005**

Would you believe Don Adams was nothing like Maxwell Smart, the klutzy secret agent he played in the '60s spy spoof *Get Smart*? "He was not at all a bumbling idiot," said costar Barbara Feldon. "Don was extremely intelligent. He was interested in history; he used to write poetry." For Adams's TV fans, the poetry was in his staccato, nasal delivery of lines like, "Sorry about that, Chief." A WWII Marine veteran who fought at Guadalcanal, Adams started out as a stand-up comic and later worked as a voice actor. But his true genius was in playing dumb. "Don was really smart," said *Get Smart* co-creator Mel Brooks. "Not Maxwell Smart— he was Don Adams smart."

# HEROES

Howdy Doody, Mr. Rogers and Gilligan amused, soothed and babysat a generation

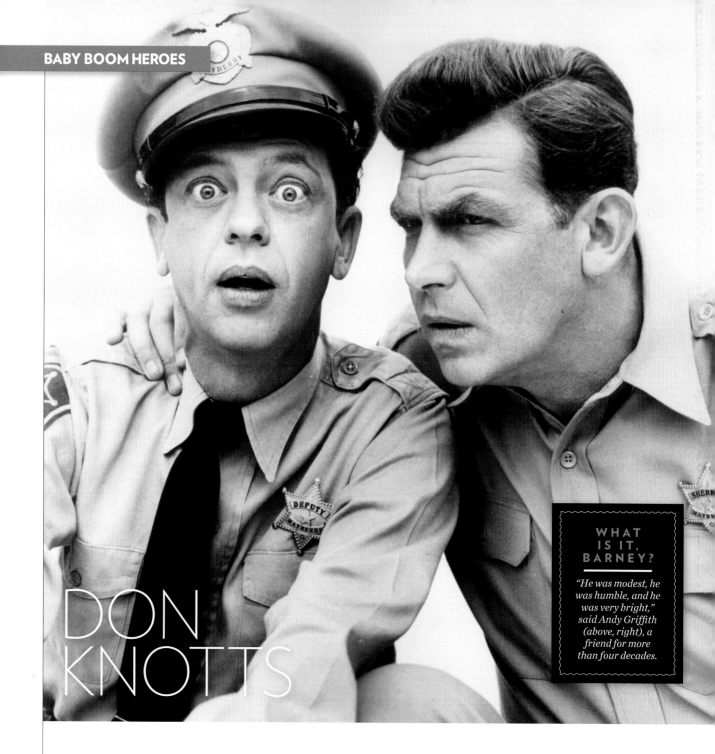

## DON KNOTTS

HEROIC.
HANDSOME.
STEADFAST.
THAT'S WHAT
HIS HAPLESS
CHARACTERS
THOUGHT
THEY WERE

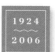

1924
2006

*The Andy Griffith Show* was supposed to be a vehicle for its star. But Knotts, playing bungling Deputy Barney Fife, soon turned Griffith into a straight man. "Don meant everything," Griffith told *The Washington Post* after his sidekick's passing. "Don made the show."

Knotts specialized in deluded goofballs. His *Three's Company* character, landlord Ralph Furley, usually resplendent in leisure suit and ascot, was under the illusion he was a lothario.

In real life, the thrice-married Knotts actually *was* something of a, er, player. "Dad was kind of wild," said his daughter Karen. "He was really quite a ladies' man, especially between marriages."

Knotts also left a trove of movie roles, including *The Incredible Mr. Limpet* and *The Reluctant Astronaut*. Said frequent costar Tim Conway: "The reason I'm in business is because of Don. . . . He left us with a wonderful, gentle character who can never be duplicated."

# FRED ROGERS

## A GENTLE MAN IN A RED SWEATER, HE WAS TELEVISION'S EQUIVALENT OF A WARM HUG

**1928 2003**

In an era of *Jersey Shore* and *Keeping up with the Kardashians,* it's possible to forget that once upon a time Fred Rogers, a Presbyterian minister from Pittsburgh, epitomized reality TV. For 33 years on PBS's *Mister Rogers' Neighborhood* he spoke frankly to children about everything from death and divorce to loneliness and anger. Children's worst fears, he believed, had to be "manageable and mentionable." "He was the last of the good guys in kid TV, which has become edgier and nastier," said Dr. Carole Lieberman, a child psychiatrist. Perhaps *Sesame Street's* Elmo put it best. "Elmo is going to miss Mister Rogers," he said, "because he always talked right to Elmo and made him feel good about just being Elmo."

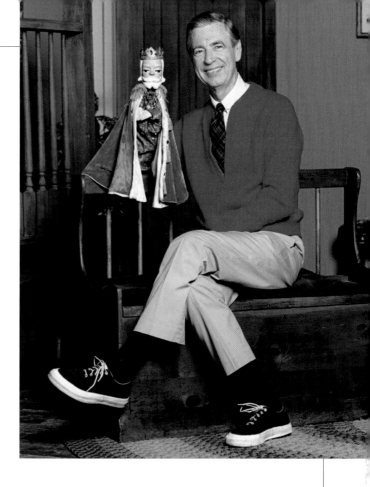

# SHARI LEWIS

## HERS WAS THE HAND THAT GUIDED THE LAMB THAT MADE LITTLE KIDS LAUGH

**1934 1998**

The daughter of a college professor and a school music coordinator, Lewis, a puppeteer nonpareil, unveiled Lamb Chop—basically a sweetly sassy sock with eyes—on the kids' show *Captain Kangaroo* in 1956; a few years later she had her own program, the first of four that would collect a dozen Emmys over 35 years. One of her secrets to a happy life? "My mother told me not to learn anything that I didn't want to do," she once said. "So I never learned to wash a floor or clean a toilet."

But she worked hard: Two hours after being diagnosed with uterine cancer, she was back in the studio, where she eventually taped three final shows before starting chemotherapy. Said her daughter: "I've never known anyone who got more joy out of their career."

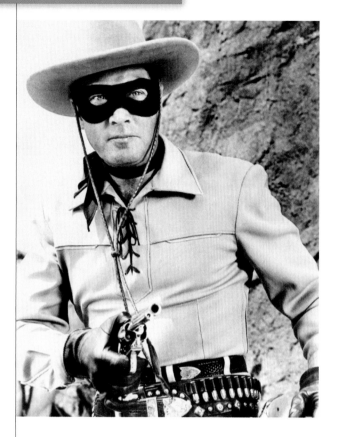

# CLAYTON MOORE

## ". . . A FIERY HORSE WITH THE SPEED OF LIGHT, A CLOUD OF DUST AND A HEARTY 'HI-YO, SILVER!' . . ."

1914
1999

With a blast of the *William Tell* overture and the words "Return with us now to those thrilling days of yesteryear . . .," any boy born in the 1950s knew it was time for *The Lone Ranger,* starring Moore and his trusty Native American sidekick Tonto (Jay Silverheels). Moore played the role for eight years on TV and in personal appearances for the rest of his life. Saying he was being true to the Ranger's code ("Fight when necessary for that which is right") he successfully battled in the '80s with the character's owners for the right to continue wearing the mask. "I've been the Lone Ranger for 30 years," he said, "and I intend to be the Lone Ranger . . . until I'm called."

# BUFFALO BOB

## THE PHILOSOPHY THAT CREATED A TV CLASSIC? "I TRIED TO BE THE BEST FRIEND THE KIDS EVER HAD"

1917
1998

Smith was a radio deejay when NBC tapped him in 1946 to create a kids' TV show. Premiering in 1947, just as millions of Baby Boom babies were being born and their parents were buying their first TVs, *The Howdy Doody Show* became an instant hit and made stars of Smith and his freckle-faced marionette. *Howdy* ran for 13 years and was so burned into the minds of an entire generation that Smith found work on the nostalgia circuit for decades. Only months before his death at 80, he had 300 misty-eyed—if gray-haired—Boomers joining in to sing *It's Howdy Doody Time.*

Offscreen he was a devoted dad who coached his three sons in Little League and had the same easy manner that made *Howdy* a success. As he lay dying of bone cancer, recalled his son Ronald, then 55, he said, "No, slugger, you can't go yet. You've got to give me a kiss. And don't worry—it's not contagious."

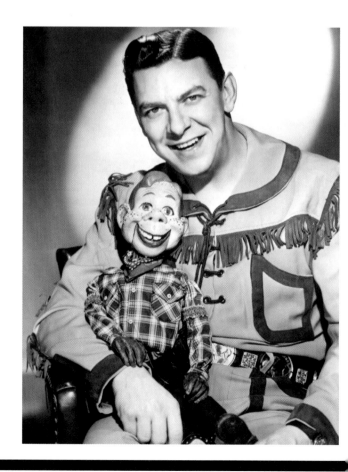

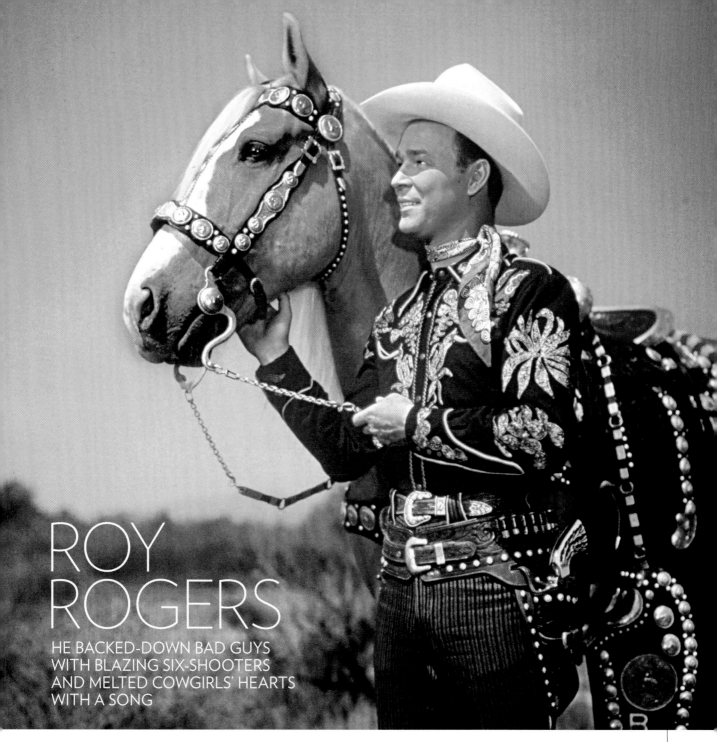

# ROY ROGERS

HE BACKED-DOWN BAD GUYS
WITH BLAZING SIX-SHOOTERS
AND MELTED COWGIRLS' HEARTS
WITH A SONG

1911
~~~
1998

For millions of buckaroos he will always be the white-hatted King of the Cowboys. Born Leonard Franklin Slye in Cincinnati, he found his calling as a barnstorming country singer and went on to star in 86 movies and 100 episodes of the *Roy Rogers* TV show. Rogers professed ignorance about his appeal, but, said his son Dusty, "we all know it was that boyish backwoods charm and that grin. He was no different onscreen or off."

So strong were fans' memories that, until very recently, they could still see Roy's trusty Palomino Trigger, his dog Bullet and his wife Dale Evans's horse Buttermilk preserved at the Roy Rogers Museum in Branson, Mo. "Trigger died, and Dad had him stuffed," Dusty noted years ago. "Bullet died, and Dad had him stuffed. Buttermilk died, and Dad had her stuffed. Now Mom sleeps with one eye open." The museum closed in March 2010; Trigger was scheduled to be auctioned in July 2010.

The straight-shooting star, who never started a fight but never lost one either, didn't like the way movies had changed. In his day, he told Dusty, "You didn't beat a man to death. You just knocked him out. . . . There's movies today I wouldn't let Trigger watch."

According to Rogers's nurse, his last words were, "Well, Lord, it's been a long, hard ride."

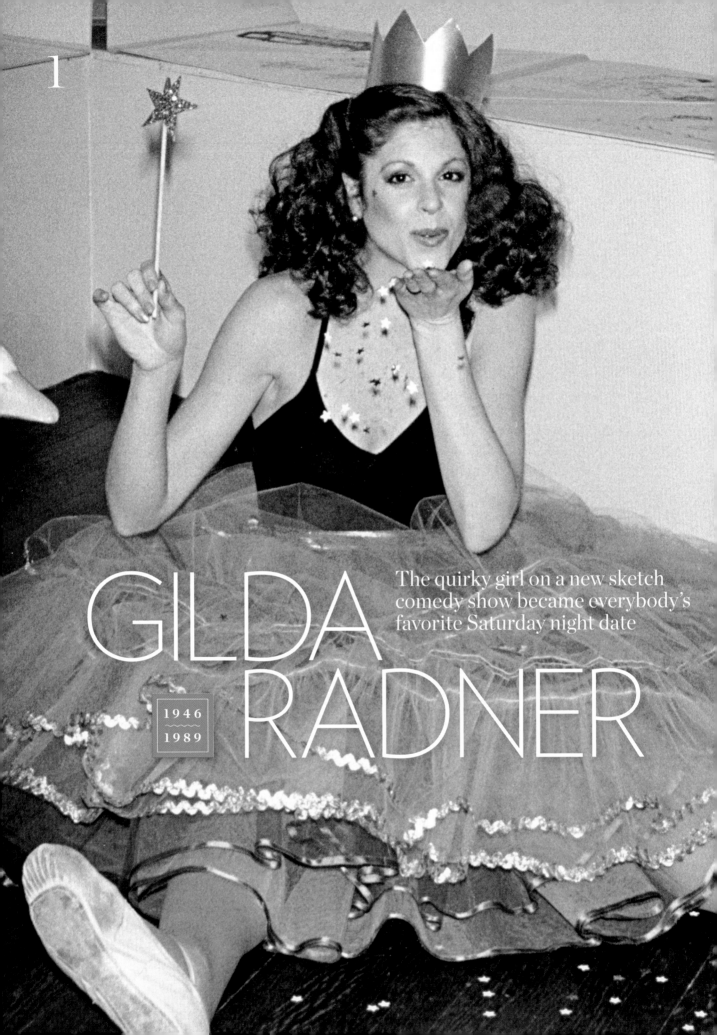

GILDA RADNER

The quirky girl on a new sketch comedy show became everybody's favorite Saturday night date

1946 1989

Lisa Loopner,

Baba Wawa, Roseanne Roseannadanna, Emily Litella: Different characters, but all shared the same goofy, childlike DNA. "So much of what made up her characters didn't come of dreaming that stuff up," said a friend of *Saturday Night Live* star Gilda Radner. "They evolved from her being so open to the funniness in life." Said Anne Beatts, an early *SNL* writer: "If *Saturday Night Live* was like Never-Never-Land, the Island of Lost Boys, she was Tinker Bell. She just hadn't lost touch with the child in her."

She got her start, like so many *SNL* alumni, in Toronto's *Second City* comedy troupe. Producer Lorne Michaels recalled being impressed by such peculiar Radner abilities as "playing 14 Bingo cards at a time" or "remembering everything she'd eaten that day. She'd just literally reel it off—the french fries off someone else's plate, a Milk Dud from the bottom of her purse." When *SNL* premiered in 1975, "What Gilda Ate" became a regular segment.

Radner met Gene Wilder while making the 1982 film *Hanky Panky.* "There was a chemistry that was palpable," said a friend who visited the set. "They hadn't yet been together, but there was no chance that they weren't going to be." Wilder "was funny and handsome," Radner wrote. "And he smelled good." They married in 1984.

Two years later Radner was diagnosed with ovarian cancer. For 2½ years, through 30 radiation treatments, she fought heroically. "My life had made me funny," Radner wrote in *It's Always Something,* her book about coping with the disease, "and cancer wasn't going to change that." Typically, she used her experience to help others. "I went bald because of chemotherapy," recalled Melinda Sheinkopf, a cancer survivor who had met Gilda. "She made it bearable. She brought me curlers, mousse and gel in a little bag. I laughed myself silly."

Radner lost her own battle, in her sleep, on May 20, 1989. She was 42.

JACKIE GLEASON

If life is a party, *The Honeymooners'* happy hedonist
scarfed the appetizers, emptied the liquor cabinet and
pinched the hostess good night

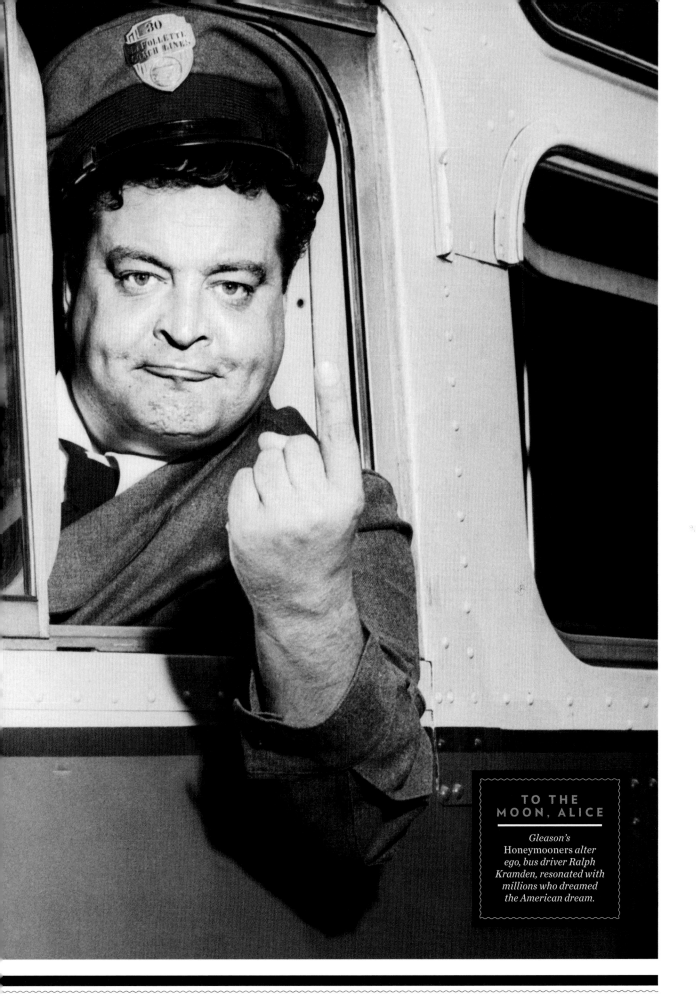

Gross in physique,

gargantuan in gourmandise, oceanic in liquid capacity, prodigal of purse, a fire hose of libido and a Niagara of comic invention, Jackie Gleason personified excess. In a now lost world of nightclubs, gin mills, dames and 3 a.m. glamour, he sampled every available temptation, then went back for seconds. And thirds. And fourths.

His life began as such a biography should: poor, in Brooklyn. His father, a drunk, disappeared when Gleason was 9 ("He was as good a father," Gleason later remarked wistfully, "as I've ever known"). His mother retreated into a bottle, and Jackie, the neighborhood wise guy, was pretty much left on his own. By 15, he was the emcee at a neighborhood theater; soon he was stealing professional comics' material, becoming a local hero and strutting the streets in a derby, spats and a yellow polka-dot scarf. By 20, he'd conquered Manhattan and began living very large. Gleason gleefully chased women (in one club, he recalled, "there were 22 chorus girls, and all you had to say was, 'Would you like to have dinner?' "); imbibed with conviction ("I drink," he said, "with the honorable intention of getting bagged"); smoked six packs a day; and happily spent far more than his very ample income (he once borrowed $500 from barkeep Toots Shor, then hired a limo to drive Frank Sinatra to a bar half a block away). For a late night snack, he'd have a couple of T-bones; when the bars closed, he'd hire a band to play in his hotel room, and invite pals.

In 1952 CBS signed him for *The Jackie Gleason Show*; two years later they offered him an astonishing $11 million for three more years. A recurring sketch, called *The Honeymooners*, became such a hit that CBS spun it off into a separate show in 1955—and so began one of the most famous sitcoms in TV history. Ever since, bits of *Honeymooners* DNA—the husband with dreams of making it big, the goofball sidekick, the no-nonsense wife—have popped up in everything from *The Flintstones* to *Home Improvement* to *King of Queens*. Groucho Marx called it TV's "only real classic." Novelist John O'Hara considered the show's blue-collar Everyman, Ralph Kramden, "a character we might be getting from Dickens if he were writing for TV."

Gleason celebrated his way: by snoring through meetings with CBS brass ("Any TV executive," he noted, "must have one important attribute: cologne!") and chartering a train for a 10-day, coast-to-coast party with live bands, booze and broads.

When *The Honeymooners* ended, Gleason started a new *Jackie Gleason Show*, which he produced in Miami, he said, "because I like to play golf." He launched a successful second career in movies (a turn as Minnesota Fats in *The Hustler* brought an Oscar nomination; later films, including *Smokey and the Bandit* and *The Toy*, with Richard Pryor, introduced him to a younger generation). Perhaps to his surprise, he began to slow down and entered a happy third marriage, to former dancer Marilyn Taylor, whom he had fallen in love with more than 20 years earlier (his first wife, a Catholic, waited nearly that long before granting him a divorce).

Looking back he had enjoyed it all. "Almost everything I've wanted to do," he said, "I've been able to do, and most of it turned out pretty good. Everybody's been damn nice to me."

And how did he want to be remembered? "Aw, hell," he said. "I'd just like to be remembered."

ALMOST EVERYTHING I'VE WANTED TO DO, I'VE BEEN ABLE TO DO"

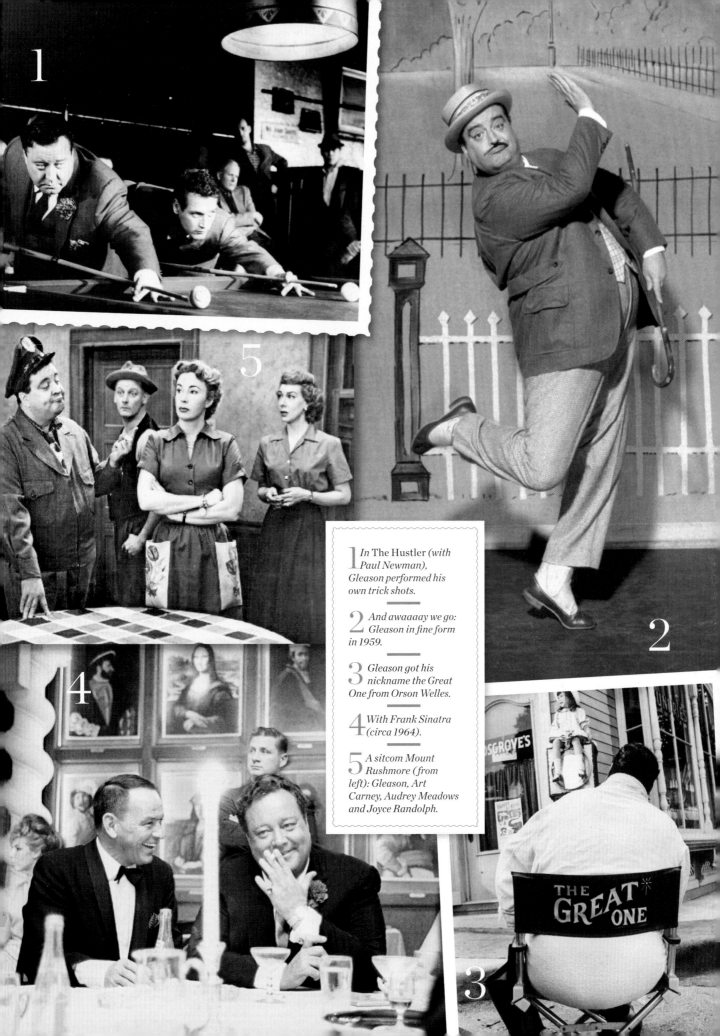

1 *In* The Hustler *(with Paul Newman), Gleason performed his own trick shots.*

2 *And awaaaay we go: Gleason in fine form in 1959.*

3 *Gleason got his nickname the Great One from Orson Welles.*

4 *With Frank Sinatra (circa 1964).*

5 *A sitcom Mount Rushmore (from left): Gleason, Art Carney, Audrey Meadows and Joyce Randolph.*

THE GREAT ONE

MUSIC

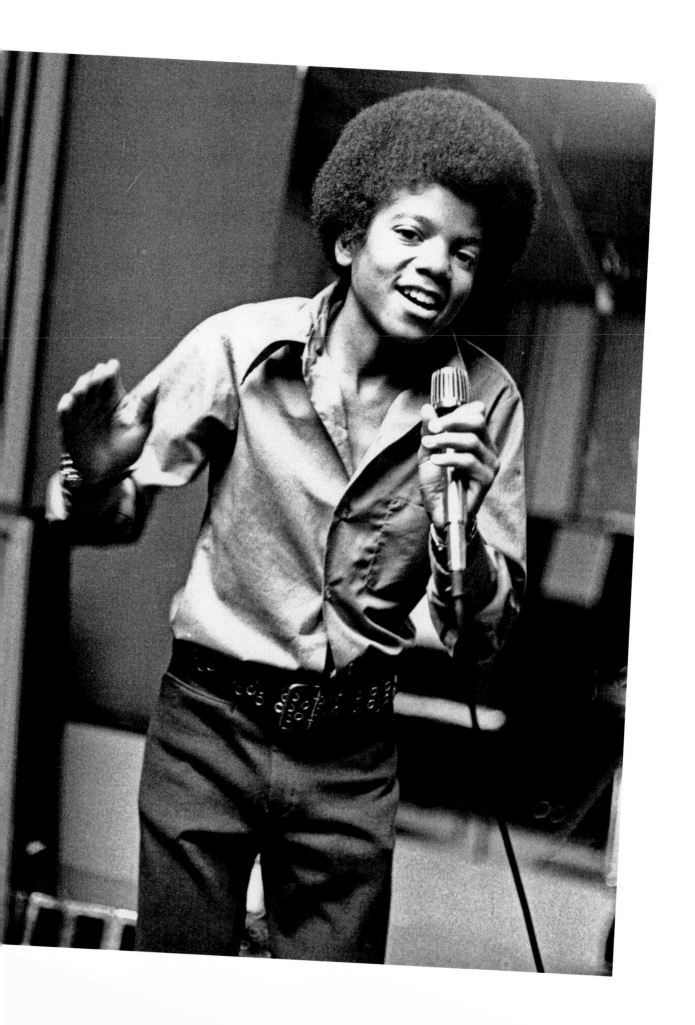

MICHAEL JACKSON

1958
2009

A singing, dancing supernova, the King of Pop
rocked the world and redefined fame

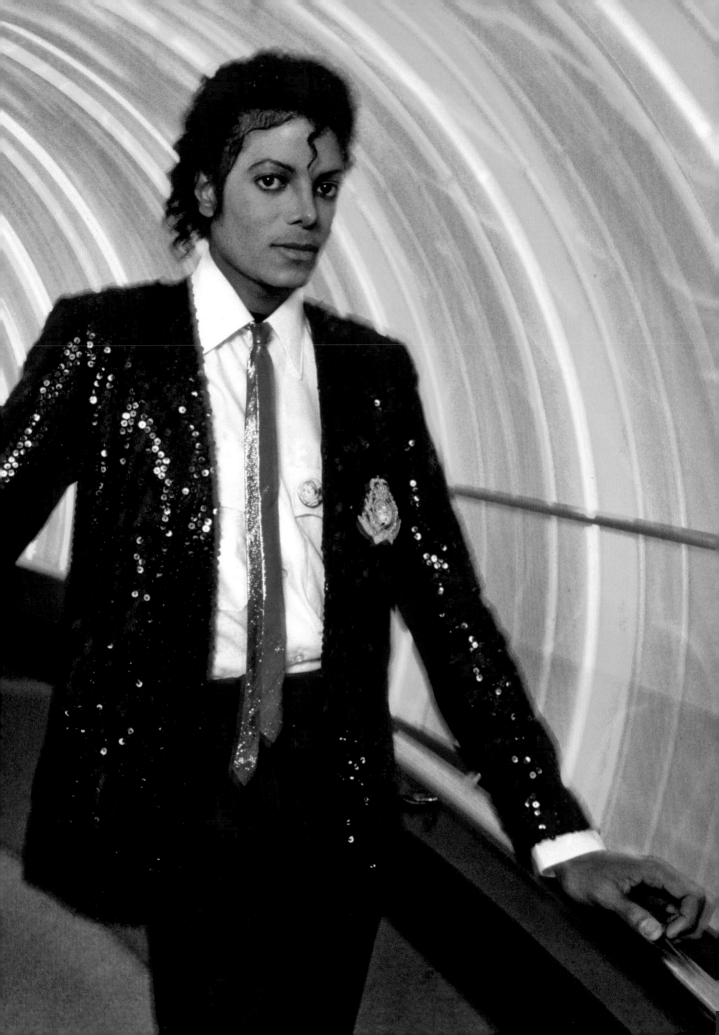

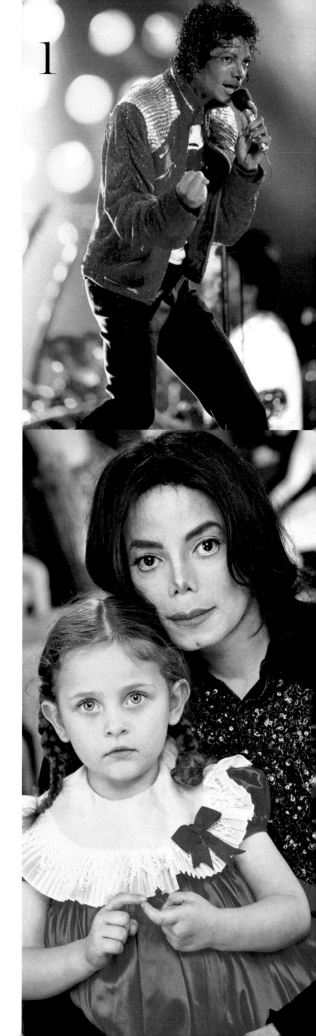

On a 1983 Motown TV

special, three minutes and 40 seconds into his song "Billie Jean," Michael Jackson took four sliding steps backward while appearing to walk forward, an otherworldly move that left viewers slack-jawed. To paraphrase history's other great moonwalker, it was one small step for a man, one giant leap into unprecedented, global stardom.

For roughly 10 years, from 1983 to 1993, Jackson commanded the world's attention like few entertainers before and none since. After the Motown special, sales of Jackson's *Thriller* skyrocketed toward a total of more than 100 million albums. Like Elvis and the Beatles before him, he saw his every appearance turn into a mob scene, reducing hordes of fans to Jell-O just by showing up. He became the first African-American artist ever featured on MTV, squired Brooke Shields to the Grammys, met President Reagan at the White House and wangled a small army of A-listers to sing "We Are the World" for charity. Charisma? When he went to the Oscars with Madonna in 1991, she later recalled, "It was pouring rain, and the limo door opened, and Michael got out first—and *my* bodyguard leaves with Michael under the umbrella! I was left standing in the rain. It was fascinating to see how people responded to him."

Of course nothing stays white-hot forever; supernovas burn out in mere weeks. His albums *Bad*, in 1987, and *Dangerous*, in 1991, were hits, but not nearly as popular as *Thriller*. Eccentricities that had once seemed charming took on a far less comfortable aura: In 1993 he was sued for child molestation and, after painfully pleading his innocence on television, settled out of court. He married Elvis's daughter in 1994; they divorced in 1996. He altered his appearance dramatically and bizarrely with plastic surgery; his skin became lighter. The year 2003 brought another claim of child molestation; Jackson, after a protracted and much publicized trial, was found not guilty, but afterward seemed to retreat from the world. He was planning a comeback tour in 2009 when he died, at 50, from a mixture of the powerful anesthetic propofol and the anti-anxiety drug lorazepam.

How great, at its peak, was MJ's mojo? Consider how *The New Republic*—not usually given to fan-mag gush—described the singer in the '80s: He's "the most successful musical performer ever ... bigger than Sinatra, Elvis, the Beatles, Jesus, Beethoven—all of them." As for the scandals and weirdness, "there will be a lot written about what came next in Michael's life, but for me all of that is just noise," said *Thriller* producer Quincy Jones. "I promise you in 50, 75, 100 years, what will be remembered is the music. It's no accident that almost three decades later, no matter where I go in the world, in every club and karaoke bar, like clockwork, you hear 'Billie Jean,' 'Beat It,' 'Wanna Be Startin' Something,' 'Rock with You' and 'Thriller.'"

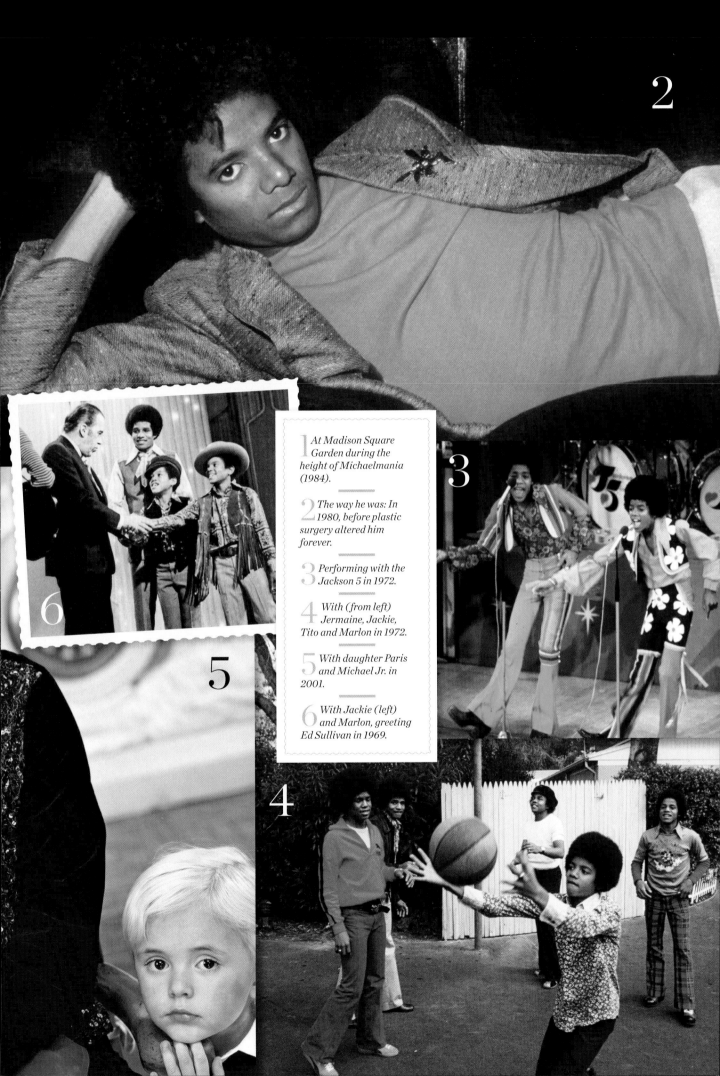

1 At Madison Square Garden during the height of Michaelmania (1984).

2 The way he was: In 1980, before plastic surgery altered him forever.

3 Performing with the Jackson 5 in 1972.

4 With (from left) Jermaine, Jackie, Tito and Marlon in 1972.

5 With daughter Paris and Michael Jr. in 2001.

6 With Jackie (left) and Marlon, greeting Ed Sullivan in 1969.

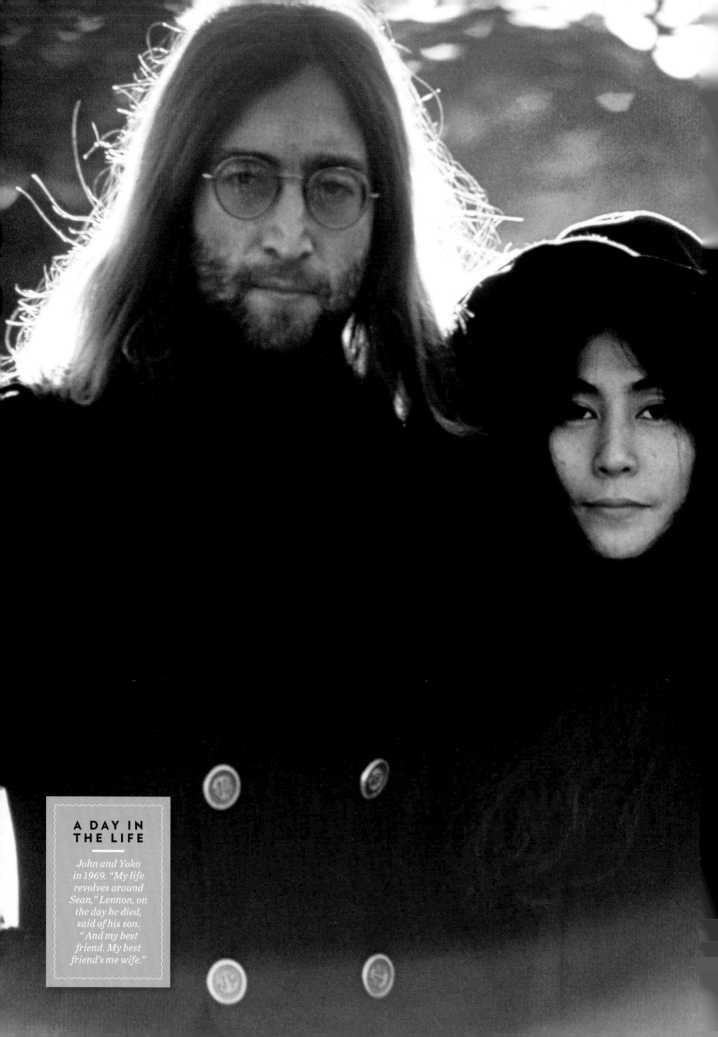

JOHN LENNON

I heard the news today, oh boy:
For millions, the murder of the
beloved ex-Beatle felt like a death
in the family

Looking back it's

possible to see some of what made John
Lennon John Lennon.

He was a sensitive kid and knew it.
"In one way, I was always hip," Lennon
said. "I was hip in kindergarten. I was
different from the others . . . there
was something wrong with me, I thought,
because I seemed to see things other
people didn't see."

His early childhood was traumatic.
His father, a seaman, abandoned the
family early; when John was 4½, his
mother, forced by Liverpool's Social
Services, handed him over to his Aunt
Mimi to raise. When he was 17, his mother,
walking to a bus stop, was hit and killed
by a drunk driver. As Lennon said later,
"I lost her twice."

And, full of energy and rebellion,
Lennon hit puberty just as rock and roll
was born (he was 14 when "Rock Around
the Clock" rattled the planet; Elvis's
first No. 1, "Heartbreak Hotel," soon
followed). Perhaps not since Picasso
got his first box of Crayolas was there
so portentous a meeting of artist and
medium. Over time Lennon would create,
or co-create, such rock-and-roll odes to
joy as "I Want to Hold Your Hand", "Eight
Days a Week" and "Help!" But, unusual
for the time, his music could also be
exquisitely personal, exploring his own
painful childhood—and, later, his adult
experiences—in ways that resonated with
millions. Penny Lane was a street in his
hometown of Liverpool; Strawberry Fields
was an orphanage near his Aunt Mimi's;
a wistful "song of love" has the same name
as his mother, Julia.

Beatlemania's wild ride, mixed with
the political-social-sexual chaos of the
'60s, left Lennon unimaginably wealthy,
famous—and foundering. In response,
he shut down, stepping away from music
in the mid-'70s, handing his business
interests over to his wife, Yoko Ono,
and devoting himself to raising his son
Sean. "Sean is my biggest pride," he told
a reporter in one of his last interviews.
"And you're talking to a guy who was not
interested in children at all before."

Only when Sean was 5 and ready
for school did Lennon take the first
tentative steps back into the music world,
releasing an album, *Double Fantasy*,
with Yoko. Three weeks later, on a random
December night, he was murdered at his
front door by Mark David Chapman, a
deranged fan.

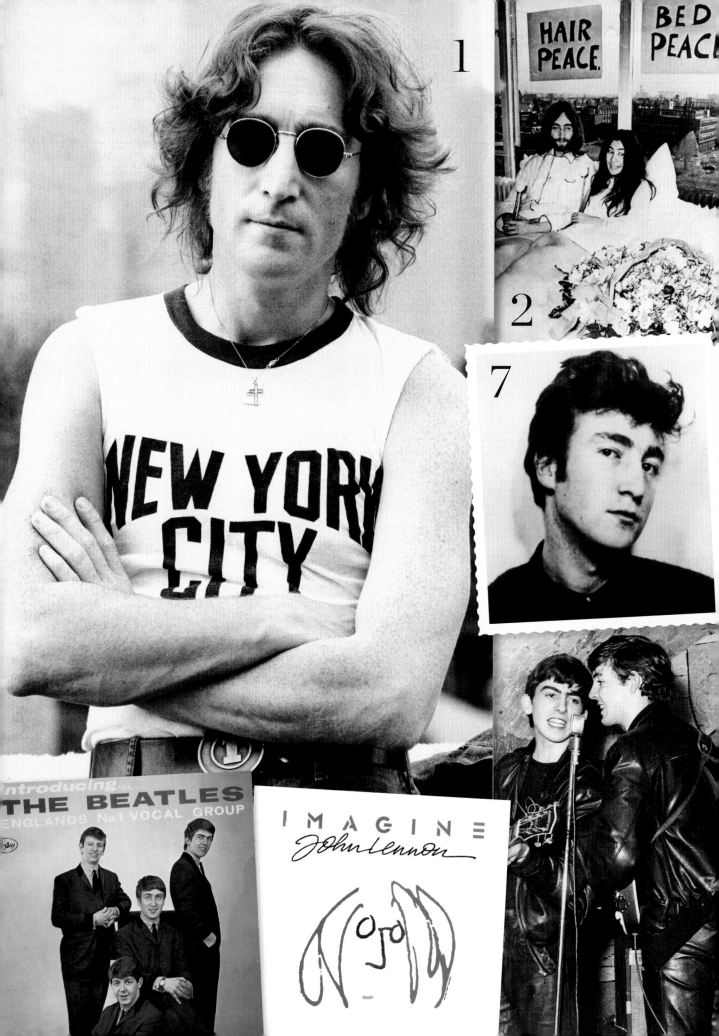

1

HAIR PEACE.

BED PEACE

2

7

Introducing...
THE BEATLES
ENGLANDS No.1 VOCAL GROUP

IMAGINE
John Lennon

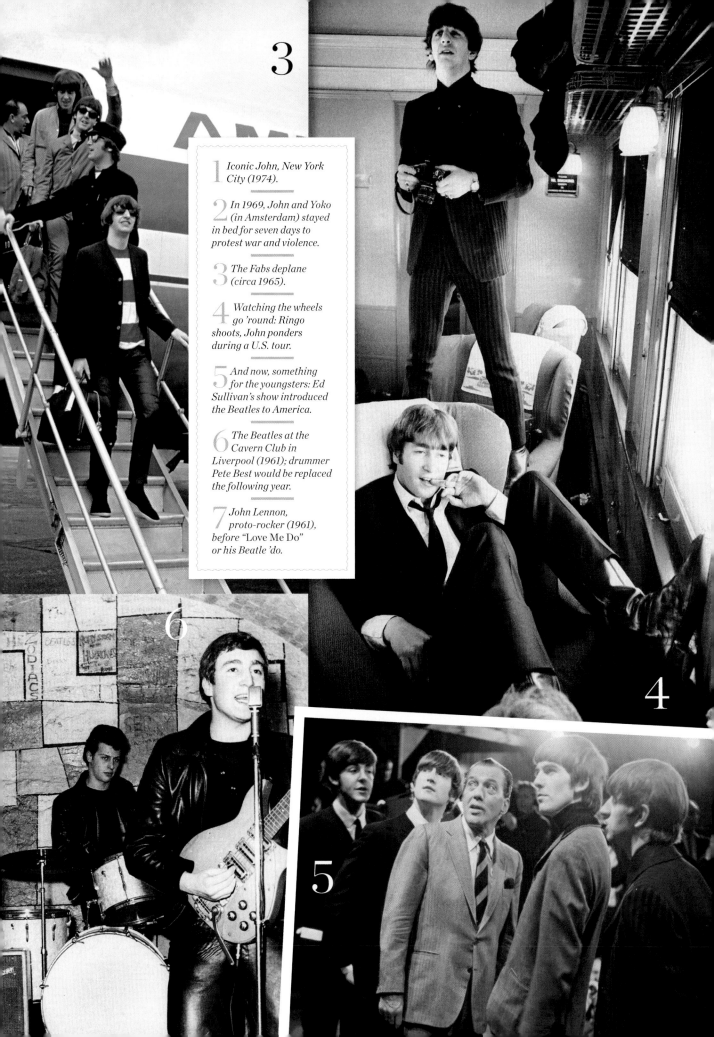

3

1 Iconic John, New York City (1974).

2 In 1969, John and Yoko (in Amsterdam) stayed in bed for seven days to protest war and violence.

3 The Fabs deplane (circa 1965).

4 Watching the wheels go 'round: Ringo shoots, John ponders during a U.S. tour.

5 And now, something for the youngsters: Ed Sullivan's show introduced the Beatles to America.

6 The Beatles at the Cavern Club in Liverpool (1961); drummer Pete Best would be replaced the following year.

7 John Lennon, proto-rocker (1961), before "Love Me Do" or his Beatle 'do.

6

4

5

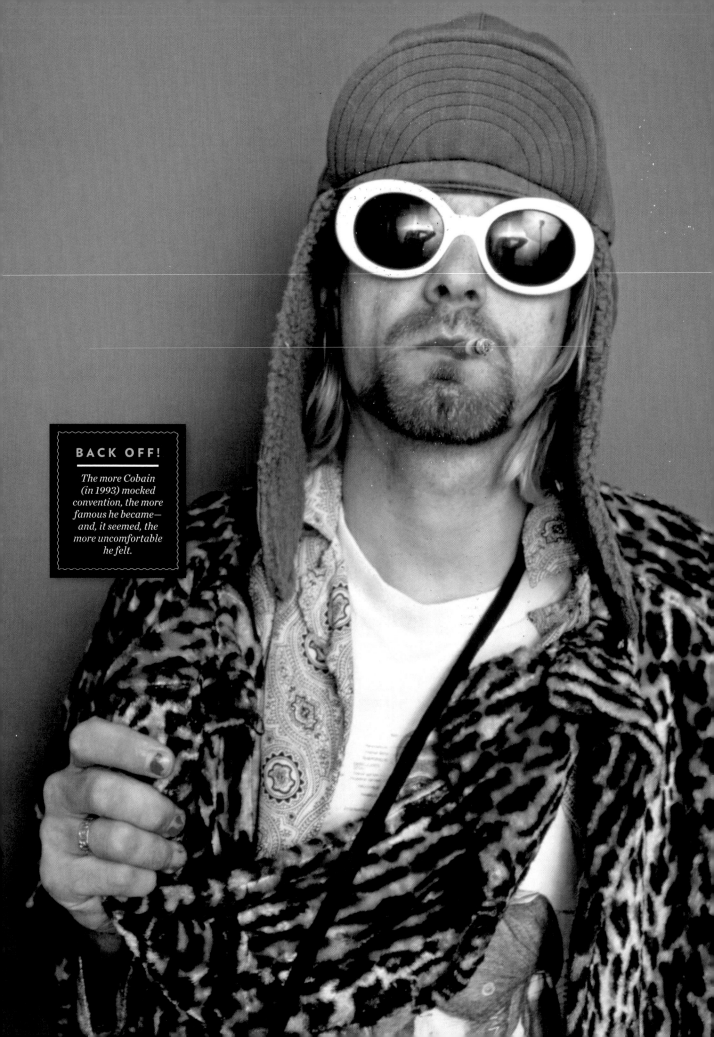

BACK OFF!

The more Cobain (in 1993) mocked convention, the more famous he became— and, it seemed, the more uncomfortable he felt.

KURT COBAIN

1967
1994

Here we are now, entertain us: A punk rocker recoils from the storm he helped create

It could have been the pain in his stomach. Or the drugs. Or the crazy life he was leading. Most likely it was all three.

On April 5, 1994, Kurt Cobain, 27, the "Smells Like Teen Spirit" singer and reluctant grunge icon, walked into the garage apartment of his Seattle home, placed his driver's license beside him—so there would be no question of identification—pointed a shotgun at himself and pulled the trigger. A suicide note he left alluded to chronic pain in his "burning, nauseous" stomach that had haunted him for years; heroin, he once said, was the only drug he had found that eased the agony. The shotgun blast was so fearsome that authorities had to use fingerprints to identify the body; Courtney Love later clipped and kept a lock of his blond hair.

Cobain, who grew up in the depressed logging town of Aberdeen, Wash., came by his alienation honestly. Two of his father's uncles had committed suicide, and, said cousin Bev Cobain, a nurse, alcoholism and dysfunctional marriages plagued the clan. "I don't think there was much functional stuff going on in the whole family," she noted. A bright, hyperactive kid who had been prescribed Ritalin, Cobain "changed completely," said his mom, Wendy O'Connor, after his parents divorced when he was 8. "It just destroyed his life." He expressed his anger by drawing caricatures of his parents on his bedroom walls, labeling them, "Dad sucks" and "Mom sucks."

What followed was a model of rebellion: Uncontrollable, he was shuttled between his parents and relatives. He dyed his hair wild colors and at school taunted the jocks. "He stood out," said a friend, "like a turd in a punch bowl." He fell in love with punk music and picked up a guitar.

Despite having won two state art scholarships, Cobain skipped college to chase what he later called the "Aberdeen fantasy version of being a punk rocker." Days were spent drinking and drugging; he worked as a janitor at his old high school and at one point lived under a bridge. He formed a band, Nirvana, and began getting noticed. "You always went away hearing Kurt's voice," said Jack Endino, who later produced Nirvana's first album.

From Aberdeen, Nirvana moved on to Olympia and Seattle. Geffen Records signed the group in 1991; friends said Cobain never recovered from the shock when their breakthrough album, *Nevermind*, sold more than 10 million copies and made "Smells Like Teen Spirit" a Gen-X anthem. In front of cameras he mugged with a madhouse gleam, acting as if only a demented world would declare him the voice of a generation. His antics, of course, only fed the legend. A saving grace was that he could at times laugh at the absurdity of it all. "Teenage angst has paid off well," he noted in one song, "Serve the Servants."

Cobain married Love in 1992, and the two had a daughter, Frances Bean, whom Kurt adored. But even his joy in fatherhood couldn't counter his demons. Why suicide? "It's complicated," said Endino. "Basically he was just a nice guy who didn't like fame. He was not your typical rock-star exhibitionist. . . . He was happy to be making music and to get the hell out of Aberdeen. But how many rock icons do you know who blow themselves away at the height of their fame?"

ELVIS PRESLEY

"Listening to rock and roll," he said, "I can't stand still." Listening to him, neither could we

**1935
1977**

According to

one story, it all started because Elvis was so nervous during his first live performances that his knees shook. Girls started screaming, so he incorporated the twitchiness, augmented by a few gyrations, into his act. The forces of righteousness were duly outraged about this discombobulatingly risqué business: Ed Sullivan, during one Elvis TV appearance, showed the King only from the waist up, and, after a Florida judge ordered the singer to keep his show clean, Elvis reined in his wandering pelvis—but, he later joked, nonetheless waggled his little finger to the tune of "Hound Dog." "Momma," he once asked, shortly after embarking on a career that would see him sell more than 500 million records and star in 33 movies, "do you think I'm vulgar on the stage?"

"You're not vulgar," his beloved mother, Gladys, replied. "But you're puttin' too much into your singin'. Keep that up, you won't live to be 30."

In the end it wasn't the singing but everything else that killed him. Col. Tom Parker, his wily manager, who banked a reported 50 percent of his client's earnings, drove Elvis like a rented mule, often keeping him on the road for 100 shows a year and signing him up for quickie movies that frequently made the rockabilly god look like dancing Velveeta. (Elvis never toured outside the U.S. because, it was later discovered, Parker was an illegal immigrant from Holland, and any trip requiring a passport would have revealed his secret.) Elvis's loyal retainers, a.k.a. the Memphis Mafia, spent his money, laughed at his jokes and never said no. Nor for that matter did his personal physician, Dr. George Nichopoulos, who was more than willing to treat the singer's ailments, physical or spiritual, with whatever modern pharmacology could provide: *The New York Times* reported that, during the final 32 months of Elvis's life, "Dr. Nick" prescribed 19,000 doses of narcotics, sedatives and stimulants for the King.

Elvis died alone in his bathroom at 42. Traces of at least 10 drugs were found in his blood. Said Linda Thompson, his last long-term girlfriend: "He was like a little child who needed more care than anyone I ever met."

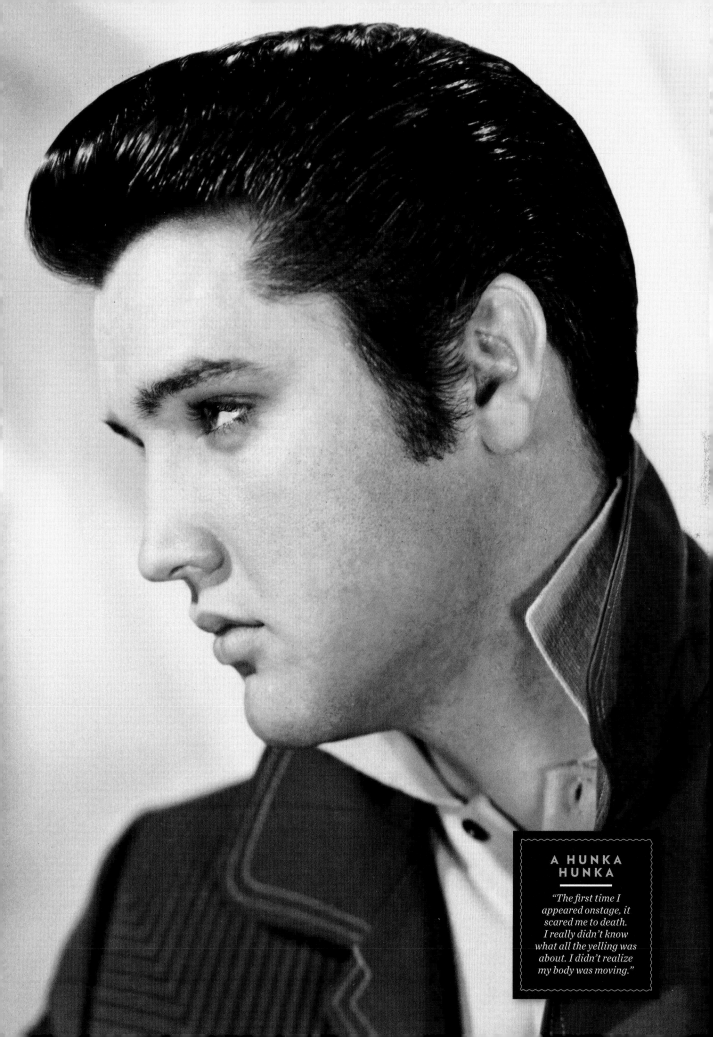

A HUNKA HUNKA

"The first time I appeared onstage, it scared me to death. I really didn't know what all the yelling was about. I didn't realize my body was moving."

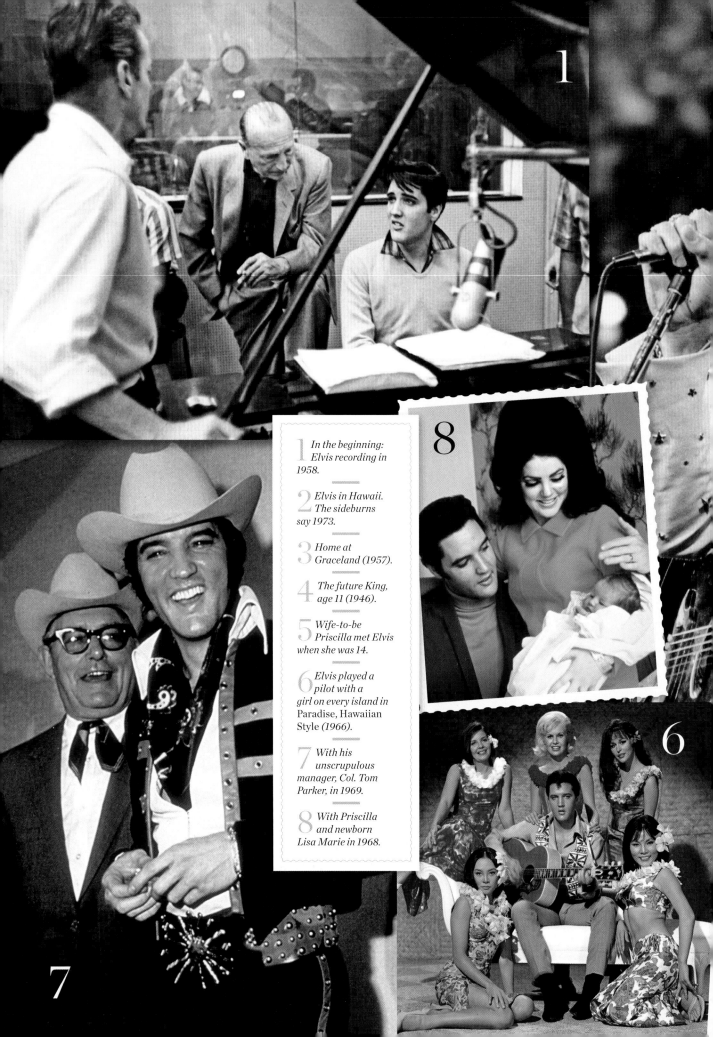

1 *In the beginning: Elvis recording in 1958.*

2 *Elvis in Hawaii. The sideburns say 1973.*

3 *Home at Graceland (1957).*

4 *The future King, age 11 (1946).*

5 *Wife-to-be Priscilla met Elvis when she was 14.*

6 *Elvis played a pilot with a girl on every island in Paradise, Hawaiian Style (1966).*

7 *With his unscrupulous manager, Col. Tom Parker, in 1969.*

8 *With Priscilla and newborn Lisa Marie in 1968.*

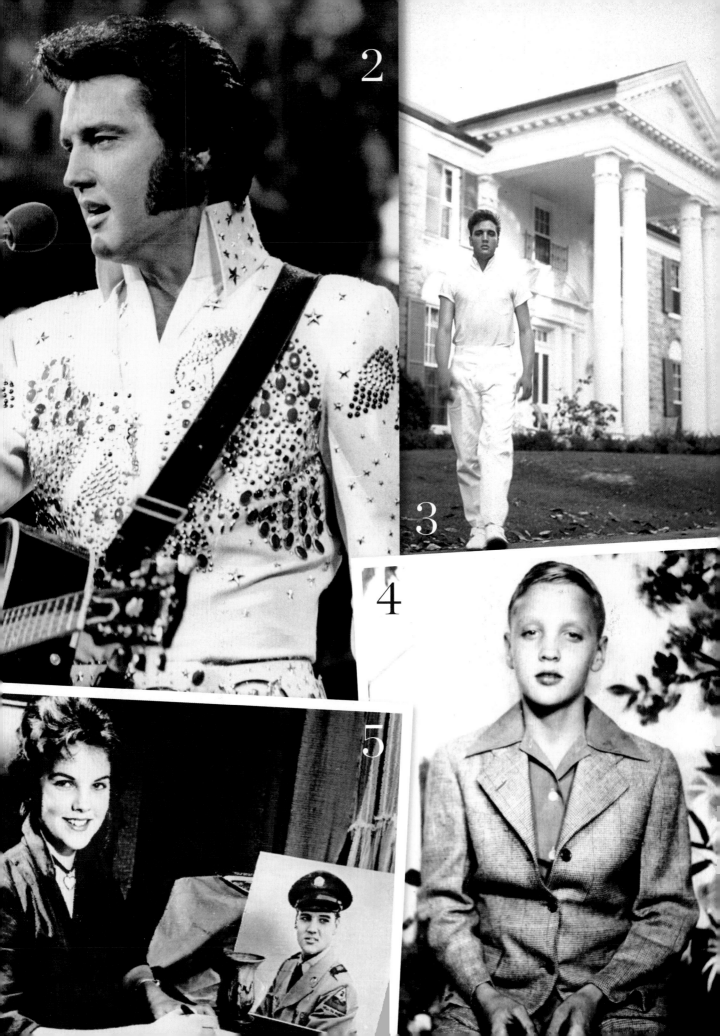

JERRY GARCIA

1942 1995

Equal parts musician and mellow ringmaster, he kept the '60s alive for 30 years

Bearded and gray

in his later years, a middle-aged man whose weight sometimes ballooned to 300 lbs., Jerry Garcia seemed the antithesis of a rock star. His idea of stagecraft was to stand rock-still and utter not a word to the multitudes who adored him. Yet he was a riveting performer, a benevolent Buddha wielding a custom guitar he seemed to play not with his hands but with his heart. "For me," he said, "it's always emotional."

On Aug. 9, 1995, Garcia's heart, 53 years old and ravaged by years of drug use and health problems, gave out. The leader of the Grateful Dead was found during a routine bed check at a California drug treatment center, which he had entered after a relapse into heroin addiction. An autopsy attributed his death not to drugs but to hardening of the arteries. "He created an entire subculture," said Chris Hillman, one of the founders of the Byrds. "He had his roots in bluegrass and blues and folk, and he was able to take that and make this eclectic mixture of sounds, always delving into more experimental

things. He was a true musical explorer."

A Pied Piper, too: As the '60s hippie culture faded, Garcia, as much as anyone, continued to hold its rainbow banner aloft, lurching forward through the decades, laughing much of the way. "It's not just music, it's a religion," said San Francisco poet Hugh Romney, better known as the cosmic clown Wavy Gravy, of the Dead's concerts. "The beauty of the Grateful Dead was their relationship with their fans. They just take this great big ball of love and bounce it out to the fans, and the fans bounce it back, and each time it just gets bigger."

That sense of community made Grateful Dead shows a cultural phenomenon: During the three years before Garcia's death, the band grossed $162 million. "When we get onstage," he once said, "we really want to be transformed from ordinary players to extraordinary ones, like forces of a larger consciousness. So maybe it's that seat-of-the-pants shamanism that keeps the audience coming back and keeps it fascinating for us too."

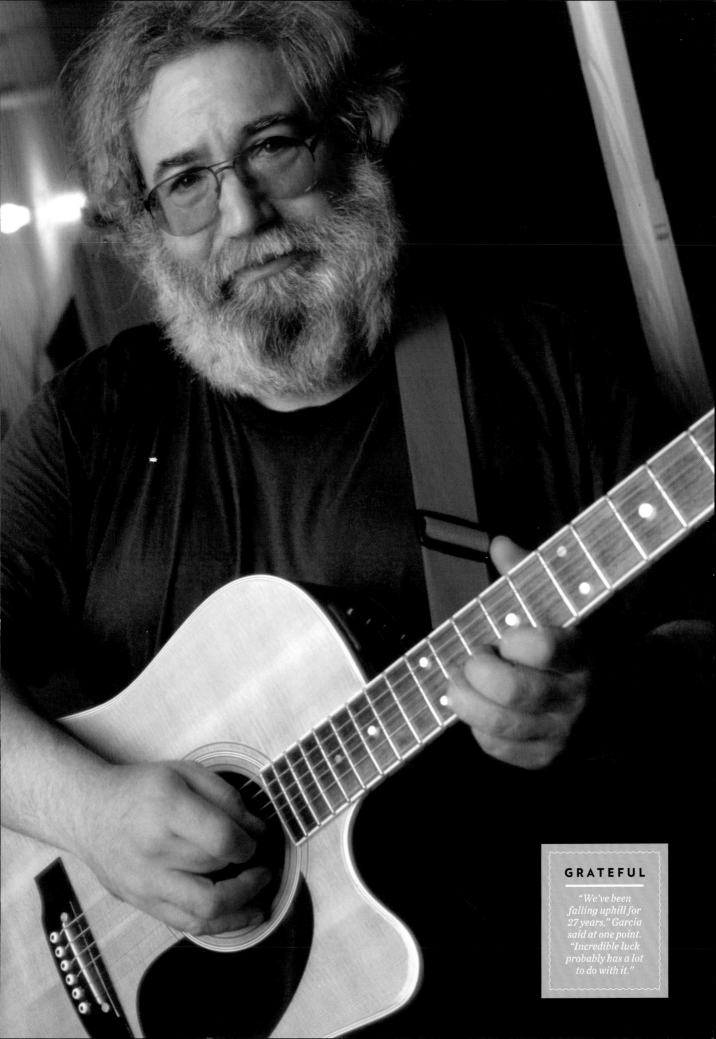

JAMES BROWN

The Godfather of Soul said it all in very few words. And they were: Good Gawd! Hunh! One time! I feel good!

Elvis was the King, but James Brown was the Godfather of Soul, Soul Brother No. 1 and, of course, the Hardest Working Man in Show Business. Famously, at the end of each performance, he would collapse onstage, exhausted, and an emcee would throw a cape over him. Brown, with help, would stagger toward the exit—then, suddenly, throw off the cape, turn back to the microphone and, somehow, summon the strength for *one more song*.

It was visceral, old-school showbiz from a man who had learned to keep an audience's attention while dancing for spare change on the streets of Augusta, Ga., his hometown. Raised in poverty, he served time for breaking into cars before scoring his first hit, "Please, Please, Please," in 1956. For decades afterward he produced a yowling, rhythm-heavy sound whose titles—"I Got You (I Feel Good)," "Papa's Got a Brand New Bag," "Get Up Off That Thing," "Say It Loud—I'm Black and I'm Proud," "Give It Up Or Turn It Loose," "Hot Pants"—often comprised most of the lyrics as well.

His personal life frequently made headlines: Brown was married four times and had at least six children. In 1988 police who were chasing him had to shoot out the tires of his truck, and he spent 15 months in jail on assault charges. The Hardest Working Man in Show Business quit working at 73, after a long battle with pneumonia. His musical legacy will continue to be a mother lode for samplers for decades. Said Island Def Jam Music Group chairman L.A. Reid: "James Brown has influenced black music more than any other entertainer, dead or alive."

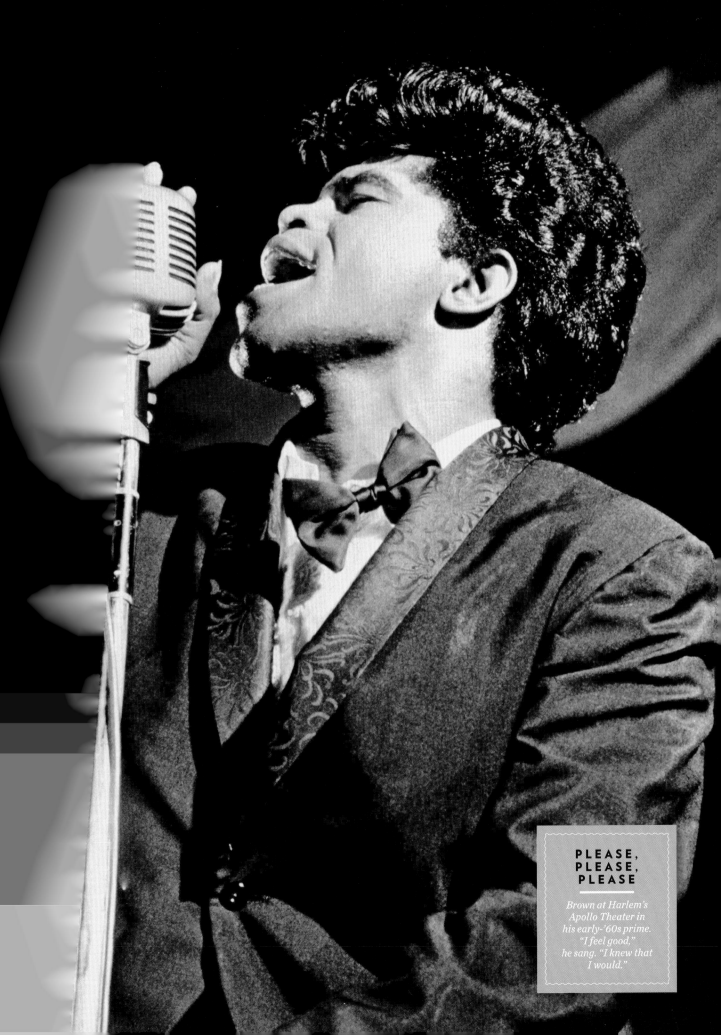

FRANK SINATRA

The stylish, skinny, swinging kid from Hoboken did it his way, and he did it better than anyone ever has

For more than half

a century, he helped listeners rediscover the powers of enchantment, in the oldest meaning of that word: a spell that is sung. And that was only half his legacy: Frank Sinatra was just as well-known as the hard-living, snap-brimmed Chairman of the Board, a womanizing tough guy who busted lips and broke hearts with reckless ease, romancing Lauren Bacall, Marlene Dietrich and Ava Gardner when he wasn't closing bars with Rat Pack pals Dean Martin and Sammy Davis Jr.—not to mention mobsters like Lucky Luciano. "Sinatra was the most confident man who ever strode the planet," said Bill Zehme, author of the Sinatra style-primer *The Way You Wear Your Hat*. "There was never any second-guessing." And few second-place finishes. "He conquered every medium—television, recording, films," said pal Tony Bennett. "He was just born for what he did."

That was in Hoboken, N.J., on Dec. 12, 1915. The doctor's forceps punctured Sinatra's eardrum, which years later kept him out of the WWII draft. At 15, Sinatra was expelled from school

for rowdiness and began trying to earn money singing at local dances. Over time he became a singing waiter at a Jersey club that broadcast its shows, and bandleader Harry James took an interest. "He considers himself the greatest vocalist in the business," James told friends. "He's never had a hit record. He looks like a wet rag. But he says he's the greatest!"

James signed him, and Sinatra's world exploded. He quickly jumped to the even bigger Tommy Dorsey band and had his first hit, "I'll Never Smile Again." He had more hits, went solo and, during a famous stint at New York's Paramount Theater, sparked a riot in which 30,000 teen girls, unable to get tickets, broke windows and battled cops in Times Square. A congressman labeled him "the prime instigator of juvenile delinquency in America."

Now married and a father of two, Sinatra signed for $1.5 million with MGM, moved to Hollywood and became a man-about-town. Dalliances with Dietrich and Lana Turner were followed by a life-changing affair with Gardner. "She was the love of his life," said a friend. "She said he was magic."

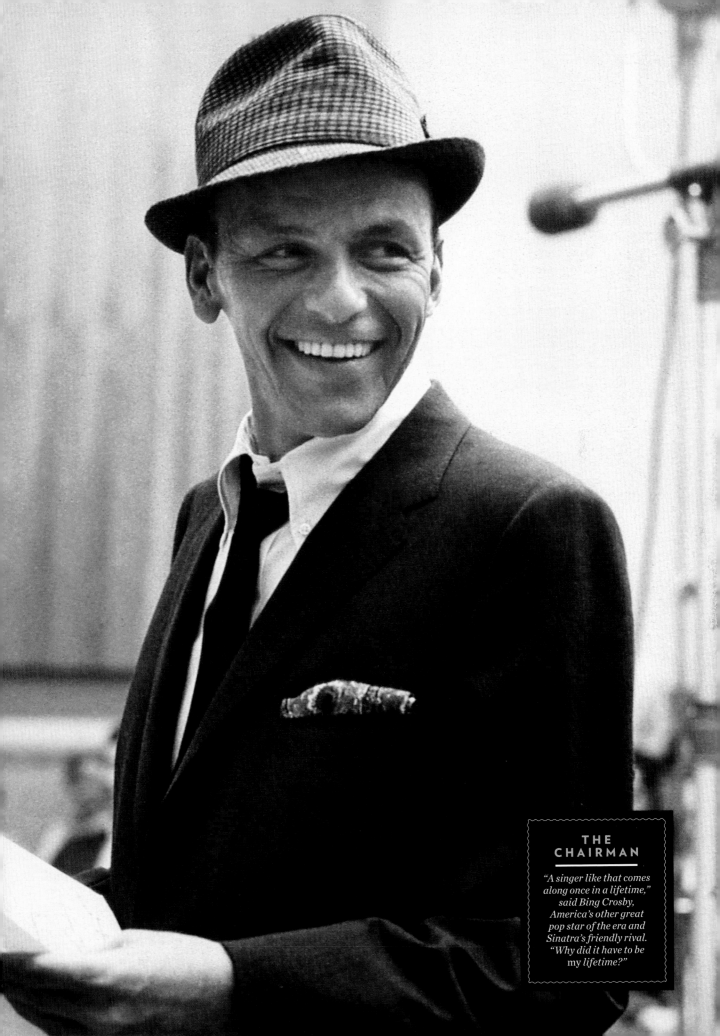

THE CHAIRMAN

"A singer like that comes along once in a lifetime," said Bing Crosby, America's other great pop star of the era and Sinatra's friendly rival. *"Why did it have to be my lifetime?"*

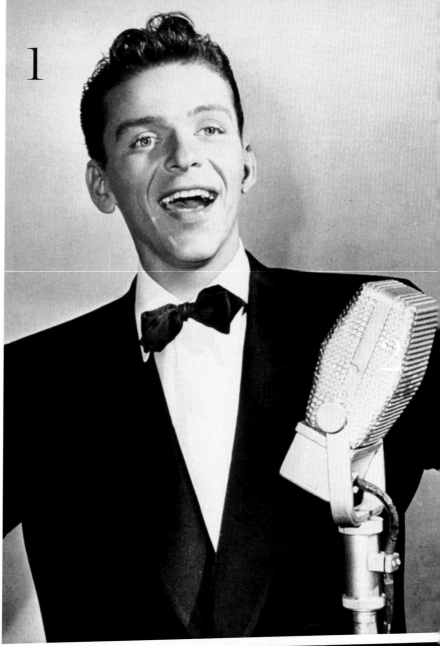

1

Sinatra divorced his wife and married Gardner, but their union was so emotionally volatile that he twice attempted suicide. Some of the songs he recorded after the marriage incinerated, particularly "In the Wee Small Hours," were among the most moving of his career.

He went on to make music and headlines for the rest of a long life. Sinatra won an Oscar for *From Here to Eternity,* frolicked with the Rat Pack and—by filling seats at the Sands casino, in which he was a part owner—helped establish Las Vegas as a high-roller mecca. He introduced pal Marilyn Monroe to the Kennedys and, at 50, married 21-year-old actress Mia Farrow. She was not cut out for the ring-a-ding life. "All they know how to do," Farrow said of Frank's buddies, "is tell dirty stories, break furniture, pinch waitresses' asses and bet on the horses." They split within two years.

He toured with Dean Martin and Sammy Davis Jr. in the '80s, only to find that, by comparison, they'd become the Nap Pack. "Dean and Sammy, they couldn't hang," said Hank Cattaneo, Sinatra's concert production manager. "After half an hour, Dean would say, 'I gotta go to bed.'" Said comedian Tom Dreesen, Sinatra's warm-up act: "Frank was nocturnal. When you tour with Frank, you have to stay up until the sun comes out." Even as his voice frayed, Sinatra filled concert halls. "You can be the most artistically perfect performer in the world," he said, "but the audience is like a broad—if you're indifferent, endsville."

Sinatra, in ailing health for more than a year, died in 1998, after suffering a heart attack. "Sometimes I wonder whether anybody ever had it like I had it," he once said, looking back. "It was the damndest thing, wasn't it?"

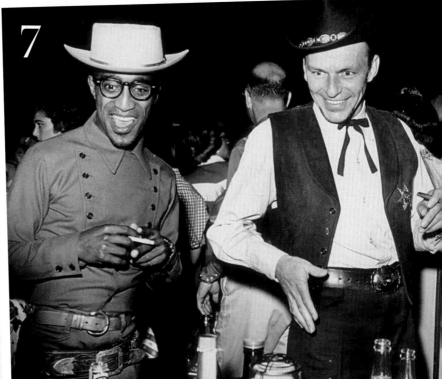

7

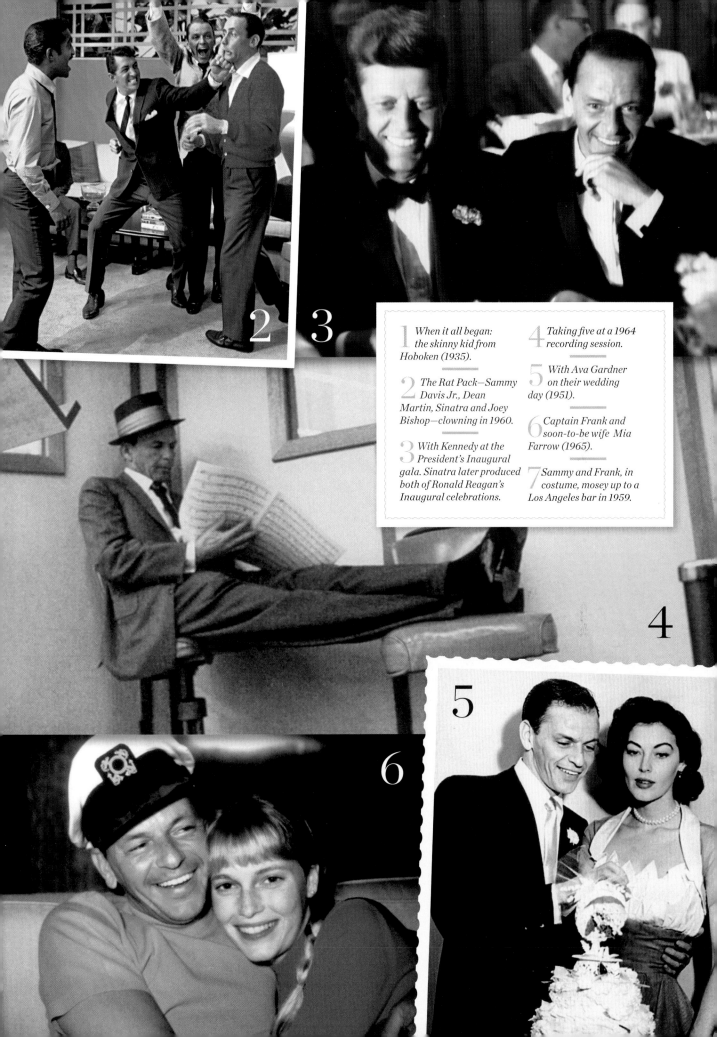

2 **3**

1 When it all began: the skinny kid from Hoboken (1935).

2 The Rat Pack—Sammy Davis Jr., Dean Martin, Sinatra and Joey Bishop—clowning in 1960.

3 With Kennedy at the President's Inaugural gala. Sinatra later produced both of Ronald Reagan's Inaugural celebrations.

4 Taking five at a 1964 recording session.

5 With Ava Gardner on their wedding day (1951).

6 Captain Frank and soon-to-be wife Mia Farrow (1965).

7 Sammy and Frank, in costume, mosey up to a Los Angeles bar in 1959.

4

6

5

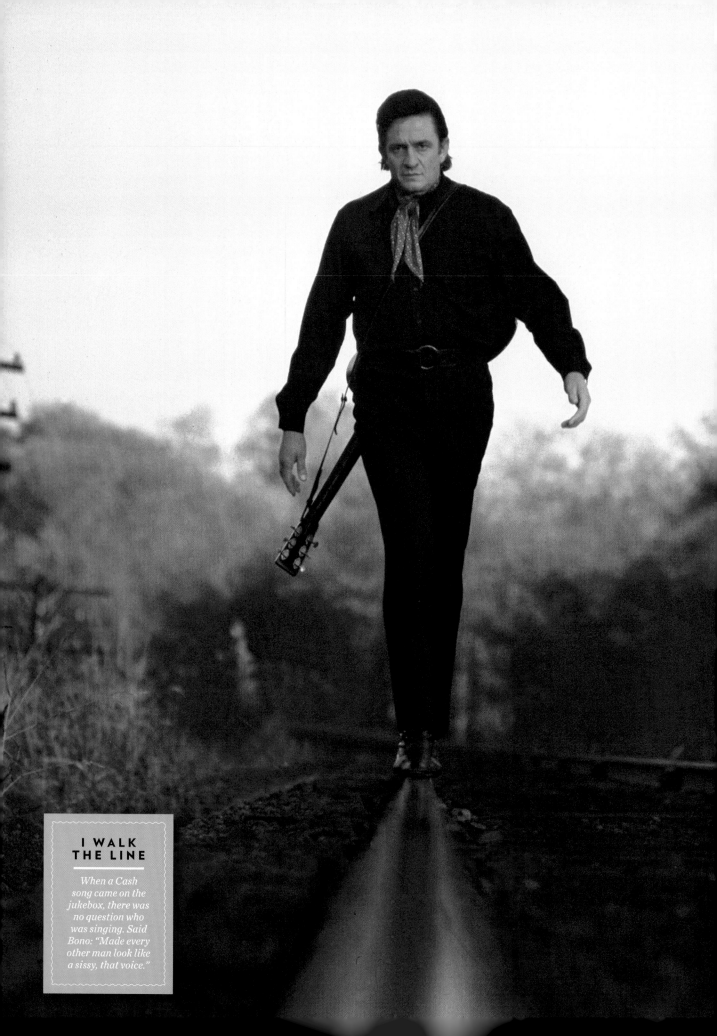

I WALK THE LINE

When a Cash song came on the jukebox, there was no question who was singing. Said Bono: "Made every other man look like a sissy, that voice."

JOHNNY CASH

1932
2003

A sharecropper's son, the Man in Black overcame his demons and became a country legend

ƒ Fans remember

Johnny Cash as a poet who seesawed through the highs and lows of success and excess, a gravelly voiced legend of country music. Yet his greatest accomplishment may have been his most unlikely: The singer who publicly battled drug addiction was at the end a family man. When he died on Sept. 12, 2003, just four months after wife June Carter, three of his five children and three remaining siblings were at his side. "He never criticized, he never condescended to us, he never forced his will on us," said daughter Rosanne Cash at his memorial service. "He respected us as much as we respected him."

The fourth of seven children born to a sharecropping family in Arkansas, Cash endured a hardscrabble childhood and, at his mother's urging, sought solace in music. After graduating from high school in 1950, he enlisted in the Air Force. While stationed in West Germany, he wrote the lyrics for the song that would become his signature, "Folsom Prison Blues." Cash "stood up for the underdogs, the downtrodden, the prisoners, the poor, and he was their champion," said singer-songwriter Kris Kristofferson. "He appealed to people all over the world."

By the mid-1960s he was performing 300 concerts a year—and gobbling amphetamines to stay awake and barbiturates to steady the rush. He trashed hotel rooms, totaled cars and failed to show up for gigs. "I was scraping the filthy bottom of the barrel of life," he wrote in his 1997 memoir. His personal life was in shambles, and in 1966 his marriage to Vivian Liberto ended. His salvation was literally waiting in the wings. Since the early 1960s, he'd been touring with June Carter, and in 1967 she helped him quit drugs cold turkey. The next year they married. "Our hearts are attuned to each other," Cash said. "I can't envision living without her."

"What kept him credible with people was that when he made mistakes, he was the first one to say, 'I did it, I messed up,'" said musician Marty Stewart. "He had a humble nature, and you couldn't not forgive him."

SELENA

1971
1995

A soaring talent with a common touch, silenced by a senseless murder

At age 9, Selena

Quintanilla was already lead singer in the family band, performing concerts at her father's restaurant. Then the restaurant went under, and the Quintanillas lost their home. "That's when we began our musical career," Selena later recalled. "We had no alternative." The band, known as Selena y Los Dinos, began touring the back country of South Texas, playing weddings and honky-tonks. "If we got 10 people in one place, that was great," said Selena. "We ate a lot of hamburgers and shared everything."

Slowly, steadily, she and the band graduated from street corners to ballrooms and cut nearly a dozen albums for a small regional label. Their break came in 1987 when 15-year-old Selena won the Tejano Music Awards for female vocalist and performer of the year. There followed six increasingly successful albums, topped by *Amor Prohibido* (*Forbidden Love*) in 1994. It was nominated for a Grammy and sold more than 500,000 copies. Selena—who had married Chris Pérez, her band's guitar player, in 1992—was now the undisputed Queen of Tejano Music.

And then: tragedy. In 1995 Selena received reports that her fan-club president and onetime friend, Yolanda Saldívar, was embezzling funds.

Selena confronted Saldívar, the two argued, and, in a motel room at the Corpus Christi Days Inn, Saldívar pulled a revolver and shot Selena in the back. The singer, 23, died from the wound. Saldívar, who claimed the shooting was accidental, was convicted of first-degree murder and sentenced to life in prison.

Fans of Latin music compared Selena's death to the murder of John Lennon. She had been larger than life, adored not just for her music but also for her immense rapport with ordinary people. From as far away as Canada and Guatemala, 50,000 mourners flocked to Corpus Christi, the town Selena and her family had called home, to pay their respects. "We will never know how far she could have gone," said one critic.

In 1997, when Jennifer Lopez was filming her starring role in the Selena biopic (a role that would help make Lopez a star), Tejano aficionados gathered in droves at the San Antonio filming location. "We came for Selena, even though we know no one can replace her," said fan Yvonne Romero, who arrived at 3 a.m., hoping to land a spot as an extra in the movie. Lamented assistant producer Nancy de los Santos: "We shouldn't be making a movie about Selena. We should be making one with her."

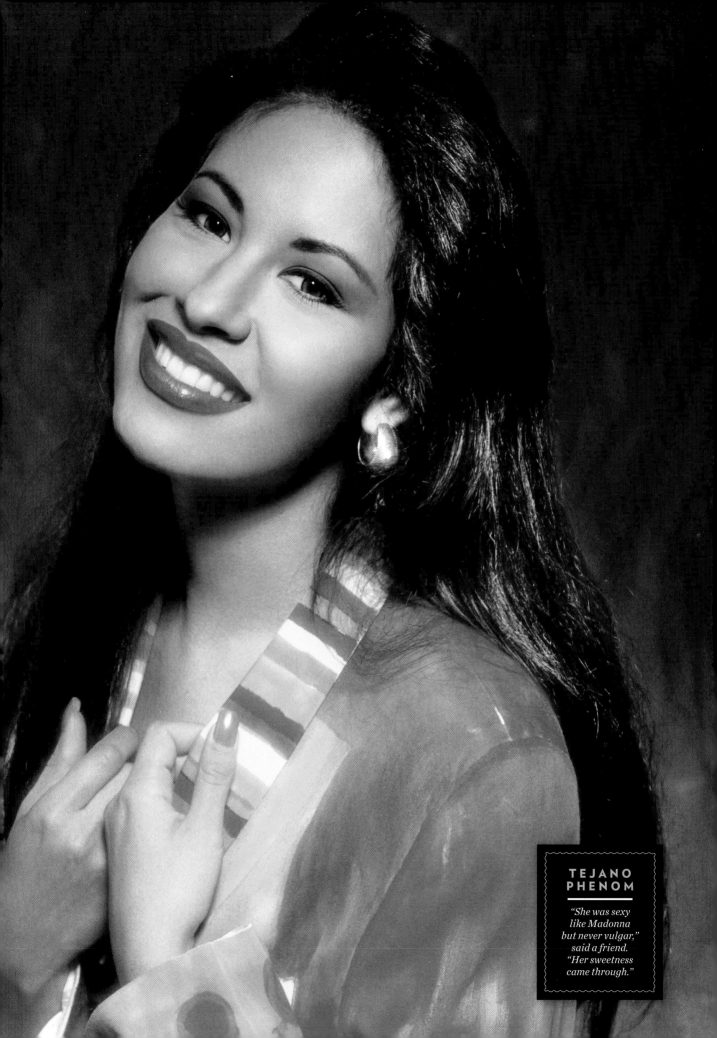

LIBERACE

**1919
~~~
1987**

Lights! Cameras! Candelabra!
The feathered flamingo of camp
lived a double life, fabulously

Baldwin

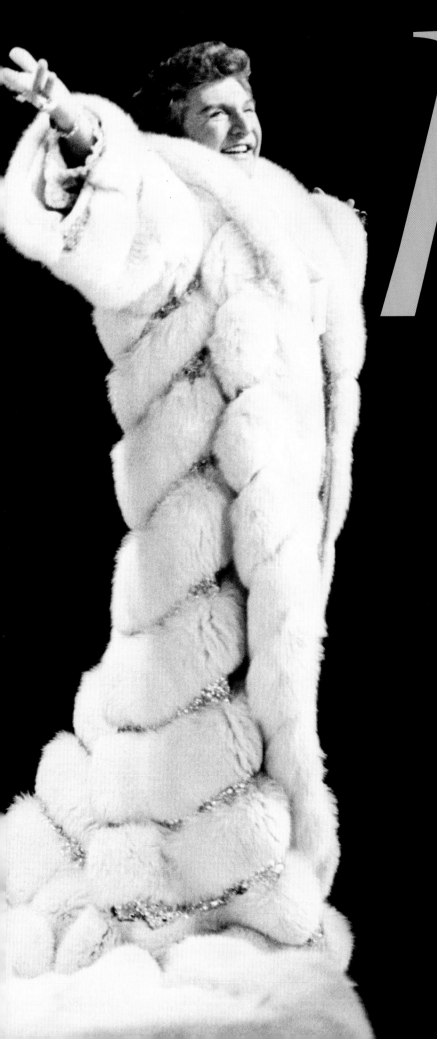

# His was a life of

exquisite paradox; of flamboyance and repression, kitsch and concealment. He appeared onstage in a 137-lb. Norwegian blue shadow mink or a 26-ft.-long pink feather train; cherished over-the-top jewelry like the gold ring depicting his beloved poodle, Baby Boy (the eyes were emeralds, the tongue rubies); had the ceiling of the Sistine Chapel re-created in his bedroom; and somehow, until his last day, clung to the belief that no one in America knew he was gay. That faith was arguably part of his charm. "He's so unlike the rest of us," his sister Angelina once said. "He doesn't much care for the real world, you know."

So he created his own, and fans—who bought his records and helped him command as much as $400,000 a week in Las Vegas—wanted a peek. Liberace obliged with piano-shaped swimming pools, pink Cadillacs, mirror-encrusted pianos and a 15-bedroom Palm Springs mansion, the Cloisters, that boasted a leopard-skin Safari Lounge and a Persian tent room. His stage decor always included an enormous candelabra and things that sparkled—sequins at least; diamonds if possible. Liberace was, critics never tired of pointing out, more P.T. Barnum than J.S. Bach.

Growing up, he adored his mother but battled with his father, a classically trained musician who hated his talented son's preference for popular music. Liberace won a piano scholarship and later performed with the Chicago Symphony, but playing pop—at one point on the honky-tonk circuit under the stage name Walter Busterkeys—was his calling.

Although his sexual orientation was Hollywood's worst-kept secret, Liberace never did discuss it publicly—even when, in 1986, he was diagnosed with AIDS. He passed away five months later. Beneath the glitz, said longtime friend Rosemary Clooney, "he was just a nice man, a gentle man."

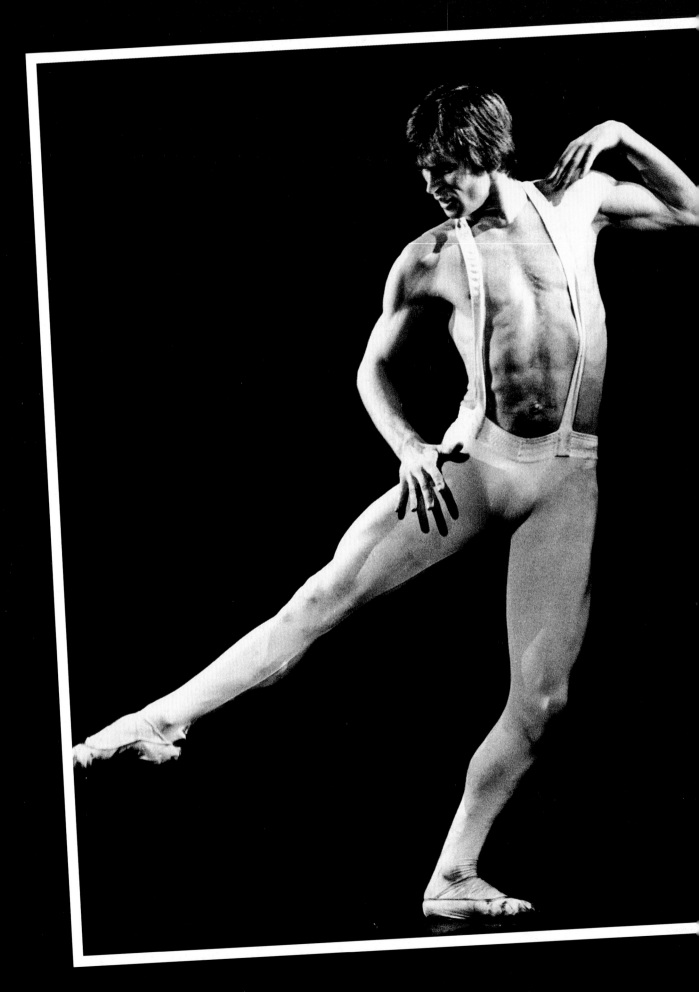

# ARTS & CULTURE

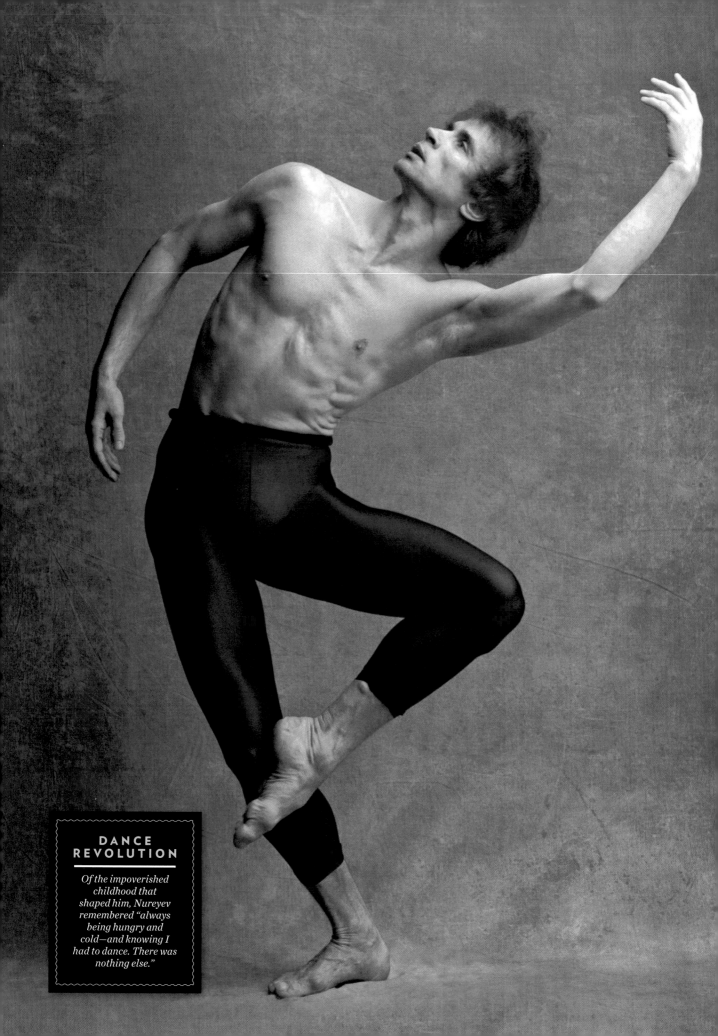

## DANCE REVOLUTION

Of the impoverished childhood that shaped him, Nureyev remembered "always being hungry and cold—and knowing I had to dance. There was nothing else."

1938
1993

# RUDOLF NUREYEV

His most famous partner called him "a young
lion leaping"; the dance world stared, transfixed

## Of course I push my body,"

Rudi Nureyev once said, explaining why he kept studying,
rehearsing and performing long after, rich and honored, he
would not slow down. "What else is there to do? I will dance
until I drop. After all, dance is not a casual affair."

One of the greatest dancers of the 20th century, the Russian-
born Nureyev was given to grand leaps, sweeping statements
and extravagant gestures. "Our Tartar blood runs faster," he
said of his of his peasant background, "always ready to boil." At
16, he bought a one-way ticket to Moscow and won a spot with
the legendary Kirov Ballet. At 23, as the troupe was performing
in Paris, he defected to the West, as much for freedom as for
freedom to dance. "I didn't come to the West to be a star," he
insisted. "I already was one. I came to dance everything."

After conquering the classical repertoire, he turned in his
30s to modern dance, retraining his body for the entirely new
stylistic demands of Martha Graham and Maurice Béjart.
His hunger to learn and perform was ravenous: During one
daunting stretch, Nureyev, 38, danced 48 performances in 47
days with three different companies.

Until the end of his life, he lived as an extravagant vagabond,
hopping between homes in New York, Paris and on his private
island, Li Galli, off Italy's Amalfi coast. When he could no longer
dance, he became artistic director of the Paris Opera Ballet;
there, in 1992, stricken with AIDS and physically supported by
fellow dancers, he took the final bow of an extraordinary life.

# NORMAN MAILER

## The swaggering, prize-winning author stirred controversy in literature and in life

1923
2007

Prolific and pugnacious, Norman Mailer won two Pulitzer Prizes, feuded with fellow writers and feminists, ran for mayor of New York City, wed six times and had nine children. "He presented himself as a tough guy; that was a front," said author Gay Talese. "He had a big heart."

But some of the scrapes were real: Famously, at a party in 1960, he stabbed his second wife, Adele, with a penknife. "He never apologized," she noted, decades later.

Raised in Brooklyn, Mailer headed to Harvard at 16 to study engineering, discovered literature and never looked back. When the war came he joined the army, served in the South Pacific and 15 months later completed his war novel *The Naked and the Dead*, which made him a literary star at 25. Later he would help reshape the concept of journalism with his "nonfiction novel" *The Armies of the Night* and other writings in which the author/reporter became part of the story. "People were captivated by the larger-than-life personality," said writer Doris Kearns Goodwin. "But it's his words that will live on."

From the moment Julia Child first grabbed her giant whisk on a Boston public television show in 1962, viewers were captivated by the 6'2" cookbook author who cracked eggs and jokes with equal joie de vivre. The show's producer Russell Morash recalled watching Child and thinking, "Who is this madwoman cooking an omelette?"

1912
2004

Americans were soon inviting her into their homes on a weekly basis. In an era when most people still counted on frozen peas as a side for their meatloaf, Child's pioneering cooking show *The French Chef* gave them the courage to attempt boeuf bourguignon—at home, from scratch. Said legendary food writer and former *Gourmet* editor Ruth Reichl: "She made you want to go in there and do it yourself." (Indeed, that fact was celebrated in the hit 2009 movie *Julie and Julia*, about a woman who devotes herself to cooking, in one calendar year, all 524 recipes in *Mastering the Art of French Cooking*, the culinary bible coauthored by Child). Who could resist a woman who said things like, "I love putting butter on a chicken—and he loves having me do it!" and merrily improvised her way through fallen soufflés, burned bits and dropped food. "You're alone in the kitchen," she noted happily, "no one will see you!"

After serving during WWII in the OSS in Ceylon (now the CIA and Sri Lanka), Child, who at the time couldn't boil an egg, took up cooking when her beloved husband, Paul, a diplomat, was stationed in Paris. At 37, she was the only woman enrolled at the famed Cordon Bleu cooking school. Her recipe for the good life—spent mostly in Cambridge, Mass.—included large dollops of ebullience and butter and, especially, she said, "red meat and gin." In 2001 Child donated her utilitarian kitchen, devoid of fancy gadgets but containing 800 knives, to the Smithsonian.

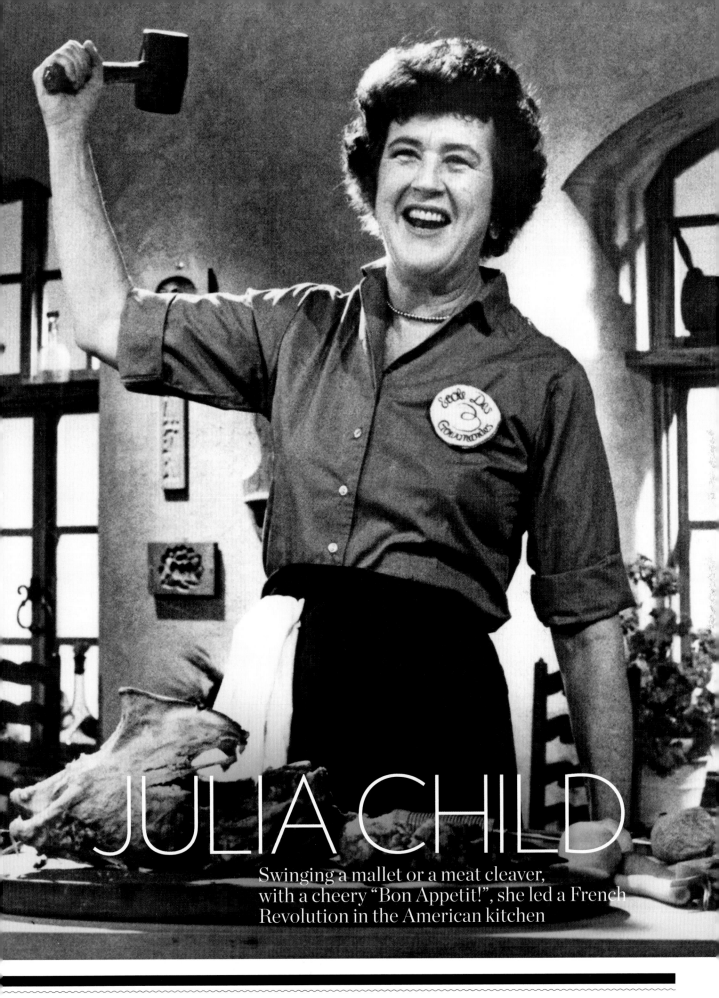

# JULIA CHILD

Swinging a mallet or a meat cleaver,
with a cheery "Bon Appetit!", she led a French
Revolution in the American kitchen

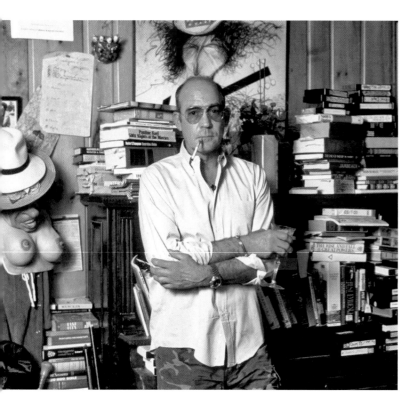

# HUNTER S. THOMPSON

"I hate to advocate drugs, alcohol, violence or insanity to anyone," said the gonzo author. "But they've always worked for me"

**1937 2005**

"People like him," reckoned a biographer, "because he said all the stuff everybody wishes they could say." But it was the outrageous way Hunter S. Thompson said it that gave birth to his patented "gonzo" journalism in provocative literary grenades like *The Kentucky Derby Is Decadent and Depraved* and *Fear and Loathing in Las Vegas: A Savage Journey to the Heart of the American Dream*. When William McKeen published his 1991 biography, Thompson, recalled the author, "sent a fax saying, 'I warned you not to write that vicious trash about me. How fast can you get fitted for an eye patch in case one of your eyes gets gouged out?' That was his way of saying, 'You did a nice job.'"

Not surprisingly, Thompson made a gonzo exit. Nearly crippled and in physical pain after decades of flamboyant drug and alcohol abuse, the 67-year-old author paid gruesome homage to his hero Ernest Hemingway by shooting himself in the head in his Woody Creek, Colo., home.

In accordance with his wishes—and with second wife Anita and son Juan, as well as celeb pals like Bill Murray, Sen. John Kerry, George McGovern and Johnny Depp (who paid for the $2 million ceremony) looking on—Thompson's ashes were fired out of a cannon and into the Colorado sky.

## Yes, there were

models before 1965, when Francesco Scavullo shot the first of his 300-plus *Cosmopolitan* covers, but it was his alchemy of styling and lighting that made them truly super. Celebs got the same treatment: Stars from Brooke Shields to Madonna knew they'd arrived when he pointed his lens their way.

Known singularly as Scavullo to fashionistas, the son of a New York supper-club owner practiced snapping his sisters before advancing to *Vogue* and LIFE. "He pulled the best out of anybody," said *Cosmo* editor Helen Gurley Brown, "by making that person think she was just glorious."

Despite nervous breakdowns, Scavullo never retired and suffered a fatal coronary at 82, just before a CNN interview. His life, said his partner, Sean Byrnes, was "work, work, work."

And not letting subjects see him sweat. "He was this smiley, wonderful man," said model Paulina Porizkova. "He never, ever made anybody look bad."

1921
2004

# FRANCESCO SCAVULLO

The *Cosmo* cover boy documented late
20th-century glam, one frame at a time

## YOU'RE BEAUTIFUL!

*Scavullo's work
ranged from a
famous nude
centerfold of
Burt Reynolds to
Madonna (left).*

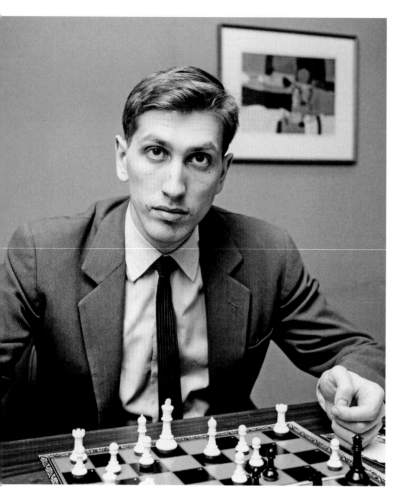

# BOBBY FISCHER

## THE CHESS PRODIGY'S BEAUTIFUL MIND HAD A SAD, UGLY SIDE

1935
2005

At the chess board he vanquished opponents with breathtaking genius. In life, though, Bobby Fischer fell victim to a more formidable foe—his own demons. Raised in Brooklyn, he began playing chess at 6. By 15, he had become the youngest grand master in the game's history. In 1972, in the depths of the Cold War, he traveled to Reykjavik, Iceland, to play the Soviet Union's Boris Spassky for the world championship. In a way that seems difficult to imagine now, the East-West showdown became a world-watched event; Fischer's victory made him a national hero and brought a congratulatory telegram from Richard Nixon.

After that: the abyss. Showing signs of mental instability, Fischer dropped from sight for 20 years. He reemerged to defeat Spassky again in 1992, then disappeared into a silence broken, jarringly, by occasional anti-Semitic and anti-American rants. He died in Iceland, having resisted treatment for the kidney disease that killed him. Still, said his biographer, Frank Brady, "He was the Beethoven of chess. His games will live forever."

# CHARLES SCHULZ

## A poet of the comic-strip panel gave voice to the world's Charlie Browns

1922
2000

He was a shy, skinny teenager who flunked algebra, physics and English. High school yearbook editors rejected his drawings. In adulthood, when he fell in love and proposed, she turned him down and married a fireman.

Armed with those experiences, Charles Schulz, in 1950, created *Peanuts* (originally called *Li'l Folks*), whose themes of loss and (rare) triumph proved so universal that the comic strip was eventually syndicated in 75 countries. How did Schulz respond? "All his life he just wanted to be witty and carefree like Snoopy," said his editor. "But despite all that success, he still felt like Charlie Brown." Those close to him felt differently. Said his son Craig: "He was the finest example of a human being I ever met."

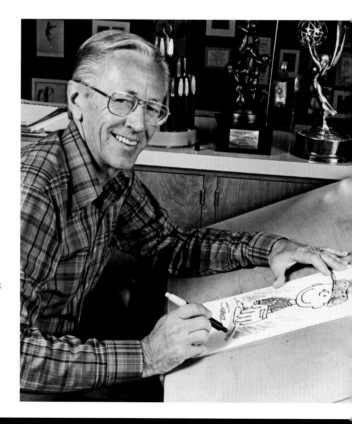

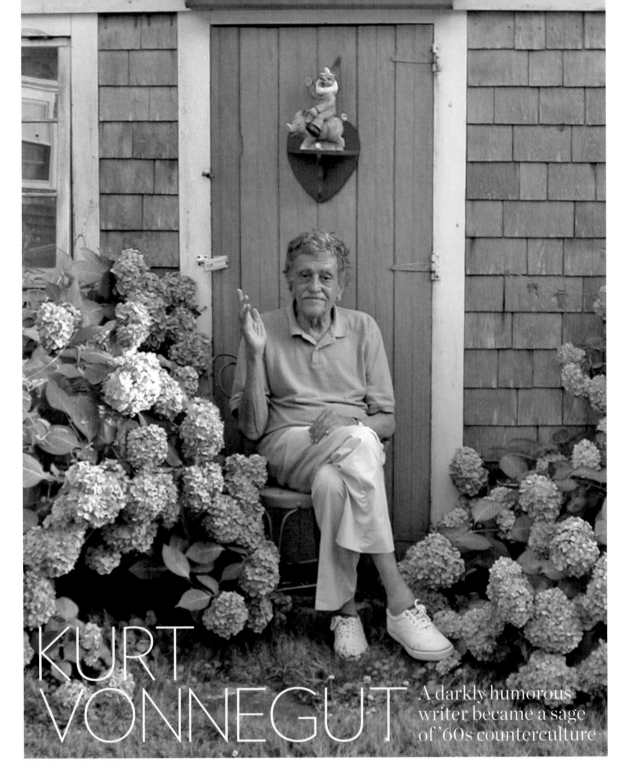

# KURT VONNEGUT

A darkly humorous writer became a sage of '60s counterculture

1922
2007

During the '60s, his novels—*Cat's Cradle, Mother Night, God Bless You, Mr. Rosewater*—were in every backpack. *Slaughterhouse-Five*, his fictionalized account of his WWII experiences as an American POW during the bombing of Dresden—tens of thousands died in the resulting firestorm—was an apocalyptic masterpiece. His gift was to capture the best, and worst, about people, often in the same paragraph. Said author John Irving, who had been a student of Vonnegut's at the Iowa Writers' Workshop: "He could write the most condemning stuff about human nature while being funny and kind."

That last part, Vonnegut concluded, mattered. Sweet-souled, world-weary and a bit of a curmudgeon, Vonnegut, who died at 84, clung to a philosophy succinctly expressed by Eliot Rosewater, the title character of his 1965 novel: "God damn it, you've got to be kind."

# LEADERS
# &
# ICONS

JACKIE KENNEDY

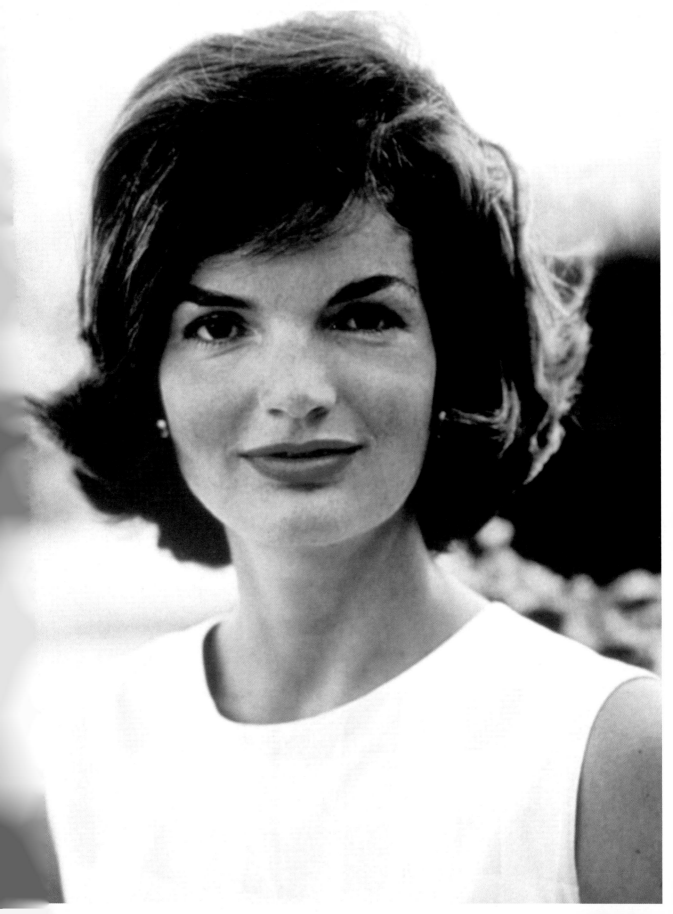

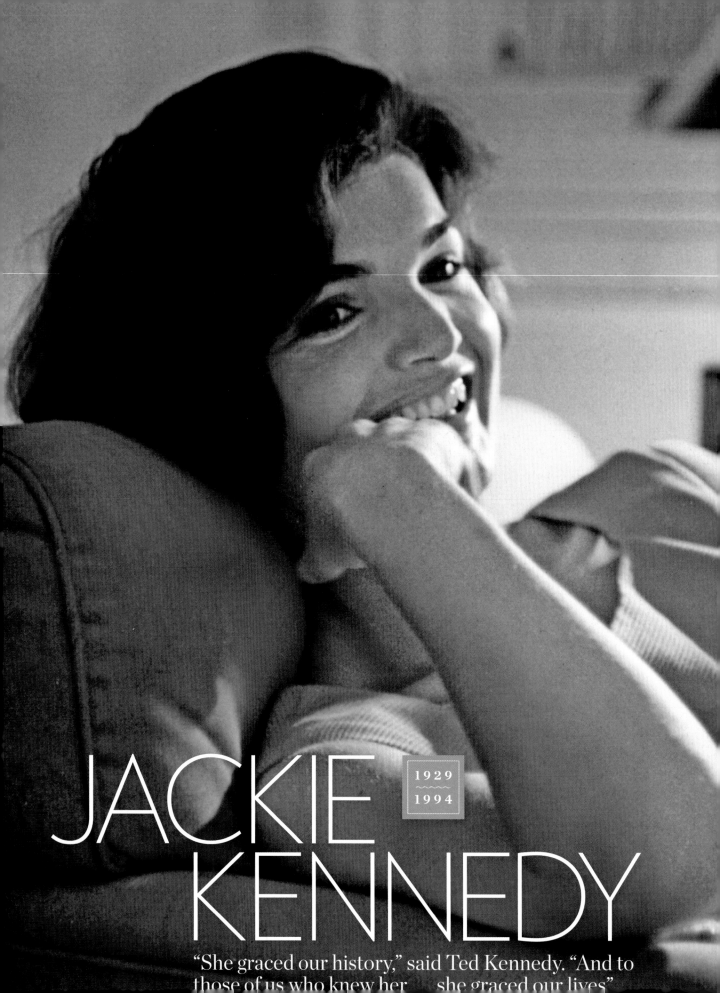

# JACKIE KENNEDY

1929
~~~
1994

"She graced our history," said Ted Kennedy. "And to those of us who knew her . . . she graced our lives."

RONALD REAGAN

1911
2004

He made his name as a Hollywood star, but his
most remarkable story was his own life

By the time Ronald

Reagan passed away at 93, he had given much
to the nation that mourned him. Outside his
presidential library in Simi Valley, Calif.,
thousands waited to view the casket of the man
many credit with ending the Cold War ("Mr.
Gorbachev, tear down this wall!" he intoned
within sight of the Berlin Wall in 1987). Even
those who didn't share his conservatism felt
the loss. "I'm not so sure about his politics, but
that's not what made him great," said a neighbor.
"He inspired people. He made us all feel better
about ourselves."

The former movie star helped restore pride
and prosperity to a nation still smarting from
the Watergate scandal and the Vietnam War.
His story was built on a series of improbabilities:
the child of an alcoholic father who became
a figurehead for family values; the skinny,
nearsighted kid who transformed into a
strapping lifeguard and a film star; and a
B-list actor who, finding his career washed up,
reinvented himself as a politician, first as a
two-term governor of California and then as
President. The nation held its breath when he
was shot by a would-be assassin months after
taking office—and cheered when he rebounded
to robust health with impressive speed.

His policies often stirred controversy.
Supporters applauded his move to a more
conservative, low-tax style of government;
critics said he did little as the AIDS crisis
exploded; questioned his role—never clearly
defined—in the Iran-Contra arms-for-
hostages scandal; and saw a spike in homeless
Americans as the dark side of Reaganomics.
Still, he was a fine one for restoring America's
can-do optimism, or comforting a nation
in trauma, as he did in the wake of the 1986
Challenger disaster. "He wasn't so much the
great communicator," former French President
François Mitterrand said, "as he was in
communion with the American people."

In the brutal world of politics, domestic
or international, he was living proof that an
ineffable quality—call it charm or charisma—
mattered. Recalled former Soviet President
Mikhail Gorbachev, who credits Reagan with
having "the wisdom to see beyond all the
contradictions that were coming from the
Soviet leadership" en route to helping dial down
decades of tension: "We had a good relationship.
Once we were having a meal together, and he
starts telling me this joke: Gorbachev comes
to Washington and is walking around the
White House with his staff when a journalist
asks, 'President Gorbachev, we're a democracy.
Anyone can come to the White House and shout,
"Down with Reagan!" Could that happen in the
Soviet Union?' And Gorbachev says, 'Of course
it could. Anyone can come to Red Square and
shout, "Down with Reagan!"' I said I really
liked that one. And Reagan says, 'Yeah, because
everyone's shouting, "Down with Reagan!"'"

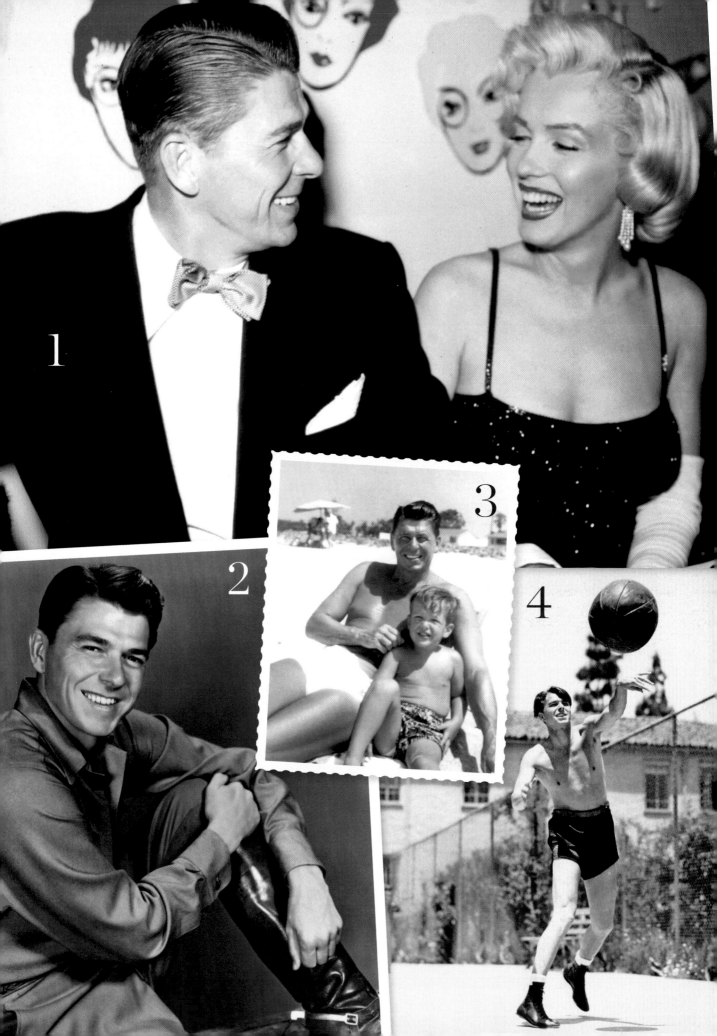

1

2

3

4

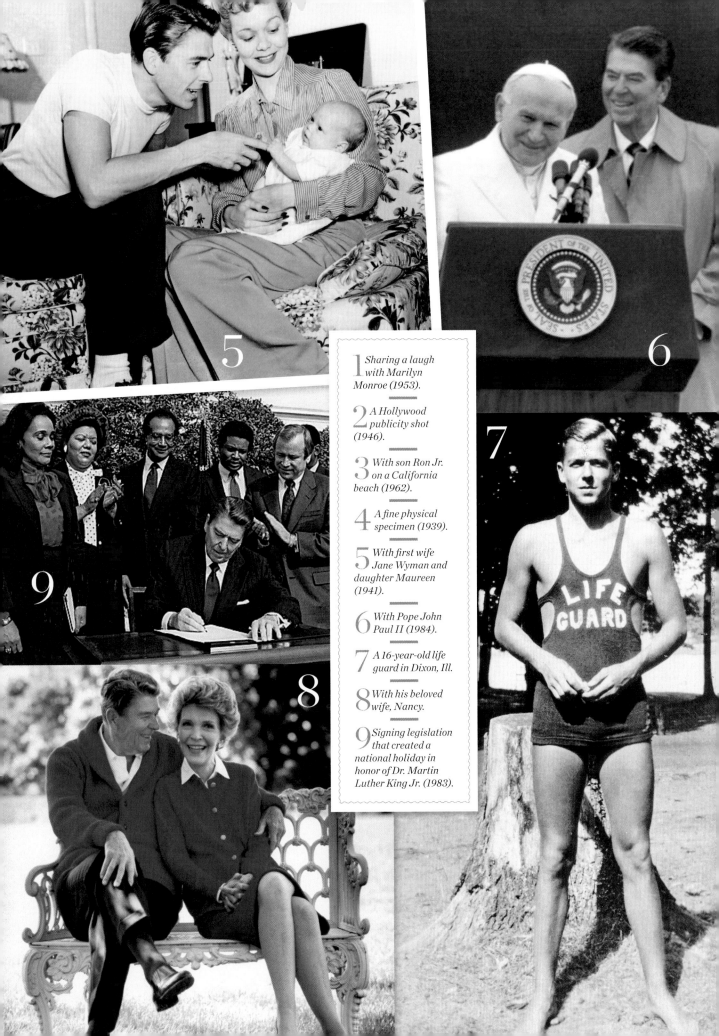

1 *Sharing a laugh with Marilyn Monroe (1953).*

2 *A Hollywood publicity shot (1946).*

3 *With son Ron Jr. on a California beach (1962).*

4 *A fine physical specimen (1939).*

5 *With first wife Jane Wyman and daughter Maureen (1941).*

6 *With Pope John Paul II (1984).*

7 *A 16-year-old life guard in Dixon, Ill.*

8 *With his beloved wife, Nancy.*

9 *Signing legislation that created a national holiday in honor of Dr. Martin Luther King Jr. (1983).*

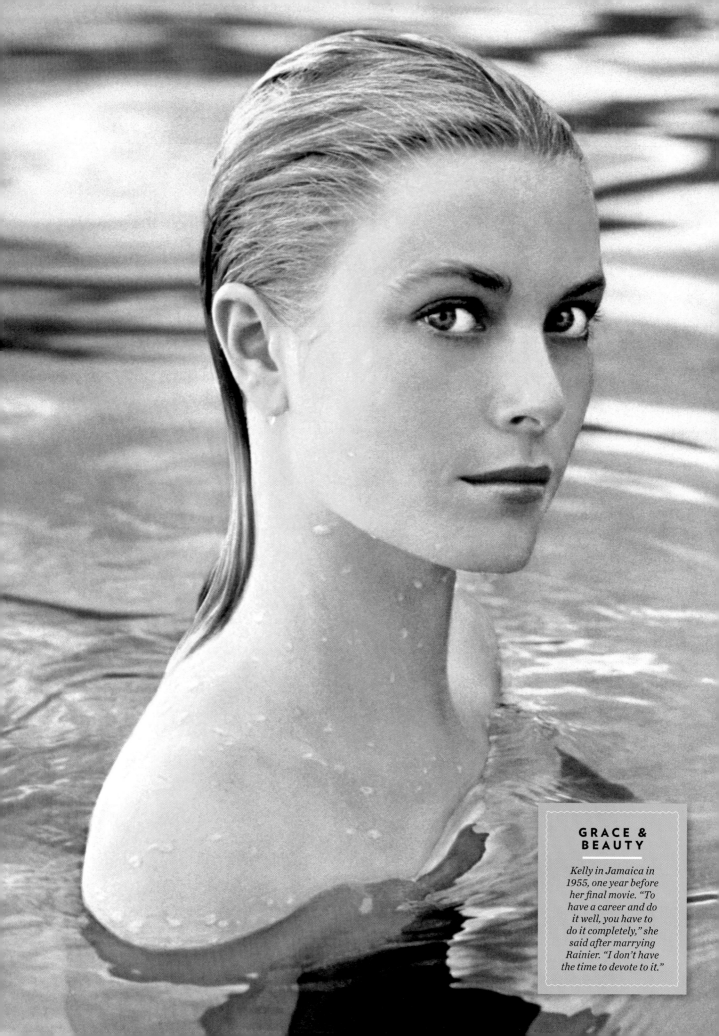

GRACE KELLY

A most uncommon commoner, the movie star turned princess lived what was to many a double fantasy

Before Diana

Princess of Wales, we had Grace Kelly of Philadelphia, a spunky debutante who proved that an American girl could grow up to become a glamorous movie star *and* a princess. Sure, she had a head start: She was born into privilege, where pearls, white gloves and cashmere twinsets came naturally to her. So, it seems, did acting. From her first role, as Gary Cooper's wife in 1952's *High Noon,* she was a star. She went on to shine in 11 memorable movies—including *Rear Window* and *The Country Girl,* for which she won an Oscar when she was only 22. Her appeal was undeniable and slyly sensuous. Her list of leading men read like a fantasy Hollywood stag party: Cary Grant, James Stewart, Clark Gable, Frank Sinatra. Her fashions—often by designers Oleg Cassini and Christian Dior—turned her into the iconic symbol of '50s chic. Then, after only five years, she walked away from Hollywood.

Actually, she was swept away. While filming *To Catch a Thief,* she met Monaco's Prince Rainier III and in 1956 they wed. The awesomely lavish nuptials were witnessed by 600 guests in person— plus an estimated 30 million on TV. After a seven-week honeymoon cruise around the Mediterranean, Grace settled into her royal role.

Being a princess seemed tailor-made for the American actress. She eagerly added ball gowns to her wardrobe and worked tirelessly for such favorite charities as the Red Cross and the Princess Grace Ballet School. At her glittering parties, while her husband sat and chatted with cronies, Grace circulated among the tables, concerned that no guest feel overlooked.

Yet her most demanding task, one she never let slide, was motherhood. She said of her children Caroline, Albert and Stephanie, "They have had the misfortune of growing up in the spotlight, and this is more difficult for them." Those difficulties were sometimes painfully apparent, as when Caroline's brief marriage to playboy Philippe Junot ended in divorce in 1980. Still, Grace handled it all with a natural nobility and humility. She said, not long before her death at age 52 (her car plummeting 120 feet off of one of Monaco's winding roads, the same roads she'd driven onscreen with Cary Grant in *To Catch a Thief*), "I don't think of my life as a fairy tale. I think of myself as a modern, contemporary woman who has had to deal with all kinds of problems that many women today have to deal with." Yes, but Grace dealt while gorgeously, graciously wearing a crown.

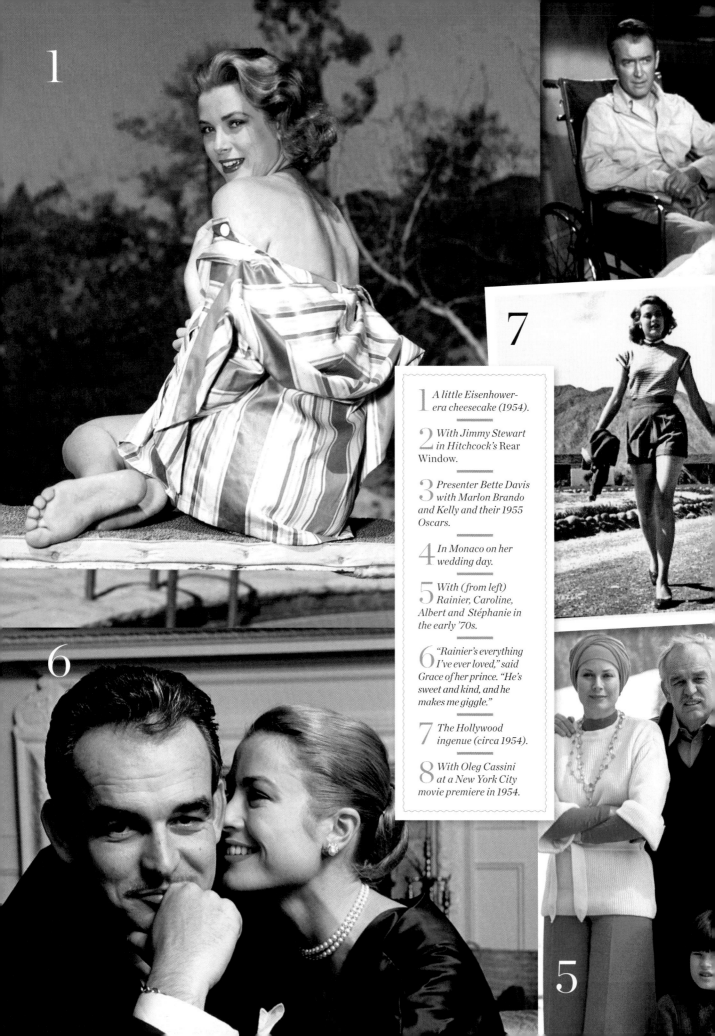

1 — A little Eisenhower-era cheesecake (1954).

2 — With Jimmy Stewart in Hitchcock's Rear Window.

3 — Presenter Bette Davis with Marlon Brando and Kelly and their 1955 Oscars.

4 — In Monaco on her wedding day.

5 — With (from left) Rainier, Caroline, Albert and Stéphanie in the early '70s.

6 — "Rainier's everything I've ever loved," said Grace of her prince. "He's sweet and kind, and he makes me giggle."

7 — The Hollywood ingenue (circa 1954).

8 — With Oleg Cassini at a New York City movie premiere in 1954.

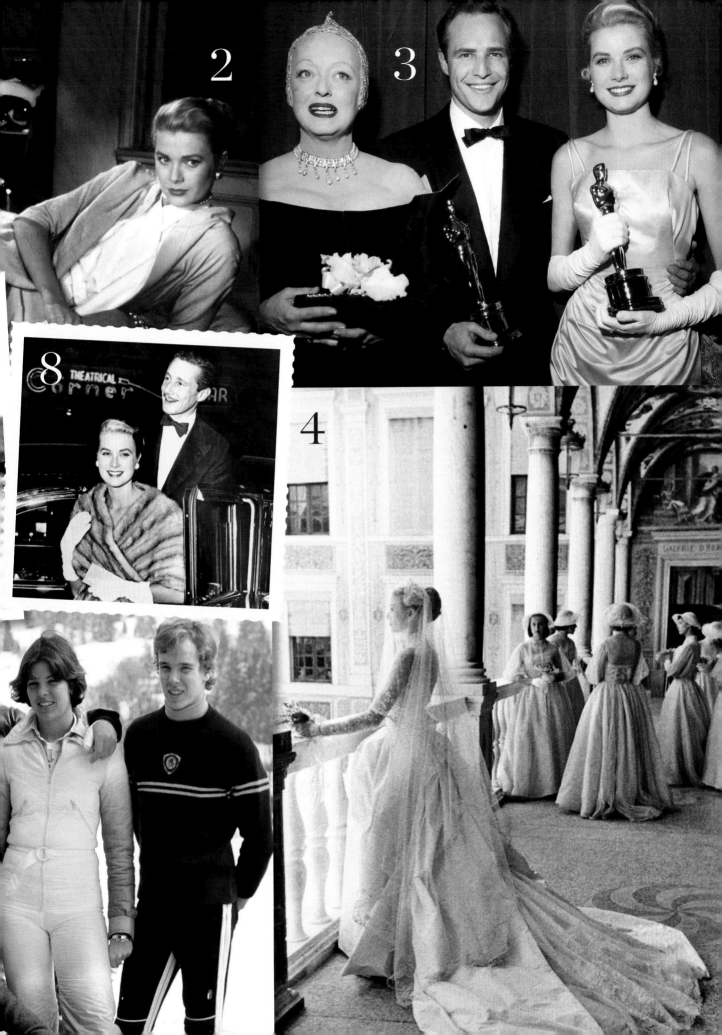

2

3

8

THEATRICAL Corner

4

GALERIE D'APOLLON

JOHN F. KENNEDY JR

A celebrity from birth, America's favorite son deftly navigated history and expectations to become his own man

John F. Kennedy Jr. once

said that he "grew up just living a normal life." Perhaps that's because it was the only life he knew. To the outside world, however, his 38 years were extraordinary. He became a heartbreaking symbol for perseverance at age 3, when, in a memorable photograph, he saluted the coffin of his slain father, President John F. Kennedy. He spent his adolescence powerboating in the Greek isles and cycling through New York City's Central Park with his mother, Jacqueline Kennedy Onassis. He dated movie stars. He piloted his own plane. And when he died in that plane—in a crash off the coast of Martha's Vineyard with his wife, Carolyn Bessette Kennedy, 33, and her sister Lauren Bessette, 34, on board—the nation mourned.

Despite his mother's wishes, John had grown up in public. Cameras trailed him when he toured Manhattan's museums with Jackie, when he jetted off to visit his mother's friends in Europe during school vacations and when, during Kennedy re-union weekends, he played endless games of touch football with his famous cousins at the clan's Hyannisport headquarters.

Yet it wasn't all glamour: To Jackie's dismay, John's failures were chronicled alongside his successes. John struggled as a student—at New York City's private Collegiate School for boys and later at Phillips Academy Andover in Massachusetts. As an

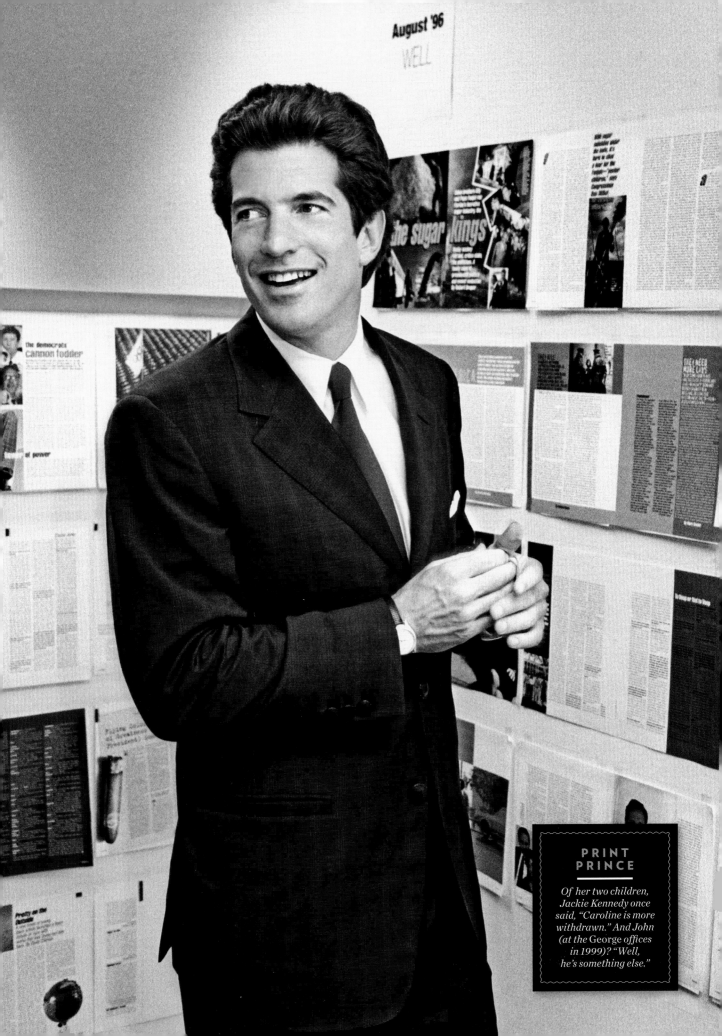

August '96

WELL

undergraduate at Brown University, he was known primarily for the slovenly state of his dorm room and his extreme absentmindedness ("He lost more bikes and stuff than anybody," said one friend). The one place he shone? The drama department. He eagerly performed in college theater productions and seemed to thrive in the limelight, but Jackie nixed the idea of an acting career. "She thought it was no life for a Kennedy," said author Edward Klein, a friend of Jackie's.

So, instead, John gravitated to the law. He earned his law degree at New York University and landed a job as an assistant district attorney in New York City. Though he famously flunked the bar exam—twice—he handled the setbacks with remarkable grace. "I'm clearly not a major legal genius," he gamely told the press. He passed the exam on his third try, but in 1993, tired of the charade, he quit his job after only four years.

From that moment on, John lived for himself. He Rollerbladed shirtless on Manhattan's streets, paraglided, kayaked in Vietnam and Iceland. When he went back to work, it was to found *George* magazine, a risky, glossy political start-up. And, finally, America's most in-demand bachelor found a woman with whom to settle down. After dating Madonna, Sarah Jessica Parker and Daryl Hannah (with whom he was linked for 5½ years), in 1996, two years after his mother's death, John wed Bessette, a fashion publicist. The couple soon became regulars on Martha's Vineyard, where John and Caroline had inherited their mother's estate. John, who received his pilot's license in 1998, flew out there himself most summer weekends. Taking off late on July 16, he encountered haze and creeping darkness that would have tested even more seasoned pilots, lost his bearings and crashed into the sea.

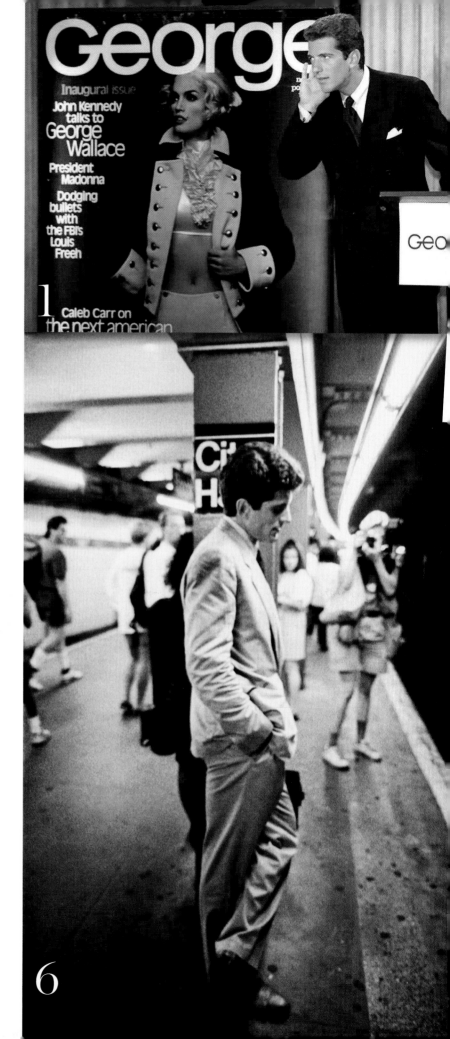

1

6

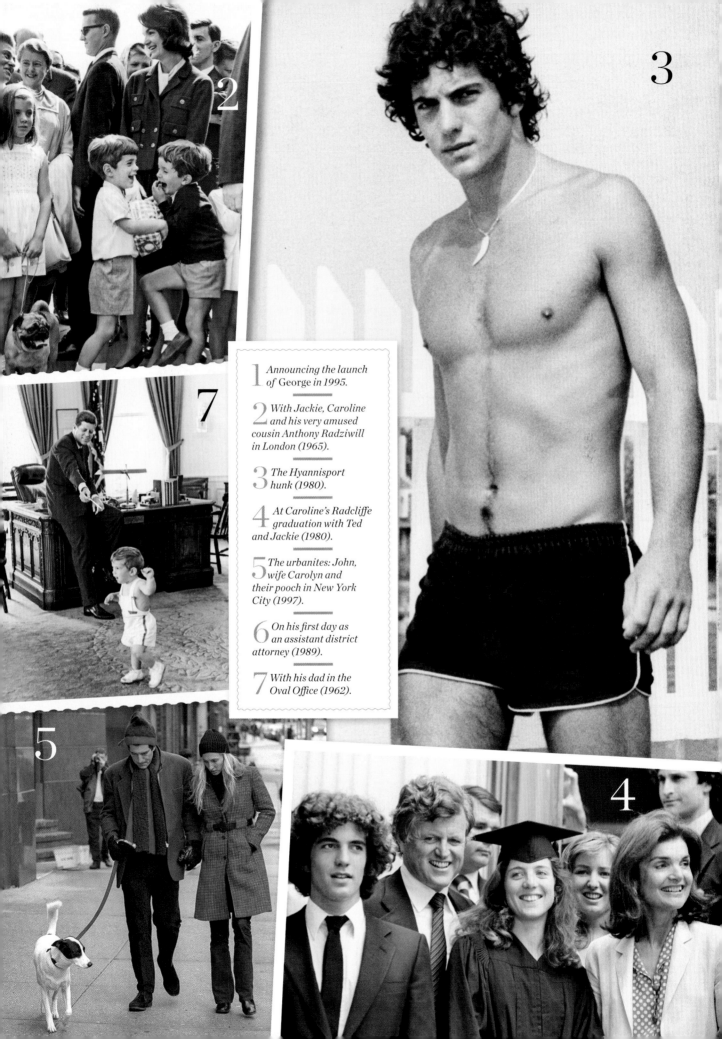

1 *Announcing the launch of George in 1995.*

2 *With Jackie, Caroline and his very amused cousin Anthony Radziwill in London (1965).*

3 *The Hyannisport hunk (1980).*

4 *At Caroline's Radcliffe graduation with Ted and Jackie (1980).*

5 *The urbanites: John, wife Carolyn and their pooch in New York City (1997).*

6 *On his first day as an assistant district attorney (1989).*

7 *With his dad in the Oval Office (1962).*

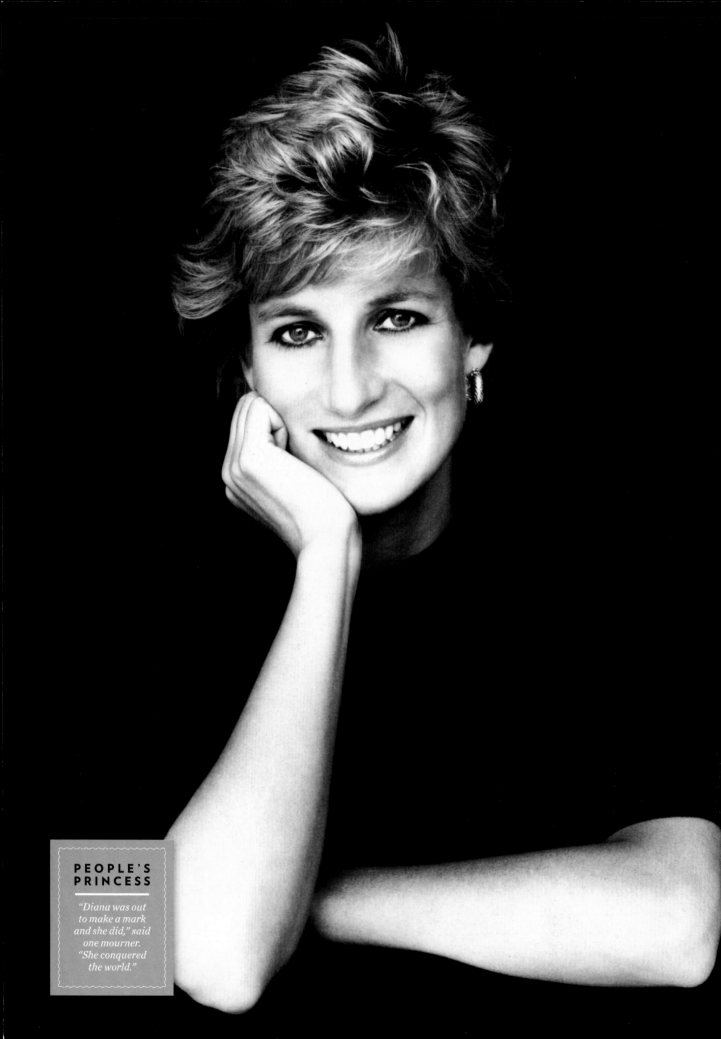

PRINCESS DIANA

Millions mourned the woman they loved, a princess with a gift for compassion

*a*fter all of it—the Cinderella wedding; the paparazzi tsunami; the births of Wills and Harry; the slo-mo, public disintegration of her marriage; the Squidgy tapes; the Camilla tape; the divorce—Princess Diana was slowly finding her footing. On the evening of Aug. 30, 1997, she telephoned *Daily Mail* writer Richard Kay from Paris, where she was staying with her new beau, Dodi Fayed. "She was as happy as I have ever known her," said Kay. "For the first time in years, all was well with her world."

At 10:30 Di and Dodi had a romantic dinner at the Ritz, the *ne plus ultra* hotel owned by Dodi's father, Egyptian billionaire Mohamed Al Fayed. As they finished, the maître d' whispered that 30 photographers had gathered outside. The couple retreated to a private suite, then decided to race past the paparazzi to Dodi's apartment off the Champs Elysées.

At 12:15 they climbed into a black Mercedes S 280 driven by Henri Paul, the hotel's assistant director of security. A former French Air Force commando, he had twice completed a Mercedes-Benz training course. Paul, who had been drinking at the Ritz bar and whose blood-alcohol level was later found to be three times the French legal limit, taunted photographers by announcing, "You won't catch up with us."

The Mercedes screeched away. On an expressway along the Seine, Paul hit speeds of more than 100 mph but lost none of his pursuers. Then it happened, just inside the Place de l'Alma tunnel. "There was this huge violent, terrifying crash, followed by the lone sound of a car horn," said witness Jérome Laumonier, who was near the tunnel entrance. Veering out of

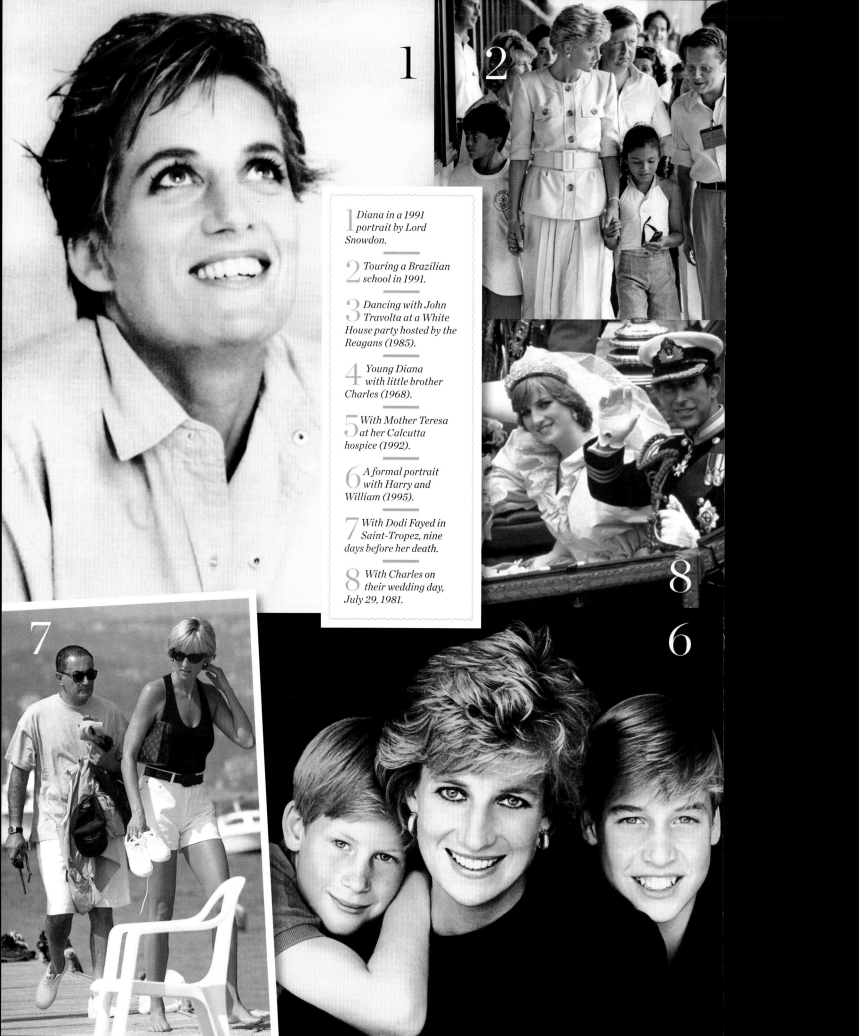

1 *Diana in a 1991 portrait by Lord Snowdon.*

2 *Touring a Brazilian school in 1991.*

3 *Dancing with John Travolta at a White House party hosted by the Reagans (1985).*

4 *Young Diana with little brother Charles (1968).*

5 *With Mother Teresa at her Calcutta hospice (1992).*

6 *A formal portrait with Harry and William (1995).*

7 *With Dodi Fayed in Saint-Tropez, nine days before her death.*

8 *With Charles on their wedding day, July 29, 1981.*

3

4

5

control on a slight curve, the Mercedes had hurtled head-on into a concrete column, rolled over, slammed off a wall and come to rest facing opposing traffic. Al Fayed and Paul were dead at the scene; bodyguard Trevor Reese-Jones—seated in front—was critically injured; Diana, barely alive, slumped in the back of the car. A paparazzo began taking pictures; angry onlookers reportedly attacked him. Gendarmes later confiscated his film.

Diana was taken to La Pitié-Salpêtrière hospital, where she went into cardiac arrest; in surgery doctors discovered a ruptured pulmonary vein. She was pronounced dead at 4:15 a.m.

On vacation at Balmoral Castle in Scotland, Charles was notified immediately. He awakened William, 15, and Harry, 12, at 7:15 and "ushered them into a private room," a source told the *New York Post.* "He said how he and their mother loved them very much, and he soberly explained that [she] had been in a very serious accident. He gently led into the fact that . . . Diana was dead."

The news rocked the world and, in no small way, the British monarchy. Millions mourned; teary Londoners by the thousands carpeted the entrance of Kensington Palace, Diana's home after her divorce, in flowers. Queen Elizabeth expressed her sorrow, but, misreading the moment, did not immediately return to London from Balmoral and, for reasons of protocol that were lost on many ordinary Brits, did not lower a national flag at Buckingham Palace to half-staff.

In microcosm, it was a continuation of the conflict that had defined Diana's relationship with the royal family: She appealed powerfully to the emotions; they stood for propriety, tradition, reserve.

Diana would have understood the needs of a mourning nation instinctively. The Queen took six days. After rising criticism, and a personal appeal from Prime Minister Tony Blair, the Queen lowered the flag on the day of Diana's funeral.

MASTHEAD

EDITOR Cutler Durkee **DESIGN DIRECTOR** Sara Williams **DIRECTOR OF PHOTOGRAPHY** Chris Dougherty **ART DIRECTOR** Cass Spencer **DESIGNER** Margarita Mayoral **PHOTO EDITOR** Annie Etheridge **WRITER** Allison Lynn **REPORTERS** Mary Hart, Kara Warner **COPY CHIEF** Ben Harte **PRODUCTION ARTISTS** Denise M. Doran, Cynthia Miele, Daniel Neuburger **SCANNERS** Brien Foy, Stephen Parabue **IMAGING** Romeo Cifelli, Charles Guardino, Jeffrey Ingledue, Robert Roszkowski **SPECIAL THANKS TO** Céline Wojtala, David Barbee, Jane Bealer, Margery Frohlinger, Ean Sheehy, Patrick Yang

ISBN 10: 1-60320-135-1 ISBN 13: 978-1-60320-135-3 Library of Congress Control Number: 2009940850

TIME INC. HOME ENTERTAINMENT
PUBLISHER Richard Fraiman **GENERAL MANAGER** Steven Sandonato **EXECUTIVE DIRECTOR, MARKETING SERVICES** Carol Pittard **DIRECTOR, RETAIL & SPECIAL SALES** Tom Mifsud **DIRECTOR, NEW PRODUCT DEVELOPMENT** Peter Harper **DIRECTOR, BOOKAZINE DEVELOPMENT & MARKETING** Laura Adam **PUBLISHING DIRECTOR, BRAND MARKETING** Joy Butts **ASSISTANT GENERAL COUNSEL** Helen Wan **BOOK PRODUCTION MANAGER** Suzanne Janso **DESIGN & PREPRESS MANAGER** Anne-Michelle Gallero **BRAND & LICENSING MANAGER** Alexandra Bliss **ASSISTANT BRAND MANAGER** Melissa Joy Kong

SPECIAL THANKS TO Christine Austin, Jeremy Biloon, Glenn Buonocore, Jim Childs, Susan Chodakiewicz, Rose Cirrincione, Jacqueline Fitzgerald, Carrie Frazier, Lauren Hall, Jennifer Jacobs, Brynn Joyce, Mona Li, Robert Marasco, Amy Migliaccio, Kimberly Posa, Brooke Reger, Dave Rozzelle, Ilene Schreider, Adriana Tierno, Alex Voznesenskiy, Sydney Webber

CREDITS